W9-CFU-592

Raphael's "School of Athens" examines one of the masterpieces of the Italian Renaissance and the artist's best-known work. Commissioned by Pope Julius II to decorate the walls of his private library, the fresco represents the gathering of the philosophers of the ancient world around the central figures of Plato and Aristotle. The adjacent walls represent theologians, poets, and lawgivers, the subjects of books in Julius's library. Presented in this volume are early criticisms of the fresco by Bellori and Wölfflin, along with new interpretations, published in this volume for the first time, of its iconography in relation to the other frescoes in the Stanza della Segnatura and in the context of humanism and the rhetorical tradition of the papal court; analysis of Raphael's groundbreaking use of light and color; and an inquiry into the role of Bramante and antique architecture in Raphael's design. An introduction surveys the critical history of Raphael and the painting, and the history of modern interpretations.

RAPHAEL'S "SCHOOL OF ATHENS"

──── MASTERPIECES OF WESTERN PAINTING ────

This series serves as a forum for the reassessment of several important paintings in the Western tradition that span a period from the Renaissance to the twentieth century. Each volume focuses on a single work and includes an introduction outlining its general history, as well as a selection of essays that examine the work from a variety of methodological perspectives. Demonstrating how and why these paintings have such enduring value, the volumes also offer new insight into their meaning for contemporaries and their subsequent reception.

VOLUMES IN THE SERIES

RAPHAEL'S
"SCHOOL OF ATHENS"

Edited by

Marcia Hall
Temple University

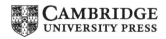

CAMBRIDGE
UNIVERSITY PRESS

PUBLISHED BY THE PRESS SYNDICATE OF THE UNIVERSITY OF CAMBRIDGE
The Pitt Building, Trumpington Street, Cambridge, CB2 1RP, United Kingdom

CAMBRIDGE UNIVERSITY PRESS
The Edinburgh Building, Cambridge, CD2 2RU, United Kingdom
40 West 20th Street, New York, NY 10011-4211, USA
10 Stamford Road, Oakleigh, Melbourne 3166, Australia

First published 1997

Printed in the United States of America

Typeset in Bembo

Library of Congress Cataloging-in-Publication Data

Hall, Marcia B.
 Raphael's "School of Athens" / Marcia Hall.
 p. cm. – (Masterpieces of Western painting)
 Includes index.
 ISBN 0-521-44447-0 (hardback). – ISBN 0-521-44899-9 (pbk.)
 1. Raphael, 1483–1520. School of Athens. 2. Raphael, 1483–1520 –
Criticism and interpretation. I. Title. II. Series
 ND623.R2A76 1996
 759.5 – dc20 96–19745
 CIP

*A catalog record for this book is available from
the British Library.*

ISBN 0-521-44447-0 hardback
ISBN 0-521-44899-9 paperback

CONTENTS

ILLUSTRATIONS

All works of art listed here are by Raphael unless otherwise indicated.

ACKNOWLEDGMENTS

I would like to thank my authors for their cheerful willingness not only to contribute to this volume but to undertake to shape their essays for the audience of students to whom the books in this series are directed. They would agree, I think, that it is often more difficult to address oneself to this group than to a small coterie of fellow scholars.

Nearly all of the essays were written for this volume. It was my intention, in keeping with the concept of the series, to demonstrate a range of methodologies that is reflective of the state of art historical studies today, at least as it applies to Raphael. If the readers finds missing the more extreme approaches being explored in some contemporary scholarship, that is due more to the centrist nature of Raphael than to choices of the authors or editor.

I have included two early essays on the *School of Athens* because of their outstanding importance. The passage from Bellori appears in English for the first time. I thank Alice Sedgwick Wohl for preparing the translation on very short notice. The Wölfflin selection is reprinted here on the suggestion of my friend and colleague Malcolm Campbell, because we both believe that it has been neglected in recent decades and needs to be brought to the attention of students and their teachers again.

I am grateful to the students in two seminars at Temple University in the fall semester of 1992 and the spring semester of 1994 on whom this material was market tested, so to speak. They read and criticized earlier drafts of the essays and gathered much of the bibliography. I am particularly grateful to Joan Beaudoin, James

Callaghan, Jennifer Kahane, Jonathan Kline, Nicole Leighton, and Rachel Owens for specific contributions. Students in my course in sixteenth-century Italian art at Temple University, Rome, in the fall semester of 1994 read and commented helpfully on the first draft of the Introduction.

Ralph Lieberman and James Callaghan read the Introduction and made many helpful suggestions. I have benefited from discussions with Paul Tegmeyer, whose extensive knowledge of the literature and thoughtful contemplation of the Stanza della Segnatura will be evident in his forthcoming dissertation on the *Jurisprudence* wall (University of Pennsylvania).

Arnold Nesselrath, Curator of Byzantine, Medieval and Modern Art at the Vatican Museums, generously allowed me to visit the scaffolding while the fresco was undergoing its recently completed conservation.

Diane Sarachman was my superb editorial assistant. Much of my work was done in the library of the Clark Art Institute in Williamstown, whose staff never failed to assist graciously: Sarah S. Gibson, Paige Carter, Peter Erickson, and Susan Roeper. Thanks are expressed especially to Valerie Krall and to Dustin Wees for help with a photograph. Diane Sarachman also made the index.

I am particularly grateful to Beatrice Rehl, Fine Arts Editor at Cambridge University Press, who conceived this series and invited me to contribute, and whose knowledge of the field of art history, together with her other qualities, makes her an outstanding editor.

Rome
May 1996

CONTRIBUTORS

MARCIA B. HALL is professor of art history at Temple University. She is the author of *Renovation and Counter Reformation, Color and Meaning: Practice and Theory in Renaissance Painting,* and the forthcoming Cambridge publication *After Raphael.*

JANIS BELL is associate professor of art history at Kenyon College. She has published numerous articles on color and color perspective in sixteenth- and seventeenth-century painting in *The Art Bulletin, The Journal of the Warburg and Courtauld Institutes,* and *Artibus et Historiae.*

RALPH LIEBERMAN is an independent art historian and photographer who has published several works on Renaissance architecture and the relationship between photography and art history in Venice, Florence and Rome.

INGRID D. ROWLAND is associate professor of art history at the University of Chicago. Her books include *The Correspondence of Agostino Chigi,* published by the Vatican Library, and a forthcoming study of Renaissance Rome to be published by Cambridge University Press.

REVEREND TIMOTHY VERDON, Ph.D., is chaplain of the Cathedral of Florence, and a visiting professor at Stanford University in Florence. He has edited and contributed to *Monasticism and the Arts* and *Christianity and the Renaissance.*

ALICE SEDGWICK WOHL is editor of the *Bibliography of the History of Art* at the Getty Information Institute. She has translated Condivi's *Life of Michelangelo* and the *Crônica de D. Pedro I* by the fifteenth-century Portuguese chronicler Fernão Lopes, and she is co-author of a book about Portugal with her husband Hellmut Wohl.

RAPHAEL'S "SCHOOL OF ATHENS"

INTRODUCTION

Great works of art are not merely satisfying to look at; they are major historical events that have causes and effects. For students of the history and historiography of Renaissance art, Raphael's *School of Athens* is perhaps the most fruitful subject of all, for it offers insights into the stylistic formation of one of the greatest High Renaissance painters; into the artistic vision of the first really imperial papal court; into how literary and theological schemes were developed and how we have interpreted them. We learn about the nature of both collaboration and competition among artists, and we can observe the cycles of definition and reinterpretation that inevitably follow in the wake of epoch-making artistic events. Each of these aspects of the work, as well as others not enumerated, could be – in fact has been – the subject of a book of its own. In this volume our ambition is less grand. Our primary aim is not to provide definitive answers to all the questions about the *School of Athens* but to address certain problems that seem important to us and to give a clear idea of just how complex and multifaceted the process of coming to an understanding of a great work can be. What must emerge from such a study of critical reception is the recognition that every few generations the work is understood in new ways – not because it changes, but because we do.

The *School of Athens,* with its complex pattern of human figures (Fig. 1), cannot be studied in isolation, for it is part of the decoration of a room (Figs. 2, 3) that was designed to be experi-

Figure 1. Diagram of *The School of Athens.*

enced as a whole – a Renaissance installation, if you will – in
which the walls, the ceiling, the floor, all contributed to the
environment the painter created for his patron, Pope Julius II.
As with any installation, the parts and their interrelationships had
to be carefully thought out, in terms of both the iconography
and the composition. When we view the painting in reproduc-
tions, relationships that would be apparent if we were in the
room with it have to be pointed out. In this introduction some
aspects of the context of this fresco – historical, intellectual, physi-
cal, and stylistic – are discussed. The furnishings and decoration
of the room were changed over time to accord with changes in
its use, but Raphael's frescoes have remained essentially unal-
tered, except by time, which has taken its toll here as much as
in other fresco cycles that have survived for almost five hundred
years.

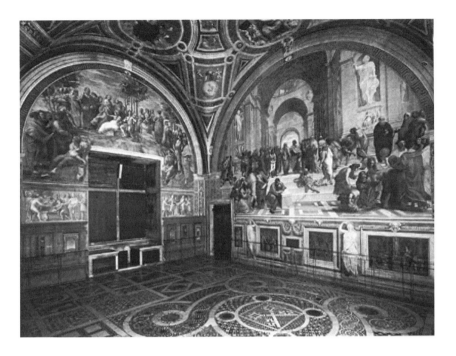

Figure 2. *Parnassus* and *The School of Athens*. Stanza della Segnatura, Vatican Museum. (Photo: Vatican Museums.)

HISTORY OF THE COMMISSION AND THE SCHEME

In Raphael scholarship today, most of the questions concerning attribution and dating appear, for the moment at least, to have been resolved. Although debate continues over the separation of hands in the workshop, attention has shifted away from style to the context in which the works were created. In Raphael's Vatican paintings we sense that the intellectual climate of the papacy of Julius II (1503–13) is reflected. The comprehensiveness of the scheme, its internal logic, and its richness have awed visitors since the sixteenth century. From what we have learned about that court, some of it quite recently, scholars have tried to interpret *how* Raphael's frescoes reflect the culture of the papal court. It is generally assumed nowadays that commissions such as this represented a collaboration between the painter and a literary adviser. How this worked is the subject of much

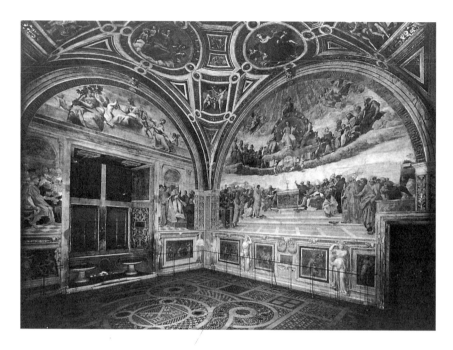

Figure 3. *Jurisprudence* and *La Disputa*. Stanza della Segnatura, Vatican Museum. (Photo: Vatican Museums.)

debate. One view is that the painter was given some kind of written program, although very few Renaissance programs survive to guide our speculations.[1] It is interesting that this supposition was not universally made by scholars of the nineteenth century. Writing in 1839, Passavant suggested that the subjects of the paintings probably had not been chosen before Raphael took up the commission and conjectured that Pope Julius requested the painter to choose them.[2] In 1882, although Crowe and Cavacaselle credited Raphael with having taken the initiative to consult the humanists at the Vatican, they confidently stated, "we may dismiss the thought that he himself was a student of the books."[3] Our hypothesis of the intellectual adviser is based on assumptions that are not voiced, and we tend to modify them as suits our needs in any given instance. Was there only one adviser? Ingrid Rowland, in her chapter in this volume, proposes that the adviser was a kind of go-between and that the ideas that he

passed to Raphael were those of a theologian, Egidio da Viterbo. In the absence of a document, we probably make too formal and rigid what was a fluid exchange between adviser, or advisers, and painter. Perhaps so few written programs have survived because much of the communication was verbal, with ideas developing as the decoration proceeded. Some of Raphael's drawings indicate that the subjects for several of the walls in the Vatican Stanze were changed:[4] Was it on the initiative of the patron or the painter? The assumption of an adviser reflects the belief that the philosophical content of a scheme such as the Vatican paintings, or the vault of the Sistine Chapel, painted at the same time by Michelangelo, was frankly beyond the meager education artists were given in the sixteenth century.[5] In the past few decades we have come to recognize that at the beginning of the Cinquecento artists were only just emerging from the medieval tradition that regarded them as manual craftsmen, whose skill was less valued than the expensive materials they employed.[6] We have only recently begun to demythologize Giorgio Vasari's *Lives of the Painters, Sculptors and Architects* – on whose witness we depend for much of our information – and recognize that he does not always accurately describe things; his book was designed in part as propaganda to establish the intellectual and social position of artists as the equals of poets and humanists.[7] An alternative interpretation gives the painter more authority, arguing that at least some artists were very well educated.[8] Raphael, after all, pored over the ancient text on architecture by Vitruvius,[9] so the assumption that he did not study the books is incorrect in his case. He might have consulted with the appropriate expert on technical issues as he needed to, perhaps asking for advice about which philosophers to include and what book would best signify the presence of Plato. In either case, his painting was a visual interpretation of the culture of the papal court, as much as the sermons of Egidio da Viterbo constituted a theological one.[10] Our concept today of such a painter as Raphael is that his genius lay in the ability to invent effective means to dramatize a subject such as the one he was given for the *School of Athens:* to portray the authors of the great books of philosophy in the ancient world.[11]

The name "Stanza della Segnatura" was given to the room by Vasari, because when he was writing the *Lives* in the 1540s, this was the

chamber where the pope formally put his signature to important documents. When it was first built by Pope Nicholas V in the middle of the Quattrocento, however, it was one of a suite of four *stanze* probably used as his summer living quarters. It is often forgotten that when Raphael began work in the rooms they were already decorated: Vasari tells us of paintings by Piero della Francesca in the Stanze d'Eliodoro which were replaced by Raphael's *Mass at Bolsena* and *Saint Peter Liberated from Prison.*[12]

In November 1507, Pope Julius II decided to transfer his quarters in the Vatican Palace from the Borgia Apartments, which were filled with emblems of his hated predecessor Alexander VI, upstairs to the Stanze.[13] The apartment on the floor above received more light and air, and it afforded a better view of the Cortile del Belvedere that Julius had commissioned Bramante to build. The pope called in various artists to undertake extensive redecoration. Exactly when Raphael commenced work has been disputed, but it must have been sometime late in 1508, because he received his first recorded payment in January 1509. Whenever it was, Raphael was not the first painter to be hired, nor do we know that Julius intended Raphael to decorate the entire suite or even the whole room. In the event, the project was continued, first by Julius, then by his successor Leo X, to be completed by the artists of Raphael's workshop finally in 1524, after the painter's death. Precisely what had already been done in the Stanza della Segnatura before Raphael arrived is still debated, but it is clear that Sodoma had begun work on the ceiling. In a document of 13 October 1508, Sodoma's brother is negotiating with the pope on behalf of the artist.[14] The layout of this ceiling resembles antique prototypes, particularly the stucco vaults at Hadrian's Villa,[15] which suggests clearly that the classical character of the decoration had been established before Raphael was hired. Vasari claims that Raphael preserved some of Sodoma's work, and technical examination of the plaster bears this out.[16]

Knowing the function of the Stanza della Segnatura is crucial to understanding the iconography of the scheme. Despite Vasari's misleading designation, which we continue to use, it has been established that the room was designed to house Julius II's personal library.[17] The bookcases were probably low ones, set against the wall and rising only to the height of the *basamento,* which was left undecorated; in accordance with Renaissance practice, the books would

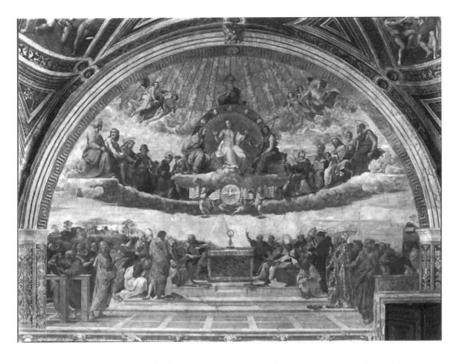

Figure 4. Raphael, *La Disputa*. Stanza della Segnatura, Vatican Museum. (Photo: Vatican Museums.)

have been divided into the four principal faculties.[18] Raphael's subjects in the murals on the two long walls are those in which the pope's holdings were most numerous and required the most space: theology, represented by the *Disputa* (Fig. 4), or the theologians discussing central tenets of the Christian faith, and opposite, philosophy, represented by the *School of Athens* (Fig. 5), depicting a gathering of the most famous philosophers of the ancient world. On the shorter walls, which have windows cut into them, further reducing the available space, are painted *Parnassus,* representing the arts (Fig. 6), and *Jurisprudence* (Fig. 7), representing law. On the ceiling the interrelationships among the disciplines are demonstrated. Taken together the decorations of the room depict the world of knowledge, Christian and pagan.

The tradition from which the program descends is that of the "Famous Men" (*Uomini Famosi*) or the heroes of antiquity, fre-

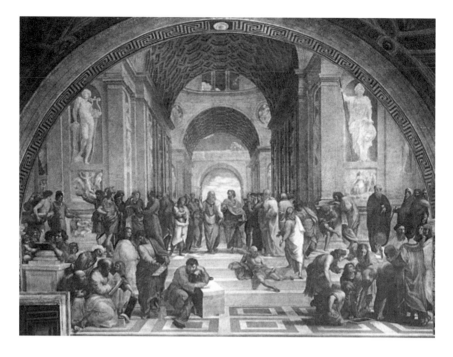

Figure 5. Raphael, *The School of Athens*. Stanza della Segnatura, Vatican Museum. (Photo: Vatican Museums.)

quently and appropriately chosen to decorate libraries, especially because the ancient Romans are known to have decorated their libraries in this manner. At least two Renaissance examples of Famous Men would certainly have been familiar to Raphael. In Urbino, the city of his birth, the duke's Studiolo was decorated with portraits of Famous Men.[19] In the Collegio del Cambio in Perugia, where Raphael may well have assisted Perugino, Famous Men are represented on two lunette-topped walls resembling those of the Segnatura (Fig. 8).[20] Beneath the allegorical figures of the Perugia Virtues, who are suspended in the clouds above, stand the heroes, exemplars of those virtues, six to a wall. Of the twelve, two are philosophers who are also depicted in the *School of Athens*, Socrates and Pythagoras; the rest are men of action. All are labeled, indicating that correct identification was a priority. Perugino's figures, like those in other such series, do not engage in any action or interact with one another. Decorations such as these approximate

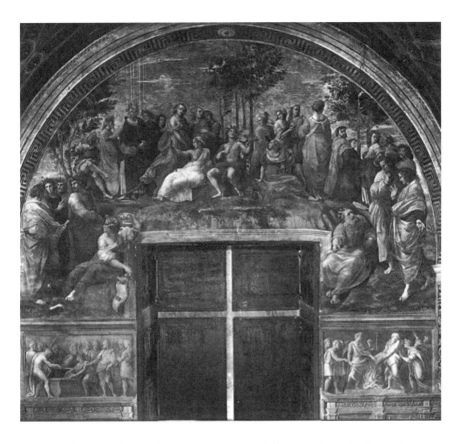

Figure 6. Raphael, *Parnassus*. Stanza della Segnatura, Vatican Museum. (Photo: Vatican Museums.)

what the pope was probably expecting to see on his walls, for nothing yet executed or even conceived anticipated Raphael's invention.[21]

One might imagine the "program," devised by some humanists of the papal court and presented to Raphael, as nothing more than lists of the men central to each of the disciplines, and the books – for there are a great many books represented here – that are emblematic of both the writer and discipline. Whoever devised the program, the genius of Raphael was that he vitalized the traditions he inherited. He transformed the static and isolated images of the Famous Men into a series of dramatic events in which the actors are presented in dialogue with one another. Besides the tradition of the *Uomini*

Figure 7. Raphael, *Jurisprudence*. Stanza della Segnatura, Vatican Museum.
(Photo: Vatican Museums.)

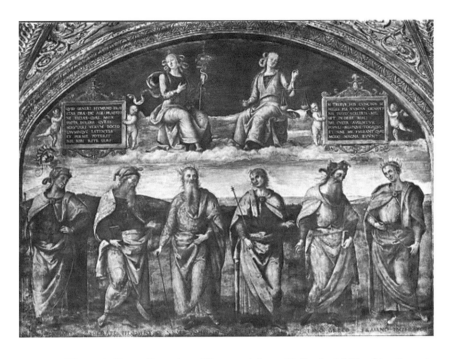

Figure 8. Pietro Perugino, *Virtues* and *Sages*. Collegio del Cambio, Perugia. (Photo: Alinari/Art Resource.)

Famosi, Raphael seems to have drawn upon the type of the *sacra conversazione,* so often used for altarpieces of this period by Raphael himself and his contemporaries. Represented here are people from many different centuries, but they are imagined to be gathered in one space. Unlike the participants in the *sacra conversazione,* however, who are lost in meditation and oblivious of one another, Raphael's actors are participating in lively discourse. That discourse is also intended to engage the viewer, a reader in this library, or one who was at least familiar with these authors. Perhaps he looks up at the fresco to rest his eyes from his reading. The dialogue that might be going on in his head is represented as taking place before him. Unlike Perugino's and other earlier representations, these Famous Men are not all labeled; Raphael has left an opening for viewers to enter with their imagination, identify some of the figures for themselves, and take part in the dialogue.[22]

For each scene the painter has staged an event that has all the

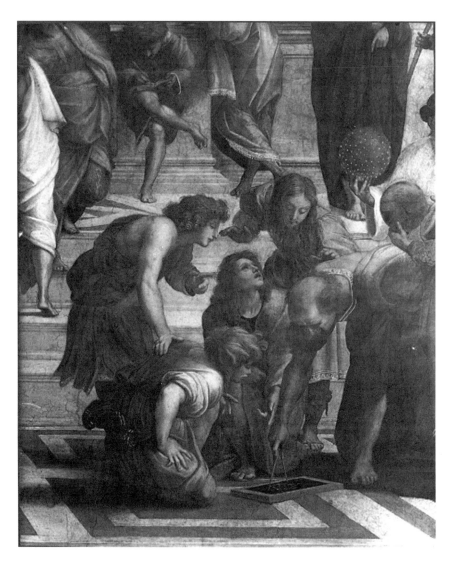

Figure 9. Euclid group. Detail from *The School of Athens*. Stanza della Segnatura, Vatican Museum. (Photo: Vatican Museums.)

drama of the theater but takes place not in some celestial zone outside of time but at a particular moment. Yet each figure is individualized and unique in its action. In the group around Euclid (Fig. 9) in the *School of Athens,* the painter describes the process of grasping a concept by breaking it down into stages and assigning one stage to each disciple: the youth closest to the master and kneeling forward follows the demonstration with the greatest intensity, for he is still at the level of literal learning (Fig. 1, no. 26 in the diagram); the other kneeling figure behind turns to his companion with the excitement of dawning comprehension (no. 25), but this one is already anticipating the outcome (no. 24). Expansive and controlling in his gesture, he can see other applications.[23] His companion, in profile, with his pointing finger and paternalistic pat on the back of his younger colleague, suggests the apprentice pedagogue, the Teaching Assistant (no. 27). Comprehension grows as we move up the group and outward, in a visual metaphor for the process of intellectual maturing. Raphael repeats this kind of analysis throughout these frescoes. One can imagine that the program stipulated a certain hierarchy of the philosophers or theologians or poets and that Raphael had to devise a composition in each case that would satisfy it.

The program of the room is laid out on the ceiling (Fig. 10). In a stroke of genius, Raphael transferred the allegorical figures, so disruptive to the unity of Perugino's fields in the Cambio frescoes, into the separate space of the ceiling.[24] Around the central and preexisting octagon are four roundels, each containing a female personification of the discipline on the wall below her, each with an inscription. Above *Jurisprudence* is the allegorical figure of Justice, whose inscription reads, IUS SUUMCUIQUE TRIBUIT ("To each his due"). Above *Parnassus* the allegory of Poetry is flanked by putti holding plaques inscribed, NUMINE AFFLATUR ("Inspired by the Divine").[25] The distinction between the kinds of knowledge represented by Philosophy (Fig. 11) and Theology is the distinction between knowledge of the intellectual kind, COGNITIO CAUSARUM ("Knowledge of causes") and knowledge from acquaintance, DIVINARUM RERUM NOTITIA ("Knowledge of things divine").[26] Although the disciplines are distinct, they are also interconnected, and the links are represented on the ceiling by the rectangular fields at the corners. Joining Justice and Philosophy is the *Judgment of Solomon;* joining

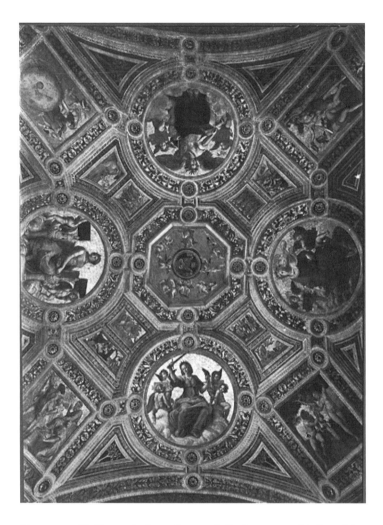

Figure 10. Ceiling paintings, Stanza della Segnatura, Vatican Museum. (Photo: Vatican Museums.)

Philosophy and Poetry is *Astrology*. *Apollo Flaying Marsyas* connects Poetry with Theology, and the *Fall of Adam and Eve* links Theology with Justice.[27]

The fresco representing Theology, the *Disputa* (Fig. 4), is composed around the apse of a fictive church, only the pavement and altar of which are represented. This open-air church is defined in

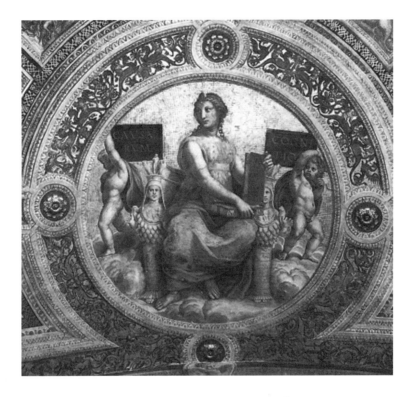

Figure 11. *Philosophy* roundel. Ceiling, Stanza della Segnatura, Vatican Museum. (Photo: Vatican Museums.)

the upper zone by a half circle of angels flanking God the Father, who appears in front of a gilded half circle. Directly below him, in another gilded circle, is Christ, flanked by the Virgin and John the Baptist, the Patriarchs, and the Apostles, all seated on clouds in another semicircle, unmistakably suggesting an apsidal space. Extending the central axis of God the Father and God the Son downward is the dove of the Holy Spirit in a golden disk, which leads downward in turn to the fourth golden circle, the monstrance with the Host on the altar. Thus with an invention that brilliantly conjoins composition and content, Raphael makes visible the doctrine that the trinitarian God is present at the Mass in the consecrated Host displayed on the altar. To reinforce the focus of the central vertical axis and coincide with it, the vanishing point of the perspective, strongly

articulated in the pavement, is placed in the Host. Gathered around the altar are the great theologians who have contributed to the doctrine of the Sacrament of the Mass, identified either by inscriptions on their haloes or by the legible titles of their books. Prominent are the four Doctors of the Church, close to the altar: Jerome, Gregory, Ambrose, Augustine. Interspersed among these dignitaries are other figures who are not identified and whom Raphael presumably did not intend us to recognize or put names to. They are shown in groups, some, like those at the left, with gestures that indicate they are discussing and debating, seeking the truth by means of rational discourse; others read, or contemplate, or dictate to a scribe. The truth referred to in the ceiling above is that of personal communication with God, what we call divine revelation. The Host displayed on the altar, leading to God the Trinity above, signifies divine presence and divine accessibility to those who seek it.

Parnassus (Fig. 6), the mountain abode of Apollo, is shown as a high, hilly place, where the god sits playing a *lira da braccio,* surrounded by the Muses and a selection of literary luminaries. Again the artist seems to want us to recognize just enough of the figures so that we know what we are looking at. The masks held by two of the Muses identify them as Comedy (Thalia) and Tragedy (Melpomene), but which is which we cannot tell because the mouths that would distinguish them are teasingly concealed. We are certainly meant to pick out Sappho, who is clearly labeled, and to recognize the familiar features of others such as Dante (the only figure to appear twice in the room, once as a poet and once as a theologian), Homer, Virgil, Petrarch, Boccaccio; but many others are unidentifiable. Of greater interest is the way the painter has suited the formal elements to the content. By designing his mountain around it, the inventive painter put the intrusive window to use. In contrast to the *Disputa,* where the design is strongly ordered, the poetic *Parnassus* is more liquid and fluid, not dependent upon a rational perspective system and not suggestive of architecture but rather of a pastoral, atmospheric landscape. In the *Disputa,* colors are definite and ordered, repeated in a discernible pattern that adds to the sense of structure. On Parnassus, there is a haze that softens and sweetens color, harmonizing it as if to the strains of the music Apollo is playing. The figures are more solitary and self-absorbed. They sway in dancelike movement, whereas in the

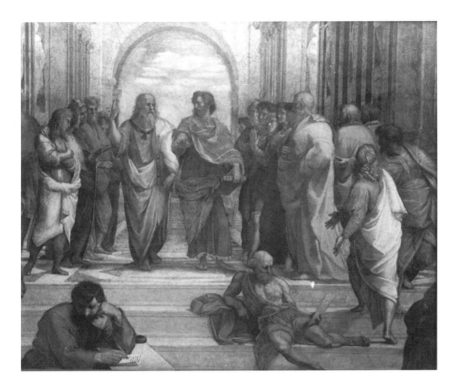

Figure 12. Plato and Aristotle group. Detail from *The School of Athens*. Stanza della Segnatura, Vatican Museum. (Photo: Vatican Museums.)

Disputa they are straight and tall, upright supports of the invisible structure they inhabit.[28]

For the *School of Athens* (Fig. 5), Raphael created a noble classical antique architecture, built by man, like philosophy itself, to contrast with the invisible holy architecture of the *Disputa* on the opposite wall. Recalling the ruined baths and basilicas of Rome, he has reinvested it with the rich sculptural decoration that had once clothed such buildings but was no more to be seen, except in the mind's eye. As Ralph E. Lieberman points out in his chapter in this book, it is neither indoors nor outside, an appropriate substitute for the grove of Plato's Academy. No Quattrocento precedent exists, nor is there any in Raphael's own earlier works. The building shelters an assembly of philosophers centered on Plato and Aristotle (Fig. 1, nos. 1–2; Fig. 12). The three barrel vaults and the central-

point perspective focus on the majestic pair. In niches looming large at either side are statues of Apollo (Fig. 13) (on the left, adjacent to the scene of his abode, *Parnassus*) and Minerva, the goddess of Wisdom (Fig. 14) (on the right, adjacent to *Jurisprudence* and beneath *The Judgment of Solomon*, the wise king) with reliefs below each. Other statues in niches line the receding walls, but they are not meant to be distinguished. As in the *Disputa*, but more than in the *Parnassus*, the participants are engaged in animated exchange. Here no inscriptions aid us in identifying the participants, and among the books depicted only Plato's *Timaeus* and Aristotle's *Ethics* are labeled. We will return later in this introduction to a discussion of which philosophers have been identified in the fresco.

The *Jurisprudence* wall (Fig. 7) differs from the others in the way the painter structured the image. Monumental classicizing architecture binds it together, but it is made up of three separate scenes. Above the entablature, against a pale blue sky, the Cardinal Virtues are arranged as a trio of female figures. At the center is Prudence, who looks forward, but, by means of a cleverly ambiguous coiffure that doubles as a Janus mask, Raphael makes her also look backward at the same time. Flanking her on the right is Temperance, with her bridle and bit to tame the passions, and on the left, with her lion, a powerful Fortitude, who counters Temperance's restraint with her virtuous passion, energy, and commitment. Fortitude's association with the passionate Pope Julius is made explicit in her embrace of a sturdy oak, adorned with acorns, the emblem of Julius's family, the della Rovere. The absence from the group of the fourth Cardinal Virtue, Justice, has been explained by Wind with a text from Plato's *Republic:* Socrates, in search of justice, cannot find it until he recognizes that it underlies and imbues all the virtues. As the ground out of which the others emerge, it is both fundamental and primary, so it is appropriate that Justice is represented above in the roundel of the ceiling, elevated over the other virtues.[29] In the spaces beside the window Raphael represented two historical scenes, the giving of the civil law and the canon law. The virtues are linked iconographically and compositionally to the image of Pope Julius at the lower right, helping to unify the design, for both flanking figures turn toward him. The window is situated off axis on this wall, further complicating the

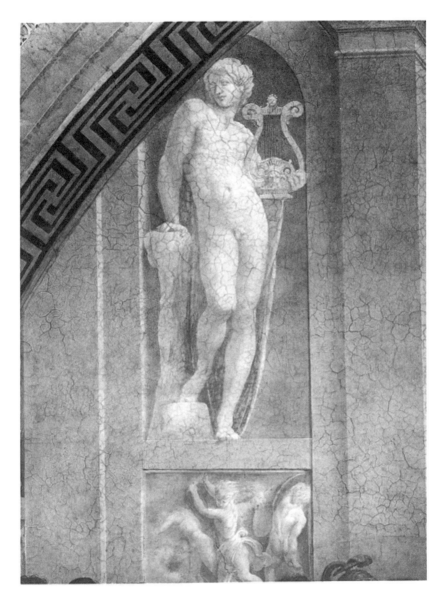

Figure 13. Apollo statue. Detail from *The School of Athens*. Stanza della Segnatura, Vatican Museum. (Photo: Vatican Museums.)

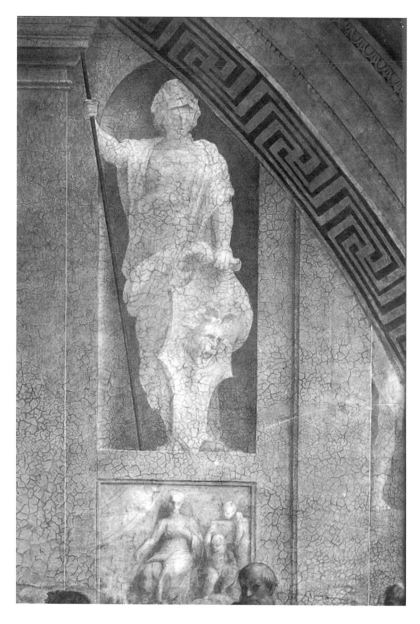

Figure 14. Minerva statue. Detail from *The School of Athens*. Stanza della Segnatura, Vatican Museum. (Photo: Vatican Museums.)

painter's search for a balanced, centralized composition. Raphael depicted similar niches and marble pavement as the setting for the analogous scenes of lawgiving. On the left, the emperor Justinian receives the corpus of civil law; on the right, Julius II poses as Pope Gregory receiving the decretals (canon law) from Saint Raymond of Penafort. Julius appropriately is accorded the wider space. In a violation of expected symmetry he faces outward, which is echoed above in the flanking virtues, who turn toward Julius. There is the further nicety in the planning that the secular scene abuts the wall of Philosophy, whereas ecclesiastical law is placed adjacent to the wall of Theology. Describing this fresco in terms of the classical style, Freedberg noted that Raphael matched his style to the disparate subject matter in the two parts of the composition, descending toward naturalism for the historical scenes in which there are portraits of members of the papal court, in contrast to the lofty idealism of the allegories above.[30]

Some of the drawings for the *Disputa* suggest that the composition was changed dramatically in the course of its planning, a change that entailed a revision of the subject. It appears that the painter did not at first conceive of the altar that would ultimately become the central focus.[31] It has been convincingly argued that the artist sought a change in subject matter in order to resolve the compositional problem he had been struggling with. The late insertion of the altar changed the subject from the mystery of the Trinity to the mystery of the Transubstantiation. We can infer that the instructions the painter had been given were only vaguely worded and that he was permitted to elaborate, or that the program was devised and revised in conversations between the iconographer and the painter.[32]

VASARI AND BELLORI

Giorgio Vasari (1511–74) was, at the same time, both an admirer and a detractor of Raphael's. Vasari's appreciation is remarkably insightful, especially when he compares Raphael to his Quattrocento predecessors. It is Vasari who gave us the framework for assessing the progress of Raphael's style. In the preface to what he calls the "Third – that is, the modern – Era" of his *Lives* (1550, 1568), he singles Raphael out for the grace and perfection of his style, for the ease with which he represented everything, and for the appropriate-

ness of his expressions, gestures, drapery, movements, the order and force with which he arranged them. In speaking of the *Disputa,* Vasari notes the propriety (*decoro*) of each figure: the venerable appearance of the Patriarchs, the simplicity of the Apostles; among the discussants, the curiosity and anxiety in their desire to find the truth and, in some of them, doubt as they listen to both sides. Recent critical studies of Vasari have emphasized his use of the rhetorical device of *ekphrasis,* that is, his description of a work of art in such a way as to evoke an emotional response from the reader by means of its liveliness.[33] What is effective about Vasari's *ekphrases* is that he carefully observed the emotions and the attitudes that Raphael gave to the figures, the gamut of response that the painter explored with such precision. As Vasari had emphasized in his preface to the "Third Era," this is what distinguishes the style of the Cinquecento from that of the Quattrocento: no two figures repeat the same attitude; nothing is stock repertory. By the same token, in describing Raphael's painting Vasari himself did not resort to stock phrases and conventional observations.

It is all the more surprising, then, to find that Vasari made a serious error in discussing the *School of Athens,* one which indicates that he was looking at a print of the painting at the time of writing, rather than at the original. He seems to confuse the *Disputa* with the *School of Athens,* for he speaks of geometers and astrologers and the Evangelists in the same breath and then goes on to identify various philosophers in the *School of Athens,* commencing with the figure of the cynic Diogenes isolated on the steps (Fig. 1, no. 28; Fig. 15). He next mentions Plato and Aristotle; the portrait of Federico, second duke of Mantua, who was in Rome when the painting was executed (no. 24 or, more probably, no. 36); and the figure with compasses, who, he says, is a portrait of the architect Donato Bramante (no. 23; Fig. 9). Zoroaster, whose back is turned, holds a globe of the heavens (no. 21; Fig. 16), and standing nearby is a portrait of the artist himself (no. 19; Fig. 16). Then we come to the most curious passage, for Vasari describes with enthusiasm the beautiful figure of the Evangelist Matthew, who is copying from the slate held for him by an angel. This is, of course, the figure now universally identified as Pythagoras (no. 33; Fig. 17), as Giovan Pietro Bellori was to point out. The figure is indeed seated in the traditional pose for an Evangelist, but we are stunned by Vasari's

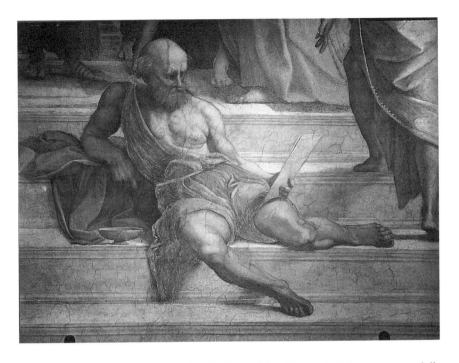

Figure 15. Diogenes. Detail from *The School of Athens*. Stanza della Segnatura, Vatican Museum. (Photo: Vatican Museums.)

failure to grasp the subject. How could he imagine that Matthew would have wandered into this assembly of pagans? The problem seems compounded by the description he gives of the subject, apparently of the *School of Athens:* "the theologians reconciling philosophy and astrology with theology." What theologians? Vasari would not have thought of Matthew as a theologian. Is it possible that he did not intend this to be a description of the *School of Athens* but rather of the whole Stanza? One of our authors, Timothy Verdon, has made Vasari's confusions the starting point for his chapter in this volume.

Giovan Pietro Bellori, the great advocate of the classical style, writing at the end of the seventeenth century, had limitless admiration for Raphael. He described his works in the Vatican again in 1695 and corrected some of Vasari's errors, as we have already seen.[34] Bellori was able to account for the Saint Matthew—

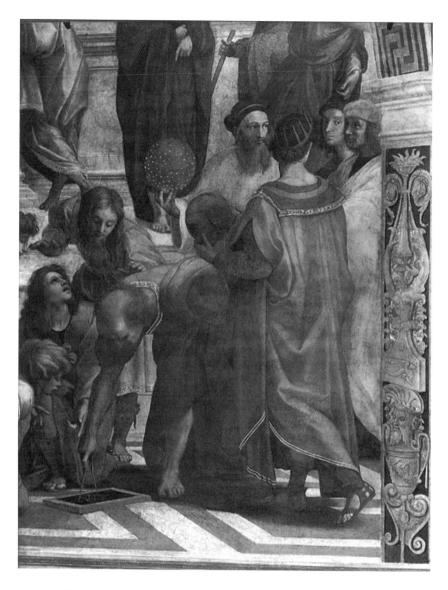

Figure 16. Detail from *The School of Athens;* lower right. Stanza della Segnatura, Vatican Museum. (Photo: Vatican Museums.)

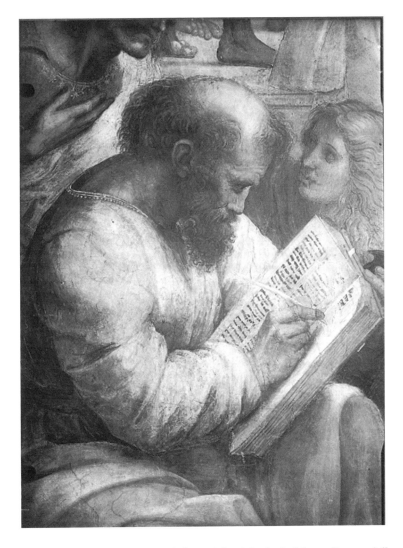

Figure 17. Pythagoras. Detail from *The School of Athens*. Stanza della Segnatura, Vatican Museum. (Photo: Vatican Museums.)

Pythagoras muddle by pointing out that Vasari must have been looking at the 1523 print by Agostino Veneziano, in which Matthew was substituted for Pythagoras.[35] Bellori established the sequence of execution in the Segnatura that became canonical. He

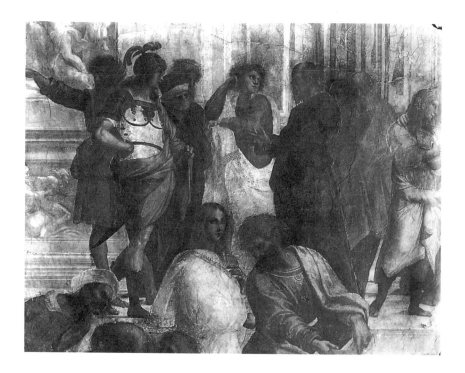

Figure 18. Socrates group. Detail from *The School of Athens*. Stanza della Segnatura, Vatican Museum. (Photo: Alinari/Art Resource.)

recognized the features of Socrates (no. 49; Fig. 18) and detected Alcibiades among his disciples (no. 45); with other new recognitions he brought the number of identified figures to eighteen. Bellori's most important legacy, however, was his equating of Raphael's style with the classical style. For him "ideal beauty" had been captured in the sculpture of antiquity and, in modern times, by Raphael, whom he placed at the pinnacle of art, in opposition to Vasari's choice of Michelangelo.

RAPHAEL AS THE ACADEMIC PAINTER

For centuries Raphael was regarded as the perfect painter, the yardstick by which other painters were measured, and, even more important, the model whom young painters were instructed to

copy in order to learn how to paint correctly. This last word, "correctly," will strike the ear of today's art student as offensive, indicating how far we have now moved from the traditional academic training of artists. In the sixteenth century Michelangelo was regarded as Raphael's principal competitor, and writers enjoyed the comparison. (In Venice, there were those who, while admitting the great merits of the Romans, preferred Titian.) The contrast between the two painters was established in the sixteenth century and was fed by the writings of Ascanio Condivi and Vasari. In his biography of Michelangelo, Condivi has Raphael expressing gratitude for having been born during the time of Michelangelo, "as he [Raphael] had copied from him [Michelangelo] a style which was quite different from the one he learned from his father, who was a painter, or from his master Perugino."[36] Vasari preferred Michelangelo to Raphael, so he subtly diminished Raphael while at the same time praising him. According to Vasari's account, Raphael surreptitiously gained entrance to the Sistine Chapel and, after viewing Michelangelo's work on the vault, transformed his own style. He redid his *Isaiah* (Sant'Agostino), giving it greater breadth and majesty, as a result of this inspiration, and his *Sibyls* in Santa Maria della Pace were modeled on what he had seen in the Sistine Chapel. By the end of the seventeenth century Raphael had many admirers, but none more ardent than Bellori, who took exception to Vasari's account and vehemently attacked it, in a work entitled *Whether Raphael enlarged and improved his style after seeing the works of Michelangelo* (1695). He quite justly accused Vasari of inventing stories that made Raphael appear to be Michelangelo's disciple, and he set the tone for defenders of Raphael, who continued to praise their favorite at Michelangelo's expense. Luigi Lanzi, a century after Bellori, wrote, "It is indeed a great triumph to the admirers of Raffaello to be able to say, whoever wishes to see what is wanting in the Sibyls of Michelangelo, let him inspect those of Raffaello; and let him view the Isaiah of Raffaello, who would know what is wanting in the Prophets of Michelangelo."[37] The contrast between the two painters became a touchstone for theorists to use in airing their principles of art.

It was in seventeenth-century France that the academic view of Raphael as the supreme embodiment of the classical ideal was

codified.[38] Together with the ancients, he provided the model for correcting the imperfections of nature and raising its imitation to noble perfection. Vasari's Life of Raphael was their starting point. Vasari had noted that Raphael drew upon many sources, from antiquity to his contemporaries Leonardo and Michelangelo; this gave the Academicians pretext to cite him as the supreme eclectic and justified their contention that eclecticism was the road to artistic success. Vasari said that Raphael "enriched the art of painting with that complete perfection which was shown in ancient times by the figures of Apelles and Zeuxis." For the Academicians, Raphael became "the modern Apelles." Although for Vasari Raphael lacked the sublimity, grandeur, and majesty of Michelangelo, when the French compared the two painters they preferred the grace, sweetness, and decorum of Raphael.[39]

In the 1660s, the battle lines were being drawn between the traditionalist Academicians, who rallied around Raphael, Poussin, and drawing – the Poussinists – and those who championed Rubens and Titian for their color and sensuous appeal – the Rubenists. Nevertheless, the champion of Rubens, Roger De Piles, while praising his hero, never denigrated Raphael.[40] Although the Rubenists advocated a broadened eclecticism that included the virtues of color, in which Raphael was believed to be deficient, they did not question his authority in drawing.

In the eighteenth century, Raphael came in for more criticism, especially outside of France. Winckelmann and Mengs found his ideal of beauty wanting in comparison to the Greeks. Sir Joshua Reynolds preferred Michelangelo to Raphael, but he recognized Raphael's greatness, particularly in the tapestry cartoons that were accessible in England (then at Hampton Court, now at the Victoria and Albert Museum) and in the frescoes in the Vatican, which were always cited as Raphael's best work. Reynolds greatly admired Titian: "It is to Titian we must turn our eyes to find excellence with regard to colour, and light and shade, in the highest degree." He acknowledged that Raphael and Titian were counterparts: "Raffaelle and Titian seem to have looked at nature for different purposes; they both had the power of extending their view to the whole; but one looked only for the general effect as produced by form, the other as produced by colour."[41]

Very few serious criticisms of Raphael can be found in the

literature, other than those of his color, but one that may reverber-
ate sympathetically with many modern viewers was made by
Roger De Piles. He remarked that many visitors to the Vatican
(visitors unfamiliar, in those days before photography, with the
appearance of Raphael's frescoes) walked right past them! What is
missing in Raphael's paintings, according to De Piles, is a kind of
immediate visual attraction. It is the painting's task to catch the
spectator's attention and to persuade him to come closer and have a
look at it.[42] This relates to the criticism that Raphael lacks emo-
tional and sensuous appeal, the position of the Rubenists, but it is
precisely what made Raphael the "perfect painter" for the Acad-
emy, which wanted an art that could be reduced to rules and then
taught. Michelangelo, because he scoffed at the rules of art and
followed his own caprice, was not useful as a model.[43]

The Academicians were anything but objective in their analysis of
painting. They looked for paintings that would illustrate their princi-
ples and then "deduced" the principles from them. Raphael was
evidently a great teacher and managed what became an enormous
workshop with consummate skill and authority – Vasari said that at
the peak of his short career fifty assistants followed in his wake daily
as he entered the Vatican – so that his style was indeed teachable.
Michelangelo, the lonely genius, never had a sizable workshop, and
those who learned his style did so largely by imitation.

In the eighteenth century some critics found fault with Raphael
in his later years for turning over too much to his assistants. Luigi
Lanzi's criticisms, in his influential *Storia pittorica della Italia* (1794)
continued to underlie assessments of Raphael's painting until quite
recently. "In regard to the province of colour, Raphael must yield
the palm to Titiano and Correggio, although he himself excelled
Michelangelo and many others." Lanzi goes on to give the appraisal
commonly held at the end of the eighteenth century:

> His frescoes may rank with the first works of other schools in
> that line: not so his pictures in oil. In the latter he availed himself
> of the sketches of Giulio [Romano], which were composed
> with a degree of hardness and timidity; and though finished by
> Raphael, they have frequently lost the lustre of his last
> touch. . . . He is, on this account, more admired in his first
> subject in the Vatican, painted under Julius II, than in those

executed under Leo X for being there pressed by a multiplicity of business, and an idea of the importance of a grander style, he became less rich and firm in his coloring.[44]

Nevertheless, Lanzi's judgment was that "Raffaello is by common consent placed at the head of his art."

The Academies of the nineteenth century had codified the rules of painting into so rigid a system that many felt it was stifling creativity. The situation was bound to foster rebellion. Not only the Impressionists in France but the Pre-Raphaelites in England sought an alternative to the system of art education that set up Raphael as the perfect painter whose style every fledgling must copy in order to learn how to paint correctly. John Ruskin, the English critic, took up the cause of the rebels, who were advocating a return to the innocence and ingenuousness of the painters who had preceded Raphael. (Botticelli was one of their patron saints.) Ruskin attacked the academic training of painters in 1851:

> It being required to produce a poet on canvas, what is our way of setting to work? We begin, in all probability, by telling the youth of fifteen or sixteen that Nature is full of faults, and that he is to improve her; but that Raphael is perfection, and that the more he copies Raphael the better; that after much copying of Raphael, he is to try what he can do himself in a Raphaelesque, but yet original manner: that is to say, he is to try to do something very clever, all out of his own head, but yet this clever something is to be very properly subjected to Raphaelesque rules, is to have a principal light occupying one-seventh of its space, and a principal shadow occupying one-third of the same; that no two people's heads are to be turned in the same way, and that all the personages represented are to possess ideal beauty of the highest order, which ideal consists partly in a Greek outline of nose, partly in proportions expressible in decimal fractions between the lips and chin; but partly also in that degree of improvement which the youth of sixteen is to bestow upon God's work in general. This I say is the kind of teaching which through various channels, Royal Academy lecturings, press criticisms, public enthusiasm, and not least by solid weight of gold, we give to our young men. And we wonder we have no painters![45]

By the end of the nineteenth century the art that had inspired so
many painters in the preceding centuries was badly in need of
rehabilitation. "We have had to swallow so much false classicism
that our gorge rises at it and we long for simpler, purer fare," re-
marked Heinrich Wölfflin in the introduction to his *Die klassische
Kunst* (1899), translated as *Classic Art,* where he would undertake
that rehabilitation.[46] In the section reprinted in this volume one
can see that Wölfflin's appreciation of what he defined as "classic"
art has nothing to do with *rules* or *correctness.* Rather, what he finds
in it is a satisfying form to use to express a serious and noble
content. It is the economy of Raphael's narrative that pleases, his
unfailing sense for the most telling pose and gesture, his ability to
eliminate or subordinate all but the essential, or, as Wölfflin says of
Leonardo, "his understanding of how to make the principal motive
the dominating one." Wölfflin's style of writing shares with the art
he describes a spareness and an aptness in shaping a phrase. Al-
though his books were the Bible of the past generation of art
historians, he is neglected today because we are not presently inter-
ested in stylistic labels or formal analysis and have mistakenly as-
sumed that this is all he can tell us. Would that what is written
today cut to the core of what Raphael intended with the clarity and
sureness of Wölfflin!

Vasari and Wölfflin part ways on one important question re-
garding Raphael's style. Vasari notes, quite accurately, that Ra-
phael learned much by studying the antiquities all around him in
Rome and that in this last decade of his life his figures acquired a
certain grandeur and majesty. Wölfflin states flatly that classical
antiquity did not inspire the classic style. Perhaps there had been
too much insistence on this point in the academic literature to
which he was reacting. The miracle, to be sure, was that Raphael
could find any inspiration in the remains that were available to
him. Often pathetic in their broken and incomplete condition,
they were all too frequently low-quality, assembly-line Roman
copies of Greek originals. His inspiration came by reconstructing
them in his imagination, so that their very incompleteness lent a
useful mystique which spurred his creativity. As Vasari under-
stood, Raphael's sympathy with the cultural and aesthetic values
that had engendered them produced in him an intuition, enabling
him to imbue his own works with the spirit of the best of antiqu-

ity. This sympathy Raphael acquired, like many of his contempo-
raries, through knowledge of the written sources.

RAPHAEL SCHOLARSHIP

The chapters in this volume present some contemporary approaches
to Raphael. They take up themes that have been treated, or ne-
glected, in the past century and a half of scholarship, in ways that
significantly reflect concerns of Raphael studies and of Renaissance
art history today. What they do not address is as interesting, from the
point of view of historiography, as what questions they find unre-
solved and worthy of attention. A significant shift away from interest
in identifying the figures, which had captivated the attention of the
scholarly writers on the *School of Athens* in the past century, can be
observed.

Around the middle of the nineteenth century, when art history
was beginning to take shape as an academic discipline, the first schol-
arly monograph on Raphael appeared. Johann David Passavant's
book (*Raphael of Urbino and His Father Giovanni Santi*) was published
first in 1839, in German, and then, in 1860, in an enlarged edition
translated into French. An abridged English version, intended for
the general reader, was made available in 1872.[47] This marks the
beginning of the search by scholars to identify every figure and to
find a hidden order or message in the disposition of the philosophers.
Passavant identified fifty of the fifty-six figures; W. W. Lloyd, in
"Raphael's *School of Athens*" (1864), gave names to fifty as well, but
not by any means the same names, and Anton Springer, in "Raffael's
'Schule von Athen' " (1883), found he could account for fifty-two,
leaving unidentified only the disciples of Euclid and a few partial
heads.[48] Wölfflin, in *Classic Art,* tried to divert attention to what he
considered more significant and fruitful lines of study. Writing only
sixteen years later than Springer, he remarked that what was impor-
tant was what the figure meant, not who he was. "It is wrong to
attempt interpretations of the *School of Athens* as an esoteric treatise in
historical and philosophical ideas."

Wölfflin was writing in the period when national traits were
under particular study and before the abuse that nazism made of
such studies with its theories of racial superiority. He anticipated
the kind of identification of national traits he would spell out many

years later in the book (*Italien und das deutsche Formgefühl*, 1931), translated as *The Sense of Form in Art*,[49] when he made this interesting indictment of his fellow northern Europeans:

> It is especially difficult for the Northern races to appreciate fully the value which the Latin races set upon physical presence and deportment. One must not, therefore, lose patience with the Northern traveller if he experiences a disappointment at first when he had expected to find in this place a representation of the most profound spiritual forces: it is perfectly true that Rembrandt would have painted Philosophy quite differently.[50]

More recently, Svetlana Alpers, in *The Art of Describing* (1984), has made a distinction that refines Wölfflin's point and can help us to understand national tendencies in interpreting works of art, explaining the difference between the Italian preference for narrative and the Dutch taste for describing.[51] A systematic study of the history of the identification of figures in the *School of Athens* undertaken by my seminar students showed that modern Italian scholars on the whole have not attempted to name more than Bellori's eighteen – already an increase over Vasari's eight. It is simply not a mode of interpretation that has seemed fruitful to them. Most of the attempts to "describe" a large number of the philosophers have been by northern Europeans.

The trend has shifted in recent scholarship to reconstructing the intellectual context of the papal court. Some of the efforts have been aimed at relating a specific humanist theologian to the program; some have been satisfied to explore in a more general manner the philosophical ambience of the court.[52] Attention has been focused in a number of studies on the diagrams in the foreground. It was Bellori who first called attention to the slate in the lower left hand corner and connected the numbers written on it with Pythagoras's discovery of the mathematical basis of musical consonances. Pythagoras, who had discovered the relationship between the length of a stretched string and the pitch its vibration produces, interpreted it mathematically in terms of the ratios displayed on the tablet: the octave (diatonic), 2:1, the fifth (diapente), 3:2, and the fourth (diatesseron), 4:3. These ratios were believed to be the key to the harmony of the universe. Raphael has placed Pythagoras and his disciples appropriately below Apollo, whose association with

music is shown by his attribute, the lyre, for Pythagoras claimed to be able to hear the music of the spheres and used music therapy to heal the passions and soothe the pains of his disciples. Plato used these ratios, derived from Pythagoras, as the harmonic proportions of the soul – as it happens, in the very book Plato holds here, the *Timaeus*. Several modern interpretations have taken this to be the key to the fresco, for the prominently displayed tablet can reasonably be understood as a kind of motto, as André Chastel, in his *Art et humanisme à Florence au temps de Laurent le Magnifique* (1959), called it.

Chastel suggested that Raphael's interpretation of Platonic and Aristotelian thought was taken directly from Marsilio Ficino (1433–99). Aristotle's gesture pointing outward symbolizes the arrangement of the world according to ethics; Plato's gesture pointing upward symbolizes the motion of cosmological thought, which rises above the tangible world to the world of ideas. Chastel adopted Springer's argument that the fresco represents an allegory of the Liberal Arts, all of which Chastel said are easily recognized: in the left foreground are Grammar, Arithmetic, and Music, clearly identified by the presence of Pythagoras; to the right are Geometry and Astronomy, represented by Euclid (Fig. 1, no. 23), Ptolemy (no. 22), and Zoroaster (no. 21); on the top step are Rhetoric and Dialectic. The "emblematic image" on the tablet held at Pythagoras's feet is the clue that the fresco is about the mathematical harmonies of the universe. Balancing the Pythagoreans around the slate at the lower left are the astrologers, symmetrically placed on the other side of the foreground. These two groups are rightly represented as counterparts, for what the Pythagoreans defined with musical consonances, the astrologers found out by studying the sky. Plato's raised finger expresses a final connection: from the science of numbers comes music; from music comes cosmic harmony; and from cosmic harmony comes the divine order of ideas. According to Chastel, in this work Raphael has depicted the Liberal Arts renewed by mathematical rule, which is the first stage of knowledge necessary to an understanding of philosophy.[53]

Some scholars have focused on the diagram that Euclid (sometimes identified as Archimedes) is drawing with his compass on the other side of the foreground space. John Onians, recalling that Vasari

tells us that this figure is a portrait of the architect Bramante and that he assisted his friend Raphael with the architecture in this fresco, sees the two tablets with their geometrical diagrams as clearly parallel, pointing to the geometry governing both music and Bramante's architecture.[54]

Konrad Oberhuber sees in the Euclid diagram of two interlocking triangles the key to the underlying geometry of the painted architecture in the fresco. Thus the figure is interpreted as Euclid–Bramante drawing the architecture of the fresco. The proof depends upon complex geometrical analyses of Raphael's building, which are less convincing than the initial contention that the diagrams – or at least the one at the left, held up for us to read – are, in some important way, a clue to the meaning.[55]

Another theme that has appeared in recent scholarship concentrates upon the image of Plato and Aristotle, standing side by side as equals. The Renaissance viewer, aware that for centuries their philosophies had been regarded as competing and irreconcilable, would have found this remarkable and timely, for in the years preceding Raphael's fresco attempts had been made to reconcile them. Edgar Wind pointed out that in the humanist circles both of the Florentine Academy and the papal court, following the lead of Pico della Mirandola, the doctrine of the "Concordia Platonis et Aristotelis" (the concord of Plato and Aristotle) had been taken up. According to Pico, any proposition in Plato could be translated into a proposition in Aristotle, provided one took into account that Plato's language was that of poetic enthusiasm whereas Aristotle spoke in the cool tone of rational analysis. Wind, in an essay from a projected book, linked the presiding statues of Apollo, the god of poetry (on Plato's side), and Minerva, the goddess of wisdom (on Aristotle's side), with their contrast in language. Unfortunately Wind never completed the book he was preparing, so we have only this enticing hint, but it suggests a major theme that had been curiously missing in the commentaries on the fresco.[56]

In the past generation the theme of the concord of Plato and Aristotle has surfaced several times and has begun to emerge with some authority as the theme of the fresco.[57] Eugenio Garin has given the most comprehensive presentation, pointing out that the *pax philosophica* was a hot issue for debate and by no means a settled matter at the time when Raphael was painting.[58] He reminds us of

Pico della Mirandola's splendid attempt in 1486 to demonstrate to an assembly of scholars the concord of all philosophies and of all faiths for the spiritual peace of humankind. Marsilio Ficino had undertaken the reconciliation of Platonism and Christian theology, but the Ficinian idea of a Platonic theology was still far from receiving universal acceptance. The debate had raged between the advocates of Aristotle and those of Plato and was by no means dead, Garin tells us. He is able to shed some light on the state of the question in the years preceding and contemporary with the fresco. When the Byzantine scholar Pletho proposed the study of Plato as a theologian, he provoked the wrath of George of Trebisond (*Comparationes,* 1458), who saw all this as a subversive, propagandistic attack by agents of the Turks on the Church of Rome and on its philosophy based on Aristotle, Albert the Great, and Thomas Aquinas. In 1469 the Latin version of Cardinal Bessarion's powerful and eloquent response to Trebisond (*In calumniatorem Platonis*) reached print and a wide audience. The debate peaked in the decades just before Raphael painted the *School of Athens* but was certainly not extinguished, as the 1523 reprinting of Trebisond's anti-Platonist manifesto in Venice bears witness. Furthermore, at about the same time Raphael was painting the Stanza, Gian Francesco Pico, nephew of the celebrated philosopher, was hard at work trying to prove the irreconcilability of Christian theology and pagan philosophy – the direct opposite of what appears in the *School of Athens.*

For Garin the key to understanding the work is in the figures of Plato and Aristotle and the books they hold. Garin asks, Why are these particular books selected? In the case of Plato's *Timaeus,* this work had been used in the teaching of natural science until the twelfth century, when it was replaced by Aristotle's *Physics.* For Ficino, however, the *Timaeus* was the book that "embraces all the questions concerning nature." In a revealing marginal note, Ficino remarks that nature is an instrument of the divine; its study provides an ascent to the divine, a stairway to God. This, therefore, is the meaning of Plato's gesture: Plato sanctifies natural things. Although Garin does not make that connection, it would seem also to link Plato to the prominent presence in the fresco of Pythagoras with his tablet of the harmonies.

If one can explain Plato's gesture and the *Timaeus* in this way, how do we account for the manner in which Aristotle is depicted?, Garin

asks. The *Ethics,* the book Aristotle holds, was a major text through-out the Renaissance, and Ficino devotedly transcribed it in his own hand. For Ficino, Aristotle was the physicist, in the sense of a man of empirical science. And although Ficino recognized Aristotle's im-portance, he seems to have looked down on him for his insistence on reducing everything to the raw empirical level. Aristotle, then, un-like Plato, seemed to "naturalize" even the things that are divine; thus his outward-pointing gesture. Pico, referring to the *Ethics,* says, "whoever holds that Aristotle dissents from Plato also dissents from me, for I uphold the concord of the two philosophers."[59] Ingrid Rowland, in her chapter in this book, building on the contributions of earlier scholars, clinches the argument with specific texts on the concord of Plato and Aristotle from works by Egidio da Viterbo, court preacher at the Vatican and close associate of Pope Julius.

Garin provides an intellectual context in which the extraordi-nary image of Plato and Aristotle as co-leaders of the School of Athens can be understood. One might expect that the two themes, the Pythagorean tablet and the *pax philosophica,* would have been linked explicitly by some scholar, but this has not yet been done. The tablet suggests that cosmic harmony is the subject of all philo-sophical investigation, that it has been investigated by philosophers using various tools and methods, and that, despite the diversity of their languages, their findings can be brought into harmony with one another. This meaning of the *School of Athens* is a subtheme of the theme of the entire Stanza, where the various disciplines, par-ticularly philosophy and theology, are presented as complementary intellectual endeavors.

SEQUENCE OF EXECUTION AND WORKING PROCEDURE

Ever since Bellori corrected Vasari, most writers have accepted the sequence of execution as beginning with the ceiling, followed by the *Disputa,* the *School of Athens, Parnassus,* and *Jurisprudence* and have dated our fresco 1510–11, although some, myself included, would place the *Parnassus* before the *School of Athens.* Recently, one scholar has proposed that the *School of Athens* was the first of the wall frescoes to be painted,[60] and another has drawn attention to a document which indicates that our fresco was the last.[61] Such radical disagree-

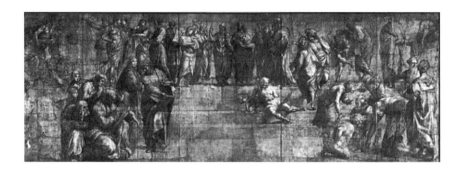

Figure 19. Raphael's cartoon for *The School of Athens*. Biblioteca Ambrosiana, Milan. (Photo: Art Resource.)

ment over the chronology makes it clear that there are very few opinions not susceptible to question and debate on this issue. The evidence of style and technique, however, tends to support a later rather than an earlier date for the *School of Athens* and favors placing the *Disputa* first among the wall frescoes. The argument has repeatedly been made that Raphael would have begun with the composition that was familiar to him, which would have been the *Disputa,* because it resembles his earlier fresco, the *Trinity with Saints* (Perugia, San Severo), and that he modernized its still Quattrocento and Peruginesque design and developed it for the Segnatura painting, a process we can observe in the surviving drawings. In fact, the question of the sequence of the frescoes may be unresolvable unless new documentation is found and may not be worth further examination. Nothing depends upon it except our view of the painter's stylistic evolution, and it is amply proven by now that this can be argued in more than one way.

We have a large number of Raphael's preparatory studies for the *Disputa* that allow us to reconstruct his working procedure.[62] Few studies for the *School of Athens* have come down to us, but what has survived is the full-scale cartoon preserved in the Biblioteca Ambrosiana (Fig. 19). This enormous drawing, more than twenty-four feet in length, is only a few inches shorter than the fresco. It excludes the architecture, which was executed directly on the wall,[63] and three of the figures are missing. Lacking are the portraits of the painter himself (Fig. 1, no. 19) and the other artist accompa-

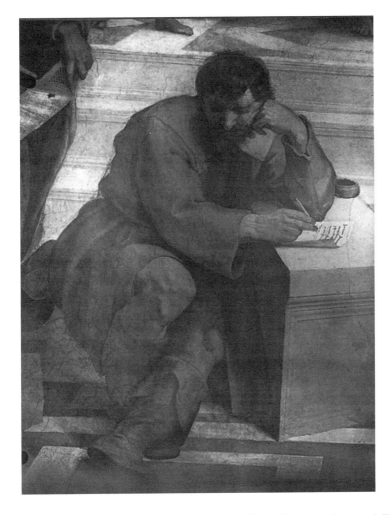

Figure 20. Heraclitus. Detail from *The School of Athens*. Stanza della Segnatura, Vatican Museum. (Photo: Vatican Museums.)

nying him, probably Sodoma but sometimes identified as Perugino (no. 20). Space was left for them at the far right, however, so they were not late additions, as was the other figure missing from the cartoon, the Heraclitus in the foreground (no. 29; Fig. 20). Technical examination of the plaster has shown that Heraclitus was inserted on a separate patch of *intonaco* after the surrounding area had been

completed, which suggests once again that the program was flexible enough to allow the painter to make unplanned additions.[64] Redig de Campos further observed that the style and scale of this figure differ from those surrounding it and that his features could be said to resemble Michelangelo's. He offered the intriguing hypothesis that Raphael added the figure after viewing the unfinished Sistine vault, as a homage to his colleague and rival. Whether or not we accept it as a portrait of Michelangelo, there can be no doubt that its monumental scale surpasses that of Raphael's other figures in the fresco and reminds us of the Sistine Prophets. But when would this addition have been made? It was supposed by Redig de Campos that Raphael saw the Sistine vault when the scaffolding was moved in August 1511. Art historians like to hypothesize dramatic events and sudden revelations such as this, but it is equally possible that Raphael saw some of Michelangelo's cartoons or that he was able to peer through the scaffolding when a few boards were removed, as we now know was possible.[65] Raphael's decision to include the Michelangelesque Heraclitus need not have been an instant response to his first glimpse of the Sistine Seers but may have been a more considered decision.

Winner's chronology places the *School of Athens* first. We should note that there is no technical reason to exclude the possibility of the addition of Heraclitus long after the rest of the fresco had been completed: since he is placed low on the wall, the scaffolding could easily have been reassembled. Nevertheless, to many observers the style of the *Disputa* is more closely linked to that of Raphael's previous work in Florence, whereas the *School of Athens* reveals a significant step forward in his use of color and chiaroscuro. Close study of the Ambrosiana cartoon and the style of the fresco makes clear the nature of the innovation.

This is the earliest full-scale cartoon that has survived. It is unlikely that such a drawing was used much before Raphael's time or that it was even needed. As Oberhuber has pointed out, it became necessary when the painter began to think in terms of massed light and shade.[66] The Quattrocento artist conceived of each figure as individually sculpted in the light entering from a fixed direction. His interest lay in creating relief. In the *School of Athens,* as Janis Bell shows in her chapter in this volume, the artist softened the independence of his figures by placing them in unified groups that interlock in the design of the whole. Among the paint-

ers of the Quattrocento, only in Leonardo can we find figures that
are worked together as a unified group rather than treated as single
individuals. Bell discusses Raphael's debt to Leonardo. Her analysis
of the way Raphael used color, particularly chiaroscuro, shows that
he extended it beyond anything that had been done before. She
studies some of the techniques he invented, such as accidental light.
In this new way of thinking about light, its purpose is no longer
merely to create relief. Occluding shadow subordinates some minor
figures, or parts of figures, for the sake of the unity of the whole.
Take the Euclid group again (Fig. 9). Within the group, Euclid
dominates because he occupies the most space and is given the
strongest gesture. Portions of each disciple receive light, but it may
be only an arm, a shoulder, or half a face. The distribution of values,
lowest at the core of the group and highest near the periphery,
defines the contours of the unit and dictates that we read it as a
whole. The colors of each figure, even of the master himself, as equal
in attraction, and because no one stands out we are led to understand
that cooperation and exchange are the essence of this learning pro-
cess, that it is not a solitary enterprise, and that each generation learns
from the last and builds on what it learns. Thus the very organization
in terms of groups of interacting figures symbolizes the nature of
intellectual inquiry. This is not always the case, of course, and the
exceptions are noted: the solitary figures of Diogenes and Heraclitus
are conspicuous in their self-absorption. But within the whole com-
position no single figure dominates either by virtue of compositional
devices, or of color, or of chiaroscuro.

The chapters in this book reveal that art historical studies today delve
more deeply into their subject than ever before, discovering more
complex relationships between the word and the image. They ex-
tend formal analysis, which was for generations concerned with
questions of style, to a broader consideration that takes into account
patronage, program, materials, and function. The theological and
philosophical, literary, and legal discussions depicted in the Stanza
della Segnatura, for all their richness and complexity, when taken
together were intended to convey the unity of the world of knowl-
edge. The style Raphael inherited from his predecessors, and which
he had evolved for himself prior to this commission, had never been
put to the task of creating the visual equivalent to such a richly

differentiated but unified world, a world of ideas composed, expressed, and communicated through words. The impression of Raphael that emerges from these studies is that of a genius of unrivaled imagination who found compelling visual equivalents of complex literary and rhetorical ideas.

The conception of Raphael as the perfect painter, the academic painter par excellence, has done much to hinder appreciation of his art in the twentieth century. It is useful, therefore, to recognize that this idea was invented by the classicists and the academies, who needed a model from whom to deduce their rules. Although Raphael's style was, as we have said, teachable, it was certainly not created according to predetermined rules. Study of the development of his art shows that he was constantly experimenting, that he never repeated himself, that he was never satisfied with a solution already achieved but constantly raising the ante, challenging himself to undertake a more difficult problem.

In our day, the academic tradition of art education has all but vanished. This is a good thing for Raphael, because, with it, the resentment that young artists inevitably felt for the painter who was regarded as "perfect" has also evaporated. It is now possible to take a fresh look at Raphael's paintings. Although some may prefer the promethean energy of Michelangelo, others the painterly magic of Titian, and still others the mysterious sensuousness of Correggio, Raphael's ideal world offers order, grandeur, generosity of spirit, and a confidence in humankind that would have soothed the anxiety of Raphael's contemporaries, whose real world was that of the threat of the Turk, division within the Church, recurrent plague, and the struggle of the French and the emperor for domination of the Italian peninsula, as much as ours is one of bewildering multiplicity, atomic threat of annihilation, corrupted human nature, and corroded confidence in our ability to hold it together, to keep the center. We, too, can find solace here.

NOTES

1. Creighton Gilbert, *Introduction to Italian Art, 1400–1500: Sources and Documents* (Evanston: Northwestern University Press, 1991), has enumerated the six written programs from the Renaissance that survive and has argued against the presumption of such written programs in most cases.

2. Passavant, 1839, 82.

3. Crowe and Cavacaselle, 1882, 2:15.

4. John Shearman, "Raphael's Unexecuted Projects for the Stanze," in Georg Kauffmann and Willibald Sauerländer, eds., *Walter Friedlaender zum 90. Geburtstag. Eine Festgabe seiner europäischen Schüler, Freunde und Verehrer* (Berlin: De Gruyter, 1965), 158–80.

5. On education in the Renaissance, see Paul Grendler, *Schooling in Renaissance Italy: Literacy and Learning, 1300–1600* (Baltimore: John Hopkins University Press, 1989).

6. See Michael Baxandall, *Painting and Experience in Fifteenth-Century Italy: A Primer in the Social History of Pictorial Style* (Oxford: Clarendon Press, 1972).

7. See, for example, the Wittkowers' analysis of the funeral of Michelangelo, designed by Vasari and others in his circle to demonstrate the social position the artist had achieved. A typical decoration of the catafalque showed Michelangelo seated in conversation with the pope. Margot Wittkower and Rudolf Wittkower, *The Divine Michelangelo: The Florentine Academy's Homage on his Death in 1564* (London: Phaidon, 1964), pl. 25. More recently, on Vasari, see Paul Barolsky, *Michelangelo's Nose* (University Park: Pennsylvania State University Press, 1990).

8. Jack Greenstein has made such a case for Mantegna, arguing that "the making of meaning was a primary, if not the primary, task of a painter working in the Albertian tradition." In Greenstein, *Mantegna and Painting as Historical Narrative* (Chicago: University of Chicago Press, 1992), 13.

9. There is ample evidence that Raphael studied various ancient texts to guide him in his projects of mapping ancient Rome and building the Villa Madama on the model of ancient villas as described particularly by Pliny the Younger. See Jones and Penny, 1983, 199–205; 226–7.

10. See in particular O'Malley, 1979, on the theological and rhetorical culture of the papal court.

11. The role of the adviser in this painting and others has been discussed by Charles Hope, 1981, 315–16. As Hope puts it, "Raphael's great innovation was to arrange figures according to the conventions of history painting, and this ingenious solution is the one thing that is unlikely to have been suggested by a humanist."

12. Vasari, 1568, Life of Piero, and Life of Raphael, conflicting versions. In his Life of Raphael he says that Piero della Francesca, Signorelli, and Bramantino had painted in these rooms.

13. Paris de Grassis, *Diarium,* in Golzio, 1936, 14.

14. Andrée Hayum, *Giovanni Antonio Bazzi – "Il Sodoma"* (New York: Garland, 1976), 17.

15. See Jones and Penny, 1983, pls. 65–6, for eighteenth-century watercolor copies.

16. Sodoma executed the divisions of the ceiling and the grotesque decorations in the small fields, but Raphael repainted the large fields. Jones and Penny, 1983, 56; Deoclecio Redig de Campos, 1965. John Shearman states that when Raphael first took charge of the Stanza it was structurally similar to the Stanza dell'Incendio as we still see it today. Raphael modernized the vault by doing away with the Quattrocento consoles at the corners and smoothing the transition between vault and walls: "Raphael as Architect," *Royal Society of Arts Journal* 116 (1967–8), 396.

17. John Shearman, 1972.

18. The dado zone, or *basamento,* frescoes we see there today were painted by Perino del Vaga in the 1540s. We know from an inventory made after Pope Julius's death that his library consisted of 218 volumes, and we know the titles. See Dorez, 1896, 97–121.

19. See Luciano Cheles, *The Studiolo of Urbino, an Iconographic Investigation* (University Park: Pennsylvania State University Press, 1986). In view of the attempts that have been made to associate the liberal arts with figures in the *School of Athens,* it is of some interest that this was the iconography chosen for the now destroyed library on the ground floor of the Ducal Palace.

20. On Raphael's role in this commission, see Pietro Scarpellini, *Perugino* (Milan: Electa, 1984), 95–8.

21. Gail Geiger has made a convincing case for Filippino Lippi's Carafa Chapel in Santa Maria sopra Minerva as a precedent for aspects of the iconography in Raphael's Segnatura. See "L'arte religiosa romana all'arrivo di Raffaello," in Marcello Fagiolo and Maria Luisa Madonna, eds., *Raffaello e L'Europa* (Rome: Istituto Poligrafico e Zecca dello Stato, 1990), 27–48. Lippi continued the didactic tradition, however, and did not anticipate Raphael's dramatization of his subject.

22. On the engaged viewer, see Shearman, 1992.

23. This reading of the Euclid group was suggested by Joannides, 1983, 82.

24. Another relevant example of the intermingling of allegorical figures with their disciplines is to be found in the Borgia Apartments, painted by Pinturicchio in the mid-1490s.

25. Students of romance languages are familiar with this distinction between *savoir / sapere* and *connaître / cognoscere.* Our word "numinous" comes from the same root as *numine,* meaning a "nod"; poetic inspiration derives, then, from a "nod of the god."

26. On the ceiling and the iconography in general, see Gombrich, 1972, 85–101. The translations of the inscriptions are his.

27. Edgar Wind analyzed the ceiling, including the small grisailles and mythological scenes, which he related to the four elements; the elements, in turn, he connected to the four faculties below. 1938–9, 75–9.

28. On *Parnassus,* see Paul F. Watson, "On a Window in Parnassus," *Artibus et Historiae* 16 (1987), 127–48.

29. Edgar Wind, "Platonic Justice, Designed by Raphael," *Journal of the Warburg Institute* 1 (1937–8), 69–70.

30. Freedberg, *Painting in Italy, 1500–1600* (Baltimore: Penguin Books, 1971), 34.

31. Matthias Winner, 1984, has reconstructed his idea of the first project from the drawings in Windsor Castle, Oxford, and Chantilly. Reproduced on 190.

32. John White, "Two Aspects of the Relationship between Form and Content," *Burlington Magazine* 103 (1961), 230–5.

33. On *ekphrasis,* see Svetlana Alpers, "*Ekphrasis* and Aesthetic Attitudes in Vasari's *Lives,*" *Journal of the Warburg and Courtauld Institutes* 23 (1960), 190–215; Norman E. Land, "Titian's *Martyrdom of Saint Peter Martyr* and the 'Limitations' of Ekphrastic Art Criticism," *Art History* 13 (1990), 293–317, with extensive bibliography; David Carrier, "*Ekphrasis* and Interpretation: The Creation of Modern Art History," in *Principles of Art History Writing* (University Park: Pennsylvania State University Press, 1991), 101–19.

34. Bellori, 1695.

35. On the engraver's motive for making this change, which the author takes to have been a commercial one, see Jeremy Wood, "Cannibalized Prints and Early Art History: Vasari, Bellori and Fréart de Chambray on Raphael," *Journal of the Warburg and Courtauld Institutes* 51 (1988), 210–20.

36. Ascanio Condivi, *The Life of Michelangelo* (1553), ed. Hellmut Wohl, trans. Alice Sedgwick Wohl (London: Phaidon, 1976), 94.

37. Lanzi, 1794; 1:372.

38. For what follows I have relied upon Martin Rosenberg, "Raphael in French Art Theory: Criticism and Practice, 1660–1830," Ph.D. diss., University of Pennsylvania, 1979. See also J. Bell, 1995.

39. Félibien, 1666, pt. 1, 1: 292, 294; quoted by Rosenberg, 1979, 25, nn. 39–40.

40. Félibien, 1666, 339.

41. "Discourse XI" (1782), in Sir Joshua Reynolds, *Discourses on Art,* ed. Robert R. Wark (San Marino, Calif.: Huntington Library, 1959).

42. "Men of knowledge have often sought for Raphael's works in the midst of them; that is, in the halls of the Vatican . . . and have asked their guides to shew them the works of Raphael, without giving the least indication of being struck with them at the first glance of the eye." Roger de Piles, *Cours de peinture par principes* (Paris, 1708), 12; English ed., 1743, 7; quoted by Thomas Puttfarken, *Roger de Piles's Theory of Art* (New Haven: Yale University Press, 1985), 55.

43. For example, Roland de Fréart de Chambray, *Idée de la perfection de la peinture* (Les Mans, 1662; facsimile, Farnsborough: Gregg Reprint, 1968), preface [n.p.], quoted in full by Rosenberg, "Raphael in French Art Theory," 16.

44. Lanzi, 1794, 385, 380.

45. John Ruskin, "Pre-Raphaelitism" (1851), in *Complete Works* (London: Allen, 1904), 12: 353–4.

46. Wölfflin, 1899, xvi.

47. Passavant, 1839.

48. W. W. Lloyd, "Raphael's *School of Athens*," *Fine Arts Quarterly Review* 2 (1864), 42–68; Springer, 1883, 53–106.

49. Heinrich Wölfflin, *Italien und das deutsche Formgefühl* (1931), trans. Alice Muehsam and Norman A. Shatan (New York: Chelsea Press, 1958).

50. Wölfflin, 1899, 88.

51. Svetlana Alpers, *The Art of Describing: Dutch Art in the Seventeenth Century* (Chicago: University of Chicago Press, 1984).

52. For example, Chastel, 1959, associated Marsilio Ficino's philosophy with the Segnatura, and Garin, 1989, has explored the intellectual climate.

53. Chastel, 1959, 476–80.

54. John Onians, *Bearers of Meaning: The Classical Orders in Antiquity, the Middle Ages, and the Renaissance* (Princeton: Princeton University Press, 1988), 239.

55. Oberhuber, 1983. An analogous diagram of the geometry of the architecture was published by Arnaldo Bruschi, *Bramante architetto* (Bari: Laterza, 1969), figs. 485–7.

56. Edgar Wind, "The Fear of Knowledge," in *Art and Anarchy* (London: Faber & Faber, 1963), 62–3. Stridbeck, 1960, appears to be the first to have worked out the hypothesis of the *concordia* as the key to the fresco, but see his notes for earlier hints of it in the literature.

57. See, for example, Gunnar Danbolt, "*Triumph concordiae:* A Study of Raphael's Camera della Segnatura," *Kunsthistorisk Tidskrift* 44 (3–4) (1975), 70–84.

58. Garin, 1989, 171–81. Inexplicably, Garin insists upon the supremacy of Plato in Raphael's image, in contradiction to other writers, who have seen the two depicted as equal, or, if Aristotle defers to Plato in looking at him, that is understood as the pupil acknowledging the master.

59. Pico della Mirandola, in the preface to his *De ente et uno,* addressed to Angelo Poliziano, regarding his comments on the *Ethics.* Quoted by Garin, 1989, 179.

60. Winner, 1984.

61. Gould, 1991, 171–82, reexamined a letter dated 16 August 1511 that speaks of two portraits in the room where Raphael was working, one

already made of the pope with his beard, the other *to be executed,* of the young Federico Gonzaga, then a hostage in the Vatican. The latter is probably the figure identified in Figure 1 as no. 36 in the *School,* mentioned by Vasari (but described by him as no. 24), who would not have known about this letter. The pope's portrait is of course the one in the *Jurisprudence.* This suggests that the time slot for the execution of the portrait of Julius receiving the canon law is between June 27, when the pope returned to Rome wearing his new beard, and the date of the letter. It should be noted that there is nothing to preclude Raphael's having executed the frescoes on the upper portions of this wall before the pope's return. Gould points out that the dates on the window embrasures, which range between 1 January and 1 November 1511, need not be read as dating the individual frescoes above, as has been done in the past, but should be understood rather as dating the painting of the window recesses themselves. He offers a convincing new reading of the chronology of the painting of the ceiling, but this reader is not persuaded by his dating of *Parnassus* before the *Disputa.* He did not consider the Ambrosiana cartoon and the problem of the late insertion of Heraclitus.

62. See Pope-Hennessy, 1970, and Ames-Lewis, 1986.

63. Arnold Nesselrath, "Art-historical Findings during the Restoration of the Stanza dell'Incendio," *Master Drawings* 30 (1992), 31–60, cites Winner (in Eve Borsook and Fiorella Superbi Gioffredi, *Tecnica e Stile: Esempi di pitture murale del rinascimento italiano,* Villa I Tatti Studies, no. 9 [Milan: Silvana, 1986], 88–90) as having pointed out that the architecture in the *School of Athens* was constructed directly on the wall. This was also true in the case of the *Expulsion of Heliodorus* and of the so-called *Coronation of Charlemagne* but not in the *Fire in the Borgo,* which was executed from a cartoon.

64. Deoclecio Redig de Campos first published this observation in *Michelangelo Buonarroti nel IV centenario del "Giudizio universale" (1541–1941)* (Florence: Sansoni, 1942), 205–19, then repeated it in his widely disseminated *Raffaello nelle Stanze,* 1965. His findings have been confirmed in the present restoration by Arnold Nesselrath (oral communication).

65. On the scaffolding, see Fabrizio Mancinelli, in *The Sistine Chapel: The Art, the History, the Restoration* (New York: Crown-Harmony, 1986), 223; repeated by Hartt in Frederick Hartt, Gianluigi Colalucci, and Fabrizio Mancinelli, *The Sistine Chapel* (New York: Knopf, 1991), 1: 367, n. 7.

66. Oberhuber and Vitali, 1972. It is understood that the cartoon would have been cut up and destroyed in use, so scholars have hypothesized a substitute cartoon, which would account for this one's survival; see Borsook, 1985; Bambach Cappel, 1992.

THE IMAGE OF THE ANCIENT *GYMNASIUM OF ATHENS,* OR, *PHILOSOPHY*

The title applied to it [the painting] by Vasari is incorrect:* the concord of Philosophy and Astrology with Theology, inasmuch as there are neither theologians nor evangelists such as he describes at length, confusing instead this second image with the first one, of Theology and the Sacrament. These errors originated soon after Raphael's death through the inadvertence of those who undertook to interpret his works, as can be clearly understood from the other print, which is incomplete, by Agostino Veneziano, published in 1524, in which the figure of Pythagoras is transformed into the Evangelist Saint Mark, and the youth who leans over beside Pythagoras with the abacus, is transformed also, into an angel with the attributes of the Angelic Salutation. The title *School of Athens* that is commonly attributed to it is more suitable, and comes closer to the properties of the figures, since it concerns a city that is mistress of the disciplines of study. In order to form the image of Philosophy, Raphael intended to bring together the studies and the schools of the most illustrious philosophers, not of one age alone, but of the most celebrated ages of the world, making very appropriate use of anachronism or the reduction of the periods in which

★ Translated by Alice Sedgwick Wohl. From Giovanni Pietro Bellori, *Descrizzione delle quattro immagini dipinte da Raffaelle d'Urbino nella Camera della Segnatura nel Palazzo Vaticano, e nella Farnesina alla Lungara, con alcuni ragionamenti in onore delle sue opere, e della pittura e scultura* (Rome: Eredi del q. Gio: Lorenzo Barbiellini, 1751), 29–47.

Translator's note: Bellori must have been looking at a print of the painting as he wrote, for his "lefts" and "rights" are reversed throughout.

they lived. If we therefore call it the *Gymnasium of Athens,* it will not be unsuitable, since we are inspired by the idea of the ancient gymnasiums where, apart from exercising the forces of the body, the soul was cultivated as well through the disciplines of study, as philosophers and other masters of knowledge came together to debate and to teach; this title will have the further advantage of not departing from the one that is already known, and spread by fame to everyone. The painter, then, depicted a magnificent edifice, not in the complete and perfect form of the ancient gymnasiums, with exedras and porticoes where philosophers, rhetoricians, poets, mathematicians and scholars of other disciplines contended and debated, but he depicted an edifice that is suited to the situation and view of the figures, and is decorated with pilasters and arches in perspective.

THE *GYMNASIUM*

The magnificence, the embellishments, and the entire aspect of the *Gymnasium,* which opens up and out with Doric proportions in the manner of a temple, are very worthy things by virtue of the excellence of the architecture and the artifice of the perspective; but the various figures deployed at various studies, and the number that fills so noble a theater, cause spectators to halt in contemplation of ancient philosophy. The building opens to reveal its interior aspect, raised on four great marble steps; some of the philosophers are practising their discipline above, others below on the principal plane of the foreground; thus the figures are displayed better, and with a more distinct ordering of views and distance, in the different levels of the site. There Pythagoras, Socrates, Plato, and Aristotle can be discerned with their more famous schools, and with them gather mathematicians, astronomers and other ancient sages and cultivators of philosophy.

Beginning, then, with the principal plane and with what is visible in front of the steps, at the right side Pythagoras [Fig. 1, no. 33] is seen sitting, surrounded by his disciples, writing his philosophy based on the harmonic proportions of music. Next to him on the far side, a youth leans and looks at him [no. 32], holding at his feet the abacus, or rather a little panel on which the numbers are depicted and the consonances of song, indicated with Greek names and letters: diapason, diapente, diatesseron, in the

form in which they are drawn here [Fig. 21]. Of these conso-
nances it is thought that Pythagoras himself was the author, and
that he drew from them the basis for his philosophy, as Plato after
him formed from them the harmonic proportions of the soul.
Pythagoras is shown in profile, and sitting down, resting the book
on his thigh, and on the book his hand and the pen, and he
expresses his attention in applying the rules of music to natural
science. Next to Pythagoras come his disciples Empedocles,
Epicharmus, and Archytas; one of them, completely bald, sitting
at his side behind him, writes on his knee [Fig. 1, no. 34]; but as
he looks over at the writings of the master, with one hand he
suspends the pen above the page, with the other he holds the
inkwell, and in his attentiveness, with great naturalness, he sticks
out his face, opens his eyes, closes his lips, showing his mind
occupied in transcribing the doctrine. At the back of Pythagoras
himself another man advances with his hand on his chest, looking
down at the master's page [no. 35]; and this one is depicted with a
cap, and a collar on his mantle, shaven chin, and the hairs of his
beard hanging from his lips. Farther back is revealed the face and
the hand of another man who, bending forward, spreads his
thumb and forefinger in the act of counting, and he appears to
indicate the doubling tones of the diapason, that is, the double
consonance described by Pythagoras. Next, in the far corner, is a
clean-shaven man portrayed life-size, who is holding a book on
the base or pedestal of a column, in which he is writing atten-
tively [no. 37]; this man wears a wreath of oak leaves, the emblem
of Pope Julius, to whose name Raphael dedicated the work signi-
fying the golden age of this pontiff, his benefactor. Nearby, at the
edge of the image, an old man [no. 40] is partially visible with a
boy [no. 39], who childishly reaches his hand out to the book of
the man who is writing, and it looks as though the parent brings
him here in order to recognize the boy's propensity. While all the
figures described are located behind Pythagoras, on his far side a
noble youth appears swathed to the neck in a white cloak deco-
rated with gold, with his hand on his chest [no. 31]. This is held
to be Francesco Maria della Rovere, the duke of Urbino, the
pope's nephew, aged twenty at that time. And it really appears as
if he comes here through desire and longing to learn the noble
studies and the most worthy arts.

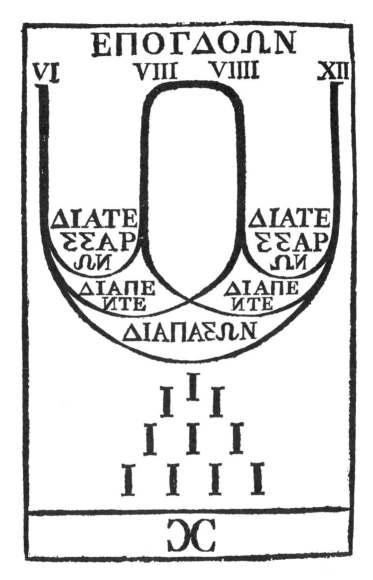

Figure 21. Diagram of tablet held up for Pythagoras. (From Bellori, *Descrizzione*. Photo: Clark Art Institute Library.)

Farther in front of Pythagoras another of his disciples [no. 30], with one foot on a stone lifts his knee and, supporting the book on his thigh, with the fingers of his hands marks a place on the page, fixing his gaze backward upon the writings of the master. On the border of this man's cloak, like an embroidery and embellishment, are depicted notes and characters that have not been deciphered, which someone has believed to be ancient musical notes: this may be Terpander or Nicomachus or else another musician and follower of Pythagoras, who was of the opinion that the turning of the stars and the motion of things occurred not otherwise than according to the rules of music. Beyond this man we recognize the meditation of another philosopher [no. 29], who sits and leans on his elbow, with one hand under his cheek, the other holding a pen over the page, and as he meditates he gazes fixedly at the ground and manifests his inner thought as he resolves the reasoning of his doctrine. He wears a sagum, with his boot tops turned down from his bare knees: in this abbreviated costume he differs from the other cloaked figures in the *Gymnasium*.

On the second step above, Diogenes is seen alone, set apart [no. 28]: such is the resemblance that, with his cloak thrown off behind him, half naked, and barefoot, he stretches out his legs on the stairs, with his bowl before him as an attribute, a cynic in his expression, in his bearing, in his attitude. He is looking at a book that he supports on his thigh, meditating on his moral philosophy that despised human ostentation, since it is thought that he handed down some precepts about virtue and about vice.

Turning now to the other, the left side of the Gymnasium, because mathematics must precede philosophy and the sciences, as their principles and elements, passing from the tangible to the intellectual, therefore Archimedes is represented in the foreground, intent upon his demonstrations [no. 23]; in his person is portrayed Bramante the architect. He stretches his naked arm out from his robe toward the ground, and with his hand he turns the compass on the slate, on which a hexagonal figure is drawn, formed of two equilateral triangles, demonstrating it to his pupils. Beside him stand four young students, with eager looks, and in scanty attire, and as they learn the figure, each of them expresses the action of his mind and his own intelligence. The first one in the foreground [no. 26], bent with one knee on the pavement, leans with one hand on his thigh, atten-

tive to the dimensions of the figure. Behind, his companion stands with one hand on his shoulder [no. 27], bending over in order to see; and as the master turns the compass, so he spreads two fingers of his other hand and appears to accompany the triangle. The other two youths draw near Archimedes' side, the first one, also bent on one knee [no. 25], turns back and shows the figure to his companion, who stands over his shoulders and leans forward with his arms spread [no. 24], anxious to see and to learn the demonstration. Vasari has it that this is Federico II, duke of Mantua, who was in Rome at the time, portrayed thus from life. Behind Archimedes come two sages: one holds the celestial globe marked with stars, the other the globe of the elements, with the surface of the earth and the water. It seems that the first refers to the Chaldeans [no. 22], authors of astronomy and of the science of celestial bodies, and his chest and the cap on his head are visible. The second one turns his back [no. 21], so that his face cannot be seen, but the radiate royal crown and the golden mantle are attributes of Zoroaster, king of the Bactrians, who apart from astronomy was most expert in the science of natural things; even though it is thought that he corrupted the true science of the occult. These two sages turn backward toward two young men who are partially visible at the edge of the image. One is Raphael [no. 19], author of the work, painted from his image in a mirror, with a black cap on his head, of noble aspect, modest, and imbued with grace . . .

Ascending now to the upper level, the first place is occupied by the two princes of philosophy, Plato [no. 1] and Aristotle [no. 2], who, placed standing in the middle of the Gymnasium, hold sway, majestic and solemn. And because the farthest arch of the Gymnasium opens at a distance behind them, the two figures alone are set against the open sky with such force and distinctness, that the eye immediately perceives them in the first place and recognizes them as the masters and princes of philosophy. Plato has under his left arm the book entitled *Timaeus,* and the sign of his great doctrine is the gesture of his raised right hand, pointing to Heaven and the supreme cause, since this philosopher in the *Timaeus* contemplates the nature of the universe and natural things mysteriously as effects and images of things divine. And as the *Timaeus* is reputed to be among the best dialogues of Plato in treating of nature, it is right that it should be placed here before the others in the school of philosophy, leaving out the *Parmenides,* which is concerned en-

tirely with the divine, and belongs to theology. At the left of Plato
stands his great disciple and master of wise men, Aristotle, who
with his left hand rests on his thigh his book entitled *Ethics* or the
moral philosophy of human behavior, and he too makes himself
understood by the gesture of his right hand, which is not raised up
but extended forward in the gesture of the peacemaker. This ges-
ture is properly suitable to ethics, which calms the emotions and
moderates human souls with the proportion of virtue; in this way
these two great philosophers correspond to the present image of
philosophy, divided in two parts, natural and moral. Plato is formed
in a majestic and venerable attitude, hoary, with long hair and
beard; Aristotle in his features expresses his genius, and his hair and
beard are somewhat curly, and blond, as a sign of his subtle tempera-
ment. At one side and the other of these two great philosophers
their pupils are grouped, old and young of every age, intent on
hearing them: some have their hands on their chests, others open
them, others move them in various expressions of emotion, and all
the figures are lively in attention to the two masters and their
teaching. Behind those listening to Plato there is Socrates [no. 49],
turned toward Alcibiades who faces him, both seen in profile.
Socrates is bald and snub-nosed, as he is described and portrayed;
Alcibiades is young, handsome, in warrior's garb [no. 45], with his
blond hair falling from his helmet over his shoulders, and his armor
is richly embellished in gold. Philosopher and warrior, he has one
hand on his side and the other wrapped in his chlamys on the
pommel of his sword; and he shows himself thoroughly attentive to
the sayings of Socrates, who as he teaches him and his other pupils
who stand before him, accompanies his words with the action of
his hand, touching the index finger of his left hand with the first
two fingers of his right, as if to designate the mean of virtue and
the extremes of vice, or some other similar argument. While
these men hang intent on the words of Socrates, the painter varied
the action to give some movement to the figures, and behind
Alcibiades he depicted a man who, turning backward, holds out his
hand and seems to be calling [no. 44], and at the same time a
servant comes running in haste, and he bears a volume on top of a
book [no 42]; and behind this man appears the face of another
servant who with his hand on his cap seems to respond respectfully
to the one who is calling [no. 41].

Among the followers of Aristotle attending on the other side, Raphael did not fail to represent in lively fashion their propensity and affection for study. He depicted one of these disciples who, having departed from below from the school of Archimedes as though mathematics were terminated, directs himself upward toward philosophy, and as he ascends the steps he seems to ask for the master [no. 11], turning with open arms and hands toward another man higher up who points out Aristotle and Plato to him [no. 12]. The ascending figure is seen from the back, and he is deployed in a white cloak in an attitude and according to a conception based on fine reasoning, in which Raphael was concerned with the ancient custom of the Greeks, who rose step by step from mathematics to the speculative sciences. Next to the man who points out Aristotle and Plato from above, there is a young student who, leaning his shoulders on the base of a pilaster [no. 13], crosses one leg and writes on his thigh, bowing his head, with his pen on the page. Next to him is depicted another man [no. 14], with clean-shaven face and old, who leans against the same base, with his arm bent on it and his chin on his hand, gazing comfortably at the page of the youth, who writes and exerts himself. Among the other figures that on this side complete the action, at the edge of the image an old man appears who [no. 15], wrapped in his cloak and leaning on his staff, comes to the Gymnasium, anxious to learn, corresponding to the vow of that Sage who with one foot in the grave still craved to learn the doctrine and to banish ignorance.

As this image refers to moral philosophy on this side and natural philosophy on the other, between two pilasters a statue is placed in its niche, namely *Apollo* and *Minerva,* presiding over the sciences and the fine arts. *Minerva* [Fig. 14] holds her staff in one hand and rests the other on her shield, upon which the Gorgon is sculpted. Beneath this goddess a square fictive marble relief represents Virtue elevated upon clouds; holding one hand at her breast, the seat of valor, she extends the other toward the earth with the sceptre of her empire; and this she rests above against the Zodiac, where the sign of the Lion appears that is the emblem of Hercules, thus she raises to Heaven the glorious deeds of the heroes. Nearby two putti are portrayed with a tablet, but there is no inscription whatever. In the other niche stands the statue of *Apollo* [Fig. 13] god of healing, depicted nude, with the lyre in one hand and the other resting on a

trunk around which coils the serpent, the symbol of health as the lyre is the attribute of virtue. And because the latter is the form and harmony of the human soul, which represses the violent emotions that are due to wrath or cupidity, under the same statue of *Apollo* in two other fictive marble reliefs are represented these two unrestrained and disorderly powers. Wrathfulness appears above, a naked man who furiously shakes and beats some figures to the ground. Below, concupiscence is symbolized in the form of a Triton or marine monster, clasping a naked nymph to his breast, who is Venus born from the waters, and these vices and mad affections are moderated by Fortitude and Temperance. Such is the subject that Raphael set forth in this great image, with as many as fifty figures deployed with regularity and rare inventions; whereby through his learned conceptions he depicted the branches of knowledge, and he taught the colors, and in the Gymnasium of the philosophers he left the true school for painters.

Lastly, attention is due to the noble edifice of the Gymnasium, depicted in the form of a most magnificent temple, which preserves a first idea of the Basilica of the Vatican, of which, according to the view, the crossing of the naves appears, the pilasters, and the arches that support the drum, and the curve of the cupola, where in the two pendentives facing out two majestic women are depicted: one with the globe of the earth in her hands, the other with the book of the true doctrine taught in the temple by the Vicar of Christ. But these are partly obscured in this view by the perspective and the edge of the arch.

THE *SCHOOL OF ATHENS*

THE CAMERA DELLA SEGNATURA

It was fortunate for Raphael that when he first arrived in Rome he was not given commissions for subjects of a dramatic nature, but for quiet assemblies of idealized humanity, pictures of calm gatherings well suited to the exercise of inventiveness in simple gesture and sensitivity in grouping, which were precisely his talents.★ Now he could demonstrate on a large scale that sensitive perception of harmonious outline and balance of mass in which he had trained himself in his Madonna compositions, and in the *Disputa* and the *School of Athens* he was to develop the composition in depth and the combination of groups which served as a basis for the later dramatic works.

The modern public finds it difficult to appreciate this artistic content and looks elsewhere for the merit of the pictures, in the expressions of the faces, in the 'literary' relationship between individual figures. Above all, it demands to know what the figures mean and is uneasy if all the figures cannot have names attached to them, listening gratefully to the guide who knows the name of each person represented, convinced that such explanations make the pictures more comprehensible. For the majority of travellers this is enough, though a few conscientious people attempt to project themselves into the emotions expressed by the faces, on which

★ Reprinted from Heinrich Wölfflin, *Die klassische Kunst* (1899), translated by Linda Murray and Peter Murray as *Classic Art* (London: Phaidon, 1948). Several paragraphs have been deleted.

57

their attention is concentrated. Few are able to grasp the action of the figures as wholes, apart from the facial expressions, appreciating the motives of reclining, standing or sitting as beautiful actions in themselves, and fewer still suspect that the real value of these pictures has nothing to do with details, but is to be sought in the general disposition, the articulation of the whole and the rhythm and animation of the treatment of space. They are decorations in the grand style,[1] but decorative in a rather uncommon sense, for I mean paintings in which the chief stress is laid, not on the individual head, or on psychological relationship, but on the disposition of the figures on the plane surface and the relationship between their positions in space. Raphael had a feeling for that which is agreeable to the eye which none of his predecessors possessed.

Historical learning is not essential for the understanding of these frescoes,[2] which deal with familiar subjects, and it is quite wrong to attempt interpretations of the *School of Athens* as an esoteric treatise in historical and philosophical ideas, or of the *Disputa* as a synopsis of church history. When Raphael wanted to make his meaning unmistakable he employed inscriptions, but this happens only rarely and there are even important figures, protagonists of the compositions, for which no explanations are given, since Raphael's own contemporaries did not feel the need for them. The all-important thing was the artistic motive which expressed a physical and spiritual state, and the name of the person was a matter of indifference: no one asked what the figures *meant,* but concentrated on what they *are.* To share this point of view needs a kind of visual sensuality, rare enough nowadays, and it is especially difficult for the Northern races to appreciate fully the value which the Latin races set upon physical presence and deportment. One must not, therefore, lose patience with the Northern traveller if he experiences a disappointment at first when he had expected to find in this place a representation of the most profound spiritual forces: it is perfectly true that Rembrandt would have painted Philosophy quite differently.

Whoever persists in his desire to understand more of these pictures will find no other way to do so than by analysis of the figures one by one, learning them by heart, and then looking at the connection between them, one part presupposing another and making its position inevitable. All this advice is given in the 'Cicerone,' but I do not know how many people follow it, since there is never the

time and it takes a great deal of practice before one achieves anything. Our vision has become so superficial from the mass of day-to-day illustrative painting, aiming only at making an approximate general impression, that, when we come up against such old works as these we have to begin all over again, learning the alphabet.

THE *SCHOOL OF ATHENS*

On the wall opposite Theology we find a representation of Philosophy, secular knowledge, in the picture which is called *The School of Athens,* although the name is almost as arbitrary as that of the *Disputa.* One could, if one wished, rather speak of this as the Disputa since the principal motive is the two leaders of philosophy, Plato and Aristotle, engaged in argument and surrounded by their audience. Nearby is Socrates with his own circle, plying his questions and counting off on his fingers each point as it is made. In the dress of a man above the needs of this world, Diogenes lies on the steps. An elderly man, who may be Pythagoras, writes something down, while a tablet inscribed with the harmonic scale is held out in front of him. The historical content of the picture is completed by the addition of the astronomers Ptolemy and Zoroaster and Euclid the geometer.

The composition presented greater difficulties here than was the case in the *Disputa* because the circle of Christ and the Saints was lacking. Raphael had no other way out of the difficulty than to invoke the aid of architecture, so he constructed an imposing, vaulted hall with four very high steps in front of it, extending across the entire breadth of the picture: in this way, he obtained a double stage – the space below the steps and the platform above them. In contrast to the *Disputa,* where all the parts tend towards the centre, here the whole is broken up into a sum of individual groups, even individual figures – the natural expression of the ramifications of philosophical inquiry. A search for specific historical allusion is as pointless here as in the *Disputa.* The idea that the physical sciences are grouped together in the lower part, leaving the upper space free for the speculative thinkers, is illuminating as an idea: yet, even so, it may well be that this interpretation is beside the mark.

The motives expressing mental states by physical actions are much more varied here than in the *Disputa;* in itself, the subject

demanded greater variety of treatment but it is clear that Raphael himself had developed and become more inventive, for the situations are more sharply characterized, the gestures more telling, and the figures more easily remembered. Raphael's handling of the group of Plato and Aristotle is of primary importance. The theme was an old one and a comparison can well be made with Luca della Robbia's *Philosophers* relief on the Campanile in Florence – two Italians argue with typical Southern vehemence, one insisting on the literal truth of his text, while the other gesticulates with both hands and all ten fingers, insisting that it is nonsense. The bronze doors by Donatello in S. Lorenzo have other examples of disputing figures, yet Raphael had to reject all these prototypes since sixteenth-century taste was in favour of reticence of gesture. The two Princes of Philosophy stand side by side in noble calm; the one with arm outstretched, whose hand, palm down, makes a sweeping gesture over the earth, is Aristotle, the 'constructive' man; the other, Plato, with uplifted finger points heavenwards. We do not know what inspired Raphael to characterise the opposite qualities of the two personalities in this way, which makes them plausible as images of the two philosophers.

Standing at the right-hand edge of the picture is another group of impressive figures. The isolated figure of a man with a white beard, closely wrapped in his mantle and absolutely simple in silhouette, is a noble and tranquil presence. Next to him is another man leaning forward on the base of a pilaster and watching a boy, who is seen from the front, bending forward with his legs crossed as he sits writing: it is by figures like these that we must measure Raphael's progress. The lying motive in the figure of Diogenes is absolutely new – it is the beggar who makes himself comfortable on the steps of a church. The variety and inventiveness go on increasing: the scene of the geometrical demonstration is not only admirably acute in psychological observation, showing the different degrees of understanding in the various students, but the actual physical movements of kneeling and bending are realized in each figure in a way which deserves the closest study and might even be learned by heart.

The group around Pythagoras is still more interesting. A man in profile sits writing on a low seat, with one foot on a stool; and behind him are other figures pressing forward and leaning over

him – a whole garland of curves. A second man also sits writing, but he is seen from the front and his limbs are disposed in a more complex pattern; between these two there is a standing figure supporting an open book against his thigh, apparently citing a passage in it. There is no need to puzzle one's head over the meaning of this figure, for in the intellectual sense of this group he has none, and he exists solely as a physical motive, for formal reasons. The raised foot, the outstretched arm, the twist of the upper part of the body and the contrasting tilt of the head give it a plastic significance of its own, and if the Northern spectator is inclined to think this an artificial reason for so emphatic and elaborate a motive he must be warned not to make over-hasty judgements, for the Italian is so much more given to gesticulation than we are, that for him the limits of the natural are quite different. Here, Raphael is obviously following in Michelangelo's footsteps and under the influence of the more powerful personality he has, for the moment, lost his natural sensibility.[3]

Analysis of the fresco should not stop short at single figures, for Raphael's rendering of movement in individual figures is a lesser achievement than the skill with which he builds up his groups and there is nothing in earlier art which can in any way be compared with this polyphony. The group of the geometers is a solution to a formal problem which few have ever attempted – five figures directed towards a single point, clearly developed in space, pure in outline, and with the greatest variety in attitude. The same may be said of the still more nobly planned group on the opposite side, where the highest art is manifested in the way in which the most varied poses complement one another and the many figures are brought into an inevitable cohesion, uniting like the voices in a chorus, so that the whole appears self-explanatory and logical. If one looks at this group as a whole, one sees the point of the young man who stands right at the back: he has been thought to be the portrait of some prince, which may or may not be the case, but what is certainly true is that he has the formal function of supplying the necessary vertical in the tangle of curves.

As in the *Disputa,* here, too, the greatest variety is displayed in the foreground: at the back, on the platform, there is a forest of verticals; at the front, where the figures are large, the lines are curved and interlace in a complex way. Around the central figures

symmetry reigns, but this is relaxed on one side to allow the upper mass to stream unsymmetrically down the steps and destroy the equilibrium, which is again restored by the asymmetry of the fore-ground groups.

What is certainly extraordinary is that the figures of Plato and Aristotle, standing so far back in the crowd, can still dominate the composition; and it is the more incomprehensible when one takes the scale of proportions into account, for, according to strict reckoning, there is too rapid a diminution towards the back-ground – Diogenes on the steps has, abruptly, quite different pro-portions from those of the neighbouring figures in the fore-ground. The miracle explains itself by the method of disposing the architecture: the disputing philosophers stand exactly in the opening of the last arch, and they would be lost without this halo which is echoed, and powerfully reinforced, by the concentric lines of the nearer arches. I call to mind the use of a similar motive in Leonardo's *Last Supper* – take away the architecture and the whole composition falls to pieces.

Yet here the relationship between the figures and the space they occupy is thought of in an entirely new way – high above the heads of the figures the great vaults recede into the distance and the spectator shares the calm and serene atmosphere of this basilica. Bramante's new St. Peter's was conceived in such a spirit, and, according to Vasari, Bramante should be accounted the author of the architecture in this fresco.

The *Disputa* and the *School of Athens* are best known in Germany from engravings and the powerful spatial impression of the frescoes is reproduced better, even in a superficial engraving, than in any photograph. In the eighteenth century Volpato made a series of seven engravings of the Stanze, which for generations were the souvenirs brought home by visitors to Rome, and even now these plates are not to be despised, though Keller and Jacoby have taken up the task with other eyes and other means. Jos. Keller's *Disputa* of 1841–56 superseded all earlier versions by the size of the plates, and while Volpato sought only to reproduce the general configuration, and in so doing arbitrarily increased the painterly appearance, the German sought a more literal rendering and tried to reproduce with his graver all the characteristics of Raphael. Clear, firm,

strong, in chiaroscuro, but without any feeling for painterly effects, he set his figures on the surface and sought, above all, to be precise in the form, disregarding the colour harmony and, more particularly, the light tonality of the fresco. [Louis] Jacoby began at this point. His *School of Athens* was the result of ten years' work (1872–82) and the layman can have no conception of the critical judgement required to find a corresponding tone on the copper-plate for every colour value of the original, to reproduce the softness of the painting, and to retain spatial clarity within the bright tonal scale of fresco. The engraving appeared as an unequalled achievement. Perhaps, however, his intentions overstepped the limits which in these cases are set upon the graphic arts, and there are still art lovers who, since the reduction of scale is so great, prefer the more summary handling of [Giovanni] Volpato, with his relatively simpler linear means, just because it is thus easier to preserve something of the monumentality of the general impression.

NOTES

1. Böcklin already uses the phrase. In Rudolf Schick's *Journal* (Berlin, 1900) we read (p. 171) that during his second stay in Rome the Stanze (in particular, the Stanza d'Eliodoro) had the greatest influence on him. "It seemed clear to him that it was the decorative grandeur (*Gross-Dekorative*) of the pictures which impressed even the most insensitive and uneducated, and it was this which he sought to emulate in his own subsequent pictures."

2. Cf. the illuminating essay by Wickhoff, *Jahrbuch der preussischen Kunstsammlungen,* 1903.

3. The prototype for this very figure is, however, to be found in Leonardo and not Michelangelo: it is developed from the motive of the *Leda* and a drawing by Raphael after the *Leda* is preserved. The borrowings from Donatello's Paduan reliefs (cf. Vöge, *Raffael und Donatello,* 1896) are confined to such subordinate figures that one may well believe them to have been incorporated into the composition almost as a jest. In any case, one must not consider these borrowings as evidence of poverty of imagination.

THE ARCHITECTURAL BACKGROUND

Of the three major creators of High Renaissance painting in Florence and Rome, Raphael was the great synthesizer. Less idiosyncratic than his older colleagues, he did not look so deeply as Leonardo into the inner workings of his world and its inhabitants, nor did he consider as fully as Michelangelo the human figure as the arena of psychological struggle and yearning, but he surpassed them both in his power to give compelling form to the visionary aspirations of his time. In the ceiling of the Sistine Chapel Michelangelo speaks for himself, and not always accessibly; in the *School of Athens* Raphael speaks for the age in a way we can comprehend instantly. Whatever uncertainty we may encounter regarding the identification of individual characters in the fresco, it is clear from the whole that we are offered a glimpse into a world governed by reason, where civilized inquiry and enlightened discourse take place in a setting of appropriate grandeur and decorum. No painter of the period summarized better the dual character of Renaissance longing for the never-never land of classical antiquity: hunger for the intellectual nourishment of its philosophical life and desire for the spiritual uplift its architecture provides. Despite some anachronisms in the architecture of the *School of Athens,* of which the forms are Roman, not Greek, no painter of any period has ever provided an equally affecting evocation of the Golden Age of classical philosophy or found the means to make concrete a similar sense of the excitement and rewards of thought.

The architectural setting, tightly wed to both the content and the form of the fresco, serves two principal functions. The first is to

provide, by means of its classical style and sculptural decoration, an environment rich in cultural and historical associations consistent with the philosophical activity depicted within it. This is achieved by the evocation of ancient architecture in a grand if imaginary form that would have spoken volumes to the patron, Pope Julius II. Beyond accomplishing this, the background also plays a determining role in the placement of the figures. In fact, from the point of view of the history of Renaissance painting, what is perhaps most interesting about the architecture of the *School of Athens* (Fig. 5) is not its style but the unprecedented degree to which the figures are arranged according to its rhythms.

A careful look at the upper row of figures, with Plato and Aristotle in the center, reveals a pattern of densely packed, then more openly spaced, bodies that corresponds to the elements of the architecture before which they stand. Plato and Aristotle are isolated under the central arch; to either side of them, under the pilasters of the barrel-vaulted "nave," seen in a sharply foreshortened view, are groups of figures tightly pressed together. To either side of these groups, corresponding to the walls parallel to the picture plane – the ones with the niche sculptures of Apollo and Minerva – are placed a few figures separated by much more space. Although the disposition of the figures closely echoes the cadences of the symmetrical architecture, Raphael avoids tedious regularity by subtle asymmetry; on the left, a group of standing figures obscures the corner at the right of Apollo's niche (Fig. 1, nos. 44–7; Fig. 22), while on the right side (Fig. 23), below Minerva, one figure lounges on a cornice (no. 14) while the other leans against the wall and bends to make notes (no. 13), allowing us to see above his head more of the architecture than we see on the left and to know how the pilaster profiles are designed. It is important that although much of the lower part of the building is hidden by figures, we are nonetheless shown enough of the architecture to understand every significant detail.

When Raphael arrived in Rome from Florence in the late summer of 1508, he entered a dramatically different world, and he turned his back on the fifteenth-century Florentine tradition in architecture and painted architectural backgrounds. He seems to have been prepared to undergo this change before he went to Rome; the work he left unfinished at his departure for the papal

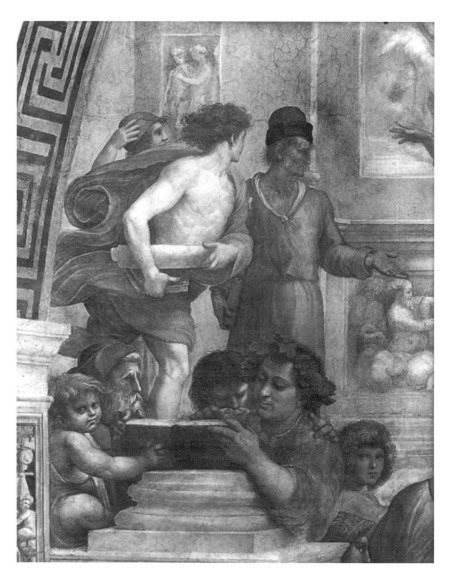

Figure 22. Detail from *The School of Athens:* left edge. Stanza della Segnatura, Vatican Museum. (Photo: Vatican Museums.)

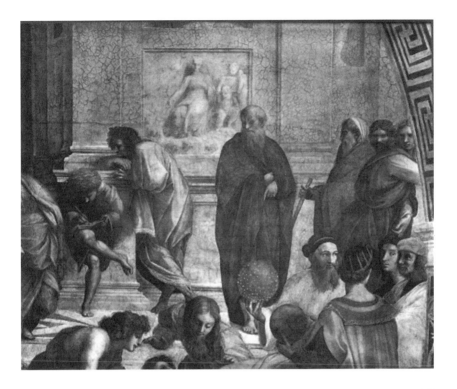

Figure 23. Detail from *The School of Athens:* upper right. Stanza della Segnatura, Vatican Museum. (Photo: Vatican Museums.)

capital, the *Madonna del Baldacchino,* now in the Pitti Palace in Florence, has as its architectural setting a niche framed by thick columns, articulated with pilasters and covered by a semidome with rosette-studded coffers.[1] Compared to the architectural elements in Raphael's earlier works,[2] the niche in the *Madonna del Baldacchino* is massive, but it is still a secondary element in a composition not distinguished by any remarkable relationship between architecture and figures.

Only a few fifteenth-century paintings deserve to be mentioned in comparison with the *School of Athens,* but one of them is certainly Piero della Francesca's Brera altarpiece.[3] Painted around 1470 for the Church of San Bernardino in Urbino, where it was to be seen when Raphael was a boy growing up there, it shows the

seated Virgin with the patron kneeling before her and a row of saints and angels standing behind them. The architectural setting is a handsome classical marble church, with coffered vaults and a large shell set in the shallow half dome of the apse. Although the architecture of the *School of Athens* is much more broadly envisioned and stylistically more advanced, the memory of Piero's interior, with its sumptuous materials, may have served Raphael as an inspiration.

The late Quattrocento painting that offers the most instructive comparison to the *School of Athens* is Leonardo's *Last Supper,* painted only about a decade earlier;[4] even a cursory consideration makes clear how thoroughly Raphael rethought the relationship between figures and architectural background and indicates how dramatically his approach differed from Leonardo's.

In the stunning variety of poses, the subtlety of the grouping, and the breathtaking translation into gesture of an emotional shock wave that spreads out from Christ to the edges of the group and turns back toward the center like ripples from a pebble dropped into a bucket of water, Leonardo's row of figures is much more profound than Raphael's. But except for the centering of Christ in the middle window under a segmental pediment that vaguely suggests a halo, there is no attempt to relate the figures to the rhythms of the flat, setlike architecture that reflects the plain monastic dining hall of which the painting is an illusionistic extension. In fact, it is in this contrast with the regular, even boring and predictable cadences of the interior walls that Leonardo's variously energized Apostles reveal their painter's genius at choreographing highly animated figures.

Raphael, on the other hand, began with an architectural vision and gave it an active role in the scene by filling it with figures whose placement makes the painting one of the best arguments ever offered for reviving classical architecture in the first place: that noble settings literally and figuratively shape the lives of people who inhabit them and inspire them to lofty thoughts. If Leonardo considered more reflectively than Raphael a complex emotional situation, in his turn Raphael looked more thoughtfully at the relationship between setting and action and created a design made coherent by the rhythmic resonances between the philosophers and the architectural forms of the school in which they study.

To understand the complex heritage of the *School of Athens* and

appreciate the degree to which Raphael's treatment was a revolutionary advance, it is helpful to consider for a moment the nature of background architecture in earlier Italian painting.

By the time Raphael began work on the fresco, there was a tradition more than two hundred years long of including what might be called "relevant" architecture in the background of pictures. Painted buildings were not usually exact portraits of real architecture, but, as far back as the time of Ambrogio Lorenzetti (1319–47), identifiable buildings were sometimes included in paintings to establish the action as taking place in a specific locale.[5] Now and then a building still in an early stage of construction appeared in a painting as if already built; in 1350, the Cathedral of Florence was still without its drum and dome, but in the frescoes in the Spanish Chapel at Santa Maria Novella in Florence it is shown complete, in a projected form that was later abandoned.[6]

Architecture is the most expensive form of expression, whereas painting is one of the cheapest. Buildings that were either too fanciful, extravagant, or structurally questionable to be built in three dimensions could be created easily in painted backgrounds. In the course of the fifteenth century, as the techniques of perspective representation became increasingly widespread, we find more extended architectural visions in the backgrounds of narrative painting than had been common before, and the illusion that one was looking at real buildings could be quite striking; whole townscapes, elegant *piazze,* grand harbors, and antique monuments were designed by painters such as Fra Angelico, Vittore Carpaccio, and Andrea Mantegna, to name but three of many.[7]

In the last third of the fifteenth century, painted buildings were only rarely portraits of specific works of architecture. When Luciano Laurana aimed at creating believable if idealized city scenes, the buildings in his paintings were usually imaginary generic versions of temples, palaces, and triumphal arches.[8] When the intention was to be more fanciful, as in the case of Filippino Lippi's scenes from the life of Saint Philip in the Strozzi Chapel in Santa Maria Novella in Florence, the painted architecture was a perspectively precise representation of architectural forms that never had existed and never would exist.[9] What makes the topic interesting is that because it is much more economical, to say nothing of much faster, to experiment in paint than in stone, now

and then painters' fantasies anticipated, perhaps even inspired, the imaginations of architects of the next generation.[10] The exploration of bizarre forms in architecture began in painting, where the consequences of failure were insignificant. There was nothing in real architectural decoration like the details of Filippino Lippi's Santa Maria Novella frescoes of the mid-1490s until Michelangelo's Medici Chapel and library at San Lorenzo, begun about twenty-five years later.

It is often difficult to know exactly what we are looking at in the painted architectural backgrounds of the late fifteenth and early sixteenth centuries; scenes are frequently regarded as reflecting the thoughts of contemporary architects about ideal cities, an area in which flights of fancy were positive virtues. Architects of the Renaissance devoted a great deal of attention to the design of whole cities, but little except the work of painters is available to show us how these brave new urban worlds might have looked. It is fair to assume that paintings offer clues to the appearance of unrealized architectural visions, because, beginning with Giotto in the fourteenth century, many people, including Raphael himself, came to the practice of architecture from training as painters and knew how to present fictitious buildings before they had had the chance to build real ones.

There is another realm in which painting and visionary architectural fantasies meet: stage design. We do not know as much as we would like to know about theatrical productions in the High Renaissance, but there was a good antique pedigree for the use of city scenes and ideal architecture on the stage, and late fifteenth- and early sixteenth-century street and piazza backgrounds have been regarded, often on intuition more than any firm evidence, as reflecting stage sets.[11]

It is therefore not surprising, given the size and grandeur of the architecture in the background of the *School of Athens,* that it has been variously described as the reflection of a specific architectural project; as a generic evocation of the architecture of the ancient world, based on things that Raphael knew in Rome; as part of an ideal city; and as a stage set. Its form may well bear the influence of all of these at once, and the following consideration of the painting will touch on each in turn.

It was first suggested more than four hundred years ago that

there was a connection between Donato Bramante's ideas for the new Church of Saint Peter being built for Pope Julius II in the Vatican in 1506 and the architecture of Raphael's fresco being painted at the same time, for the same patron, in the Vatican Palace a few yards away. In his Life of Bramante (but not, interestingly enough, in his Life of Raphael), Vasari says that Bramante drew the architectural background of the *School of Athens*.[12] At Bramante's death in 1514 Raphael succeeded him as architect of Saint Peter's, which implies that his involvement, or at least his familiarity, with the design of the building began before that time. Furthermore, still according to Vasari, Raphael and Bramante were kinsmen, both from Urbino, and it was Bramante, the pope's favorite architect, who introduced Raphael at the papal court.[13]

In both Saint Peter's Basilica and the painting, large, coffered barrel vaults extend from under a drum carried on pendentives with roundels in them.[14] In the layered forms of its walls, its carefully contrived implication of vastness, and the clear sense it conveys that the only suitable architectural vocabulary for the expression of splendor and seriousness is that of imperial Rome, the setting has elements in common with Saint Peter's. These similarities, combined with Vasari's claims, have led to the assumption that we see in the painting "a grand space reflecting Bramante's intentions for Saint Peter's,"[15] but careful scrutiny of this easy conclusion raises many doubts about it.

Vasari's attribution to Bramante of the architectural background of the *School of Athens* seems to be based more on the vague analogy between church and painting than on any real knowledge that Bramante helped Raphael with the fresco. It was perfectly in character for Vasari to suggest that Bramante was the designer of the painted architecture, for one of Vasari's dreams was of a kind of community of artists who worked together on large projects, and he consistently told the history of Italian art as though such a community had long existed. The *School of Athens* was not the first painting whose architectural background Vasari attributed to an architect friend of a painter rather than to the painter himself.[16] Furthermore, Vasari's claim that Bramante and Raphael were kinsmen is exactly the sort of thing he often made up.[17]

Before we consider who is responsible for the architecture in the painting, however, we must decide if the setting reflects serious

thought about a real building or if it is just a painter's fantasy, in which architectural forms serve primarily pictorial functions.

It is difficult to determine what kind of building we see in the fresco and what all of its features might be. Although it is clear that we are looking into a structure in which two coffered barrel vaults that extend into the distance are separated by a drum on pendentives, we do not know if another pair of barrel vaults, at right angles to the two we see, intersects them at a crossing. Nor is it clear if we are to assume a dome over the crossing or just an open drum pierced with columned windows. Judging from the light-drenched crossing we see in the fresco, a dome seems unlikely, and if there were to be no dome, windows in the drum would be unnecessary. But the drum window is critical to the design of the painting, establishing the handsome alternation of shadowed masonry and cloud-flecked blue sky that extends from top center down to the central figures in the scene. So the drum window is there because it is required by the logic of the pictorial composition, not by the building represented.

Similarly, the distribution of elements on what we might call the facade of the building, with blocklike projections on either side of the opening into the barrel-vaulted nave, is somewhat odd if we take it literally as a picture of architecture, but it is very effective within the painting. The elements of the building that we see were carefully accommodated to the shape of the available space; to a considerable extent they were designed to be cut off by the semicircular frame, and they are placed within it with impressive conviction. In our vignetted view of the facade we see only as much as is necessary to understand that the forms build up from the single-story blocks to the higher wall with the opening of the barrel vault; the setback of the outermost walls, visible at the edges of the painting, provides interesting variety and implies a shape without the necessity of being specific. The elements of the imaginary building would likely have been different if Raphael had not had a semicircular space to fill. There would have been the same axial view down the central barrel vault, which was firmly established in the tradition of perspective painting, but the forms to either side of it would probably be less effective if we saw more of them in a fully rectangular frame.

The nave of the painted architecture is particularly close in

character to the coffered transverse barrel vaults at the Basilica of Maxentius in Rome, and although the pattern of the coffers is different (in alternating rows of hexagons and squares in the fresco but of octagons and squares in the Basilica of Maxentius),[18] it seems virtually certain that Raphael was thinking of the great early-fourth-century basilica when he painted the *School of Athens*. In the fresco there are coffered vaults that lead to an area open to the sky, and in Raphael's day, as in ours, the ruined Basilica of Maxentius is the building in Rome that is closest in this regard to what we see in the painting.

The "triumphal" arch in the distance may or may not be connected to the rest of the architecture; it does not matter which, for its primary role is nonarchitectural; it serves to extend the sequence of barrel vaults and sky. With the view to the horizon almost completely closed by figures, the vaults also serve in place of a tiled pavement as the primary perspective coordinates of the space.

The transverse foreground space beyond the large arch that frames the painting is, to judge again by the bright light that fills it, open to the sky, but the light is inconsistent;[19] it seems fair to conclude that Raphael was more concerned to show the architectural and sculptural elements of the middle-ground space in bright, revealing light than with the creation of coherent illumination.

The most problematic part of the painted building, and the most compelling evidence that Bramante had no role in its design, is the intersection of the barrel vaults with the drum, for the curve of the cornice above the pendentives is not reflected in the cornices below them. It is not just that the architecture of the fresco is unbuildable that argues against the involvement of Bramante,[20] but the fact that he spent more time working on the crossing piers of Saint Peter's than he did on any other part of his design,[21] and it does not seem likely that at this stage of his life, had he drawn the architecture of the fresco after pondering church crossings for several years, he would have designed so unconvincing and irrational a passage as the one we now see.

Although the setting of the painting is decidedly grand in character, compared to Saint Peter's it is relatively small and intimate in proportion to the human figures in it, and its sculptures are by no means heroic in scale. The top of the near barrel vault works out to be only about four times the height of Aristotle (Fig. 1, no. 2), and

the figure of Minerva is only slightly taller than the isolated figure who stands below her and in virtually the same plane (no. 15; Fig. 23).[22] The elevation, though rich, is not at all overpowering; it is the long view down the central tunnel that suggests great size. In creating the impression that we are looking into a building huge in all directions Raphael skillfully manipulates our perceptions, and we extend to the vertical dimension something of the great horizontal depth of the nave. He also makes deliberate use of our association of ancient architectural forms with large size, so that we leave the experience of the *School of Athens* with the recollection that a vast building totally dwarfs the people in it.

The arrangement of the "nave" wall is more complex than it first appears and does not fit into the context of church design of the first decade of the sixteenth century; it reflects design features of church facades rather than those of church interiors, both in its rhythms and in the importance given to figure sculpture.

The two projecting blocks with the statues of Apollo and Minerva have single pilasters at their corners. Under the barrel vaults the wall is divided by doubled pilasters, a feature that neatly distinguishes the nave walls from the sides of the adjacent blocks. In the sharp angle at which we see the nave walls, and because we can see virtually nothing above the projecting blocks, we read the elevation as composed of a unit of three bays, framed with doubled pilasters, that breaks forward from the plane of a bay framed by single pilasters. This kind of projection was to become increasingly common in the following one hundred years, on both palace and church exteriors, but it never had much place in interiors, especially in churches, where long walls that project in the center would have had the effect of choking the space in an awkward way. When Raphael painted the fresco, the arrangement was still uncommon in facade designs as well, and nowhere were there any vaulted spaces that were treated in this way.

In the early sixteenth century great concern was shown by architects and antiquarians for the correct use of the classical orders, and the building in the *School of Athens* clearly reveals Raphael's awareness of the varied possibilities offered by the Doric order as it appeared on buildings in Rome. The pilaster capitals are simple, composed mostly of straight mouldings. The frieze above them does not show the usual Doric alternation of triglyphs and metopes

found on most examples in Rome, but on the Colosseum the Doric frieze is similarly blank.[23] When Raphael later employed the Roman Doric in his buildings, he gave it its complete form. Although the rather severe architectural vocabulary in the fresco may have resulted from a desire to keep forms that would be seen in a sharply foreshortened view as simple as possible – a pictorial shorthand sanctioned by ancient example – at the same time Raphael was making it clear to knowledgeable viewers that the building is antique in its details.

The ground plan of the frescoed architecture cannot be determined in its entirety: too much is hidden from view and unknowable. Nonetheless we understand enough to be sure that the arrangement of the schoolhouse of Athens is unlike any real building known in either constructed form or from an architect's drawing and to be confident that we cannot take it literally.[24] This is not to suggest, however, that as painted architecture the building is not intelligent and effective or intended to evoke something to which Raphael had devoted a great deal of thought.

In analyzing the architecture of the *School of Athens* it is important to consider the subject of the painting. The "school" of Athens was Plato's Academy. Raphael's contemporaries seem to have understood that this most famous of ancient intellectual centers was outside in a grove, not in a building, but a grove would not have been nearly as suggestive as a great vaulted interior, which evoked classical antiquity for Raphael's generation as nothing else could. So the painter granted himself the poetic license to stage the scene in an architectural setting.

From classical authors Raphael and his contemporaries knew something of how Roman baths and basilicae were used in antiquity. Often decorated with statuary, they functioned in part as meeting places where men could discuss business or philosophical issues in indoor/outdoor settings quite like what we see in the fresco, and, in its sequence of related but changing forms, the architecture of the painting resembles such Roman buildings.[25] Given this, it seems best to understand the architecture of the fresco as the reconstruction of a Roman building, and if it looks vaguely like a High Renaissance church, that is because the designs of such churches were derived from the same architectural sources as the fresco. In Raphael's representation the building still retains some of the ap-

pealing, light-drenched quality of those ancient ruins and provides both the interior/exterior setting of a Roman bath and the open air of Plato's Academy, without the trees. The placing of Greek philosophers in a Roman context reveals the tendency in the later fifteenth and sixteenth centuries, when Roman sculpture was often mistaken for Greek, to fuse the two antique cultures and to accept as appropriate for a Greek scene what was in fact Roman.

We have observed that stage sets are sometimes cited as possible sources for architecture depicted in Renaissance paintings. An objection to seeing the *School of Athens* as based on a scene design is that stage sets generally showed city spaces, not the interior of a single large building, but in the fresco the architecture is not convincing as a real building, and with its deep central perspective funnel and openings to wings at each side it looks very much like a stage. It would be easy to imagine the action on a shallow stage, with all of the architecture and sculpture from the plane of Apollo and Minerva back to the horizon painted on a flat screen or built in forced perspective to suggest great depth, an illusion dear to the designers of early sixteenth-century stages such as Sebastiano Serlio. The conception of the painting is clearly theatrical, with the architecture as a stage set for a philosophical dialogue. Furthermore, the figures in the painting are arranged as they might be in a theater stage; they keep to the front, and none appears in the depths of the architecture. The theatrical aspects of the Platonic dialogues – one could stage any of them – might also have suggested such a treatment. This is not to suggest that a stage design was the specific source for the *School of Athens,* only that Raphael's theatrical approach to his subject resulted in an arrangement that resembles a set.

What, then, are we to make of the setting of the *School of Athens,* with its many possible sources and loose analogy to the design of Saint Peter's? Is the slightly Bramantesque character of the frescoed building to be attributed, as it was by Vasari, to the determining hand of the favorite architect of Julius II? At Saint Peter's Bramante responded to the grandeur of Roman architecture (primarily the Pantheon, the Basilica of Maxentius, and the baths) to create the great locus of papal imperialism. He is supposed to have said that at the Vatican he wanted to put the Pantheon on top of the "Temple of Peace," his term for the Basilica of Maxentius.[26] It seems most

likely that Raphael's response to the same forms resulted in the
"Bramantesque" flavor of the architecture of the *School of Athens*.
Because the architecture of Saint Peter's is in a grandiose Roman
revival style, there is a tendency, which goes back to Vasari, to
attribute to Bramante's influence whatever else looks Roman, but
in the case of Raphael, despite his subsequent connections with
Saint Peter's, this is unjustified. The misleading similarity between
Bramante's church and Raphael's painted architecture reflects the
artists' attention to Roman ruins, as well as the common patronage
of Julius II. Both works were parts of a papal rebuilding program of
imperial scope, and in both the Julian sense of heroic scale and
classical gravity are to be observed. Given these facts, a general
similarity was virtually inevitable.

The *School of Athens* was one of the first works that Raphael did
in Rome. In the course of the following eleven years until his
death he was to assume several important roles that brought him
into increasing contact with ancient architecture, which he studied
with care. He was appointed "prefect of Roman antiquities" in
1515, which sounds as though his job involved their protection,
but in fact the office he held was concerned with the location and
removal of ancient works that could be appropriately reused in the
construction of Saint Peter's.[27] In the last years of his life Raphael
was working on a description and graphic reconstruction of ancient
Rome that he left unfinished at his death in 1520.[28] It is not entirely
clear what it was to have been, but there seems little doubt that
toward the end of the second decade of the Cinquecento he was
one of the men most interested in and knowledgeable about the
antiquities of Rome. Raphael's approach was not that of the system-
atic and studious humanist but of a painter and, by then, a busy
architect. He was not a classical scholar; he could read Vitruvius's
On Architecture only in an Italian translation made for him from the
original Latin by Fabio Calvo. But when Raphael began the *School
of Athens,* all of this activity lay nearly ten years in the future, and
although it is tempting to think of the fresco against the back-
ground of events and projects that were to follow, it is misleading
to do so. Raphael did not begin his brief but productive career as
an architect until after the fresco was finished. It is not unreasonable
to expect that we would find in his later buildings architectural
forms that draw on the ideas suggested in the fresco, but beyond

some generic similarities there is in fact little connection. It would seem that in the *School of Athens* Raphael was concerned primarily with the pictorial effects of his architectural setting and that when he began later to build real buildings in three dimensions he was concerned with different things. Yet the spirit of grandeur and classical gravity that we see in the fresco is found in Raphael's built work, and his commitment to the principles of antique architecture was unswerving from the time he painted his great imaginary building.

In the niches facing us in the fresco are the only two unmistakably identifiable sculptures. Apollo (Fig. 13) and Minerva (Fig. 14) – , or Athena, to give her her Greek name, more appropriate to the *School of Athens* – are the Olympian deities most closely associated with poetry and music, on the one hand, and wisdom, on the other; they stand, male and female, for all the powers of the mind and the creative spirit and appropriately preside over the gathering of philosophers. More than any other aspect of the fresco, it is this that makes it clear we are in a pagan building and not a church.

It is worth considering the relationship between the *School of Athens* and the *Disputa* (Fig. 4), the fresco by Raphael directly opposite it in the Stanza della Segnatura. There is no visible architecture in the *Disputa;* the figures themselves form a structure or reflect the shapes of an invisible architecture. The hemispherical arrangement of figures suggests an apse, as the view down the barrel vault of the *School of Athens* suggests a nave. In the earthbound architecture of the nave are the Greek philosophers; in the invisible, otherworldly architecture of the apse are saints and the Fathers of the Church. The division of the realm of Christian thinkers from that of the pagan ones is an idea that goes back to Dante; in Canto IV of the *Inferno* we find even the greatest of ancient philosophers and authors in Limbo, because they were born before the advent of Christ. In the Stanza della Segnatura the Greek philosophers are allowed to see into the apse, but they do not enter it, just as in a church the distinction is made between celebrants in the apse and the nonordained, who watch from the nave.

Raphael was not a sculptor, yet the most unusual aspect of the *School of Athens* setting is the dense crowd of statuary; every bay visible contains a niche with a sculpted figure. In the rich use of sculpture the building in the fresco is quite unlike Saint Peter's,

for there is no comparably large program of statuary in any of Bramante's Vatican church projects; what we see is less a church of the period than a Renaissance vision of an ancient basilica filled with sculptures.

The great importance given to figure sculpture in the setting of the *School of Athens* is particularly striking in view of the fact that at this stage of his career Raphael had shown little or no interest in statues.[29] In the fresco fourteen slightly greater than life-size figure sculptures are indicated, although only the figures of Apollo and Minerva reveal enough of themselves to allow analysis; the rest are either cut off by the framing arch around the fresco or seen at such a sharp angle as to be almost entirely hidden. This concentration of sculpture is, in its density, well beyond anything Raphael had ever represented before, in fact beyond anything that had ever been executed in stone, and it is appropriate to wonder where he got his ideas about the use of figure sculpture in architecture.

The definitive analysis of early sixteenth-century notions about the integration of figure sculpture and architectural settings remains to be written, but when it is, Michelangelo's designs for the tomb of Pope Julius II will surely be the source for many of them. Commissioned in 1505, the tomb was to have had dozens of figures, life-size and larger, as well as relief panels, set in an architectural system of niches framed by pilasters.[30] By the time Raphael was painting the *School of Athens,* work on Julius's tomb had been suspended, and Michelangelo was busy on the Sistine Chapel ceiling instead, but the huge Julian project was never far from Michelangelo's mind; in fact he rethought poses and gestures first conceived for sculpted figures on the tomb and used them for the frescoes.

The Julius tomb and the Santa Casa at Loreto, on which Bramante worked a few years later,[31] were essentially blocks decorated on their exteriors, and the projections we see on either side of the main barrel vault in the *School of Athens* resemble them in a general way, but the extensive sculptural decoration of the nave interior that we see in the fresco seems to be unprecedented for 1509.

Of the sculptures represented in the *School of Athens* the most interesting is that of Apollo (Fig. 13), which is a very thoughtful study in sculptural statics. In a contrapposto figure the hip over the supporting leg is always higher than the hip over the bent leg. In

the figure of Apollo this effect is carried to the upper part of the body as well; the shoulder above the arm that leans on the supporting tree trunk is higher than the shoulder over the unsupported bent arm that holds the lyre. It is not inconceivable that a painter could have devised this figure on his own, but Apollo's soft, handsome body and his languid pose, in exaggerated, twisted contrapposto with one foot raised on a block, almost certainly has it origin in Michelangelo. Frederick Hartt suggested that Raphael's figure is evidence that he had seen drawings for Julius's tomb,[32] although the source might also have been figures in the background of the Doni Tondo or from the Sistine ceiling. But if the form of Apollo and the scheme of placing a highly torqued figure in an architectural setting were inspired by Michelangelo, Raphael has, as always, carried a borrowed idea to a new height. The figure of Minerva (Fig. 14), more difficult to see in the fresco but obviously less striking in terms of her pose, may also derive from Michelangelo's ideas for the Julius tomb, where clothed female figures were to have stood in niches.[33] The difference between the figures of Apollo and Minerva may be evidence that Michelangelo was the source for them, for at this stage of his career Michelangelo's male figures were almost always more interesting than his females. Raphael's painted sculptures show a parallel difference.[34]

In the integration of the interior architecture and sculpture of the *School of Athens,* Raphael appears to have been ahead of everyone. Not yet a practicing architect – and never a sculptor – he had no axes to grind and no limiting loyalties to one medium or the other. As a result he was able to achieve a graceful balance between the figures and their setting that was beyond even Michelangelo, in whose work sculptural ideas tended to be dominant. There was no contemporary "source" for Raphael's arrangement, in the traditional sense; he seems simply to have invented, or reinvented, this astonishingly effective classical design by very thoughtful consideration of all the things he had seen. The imaginative leap he made in the background of the *School of Athens* is every bit as revolutionary as the one he made in the figures in the foreground.

The painted setting of the *School of Athens* is a more evocative image of an ancient ensemble of architecture and sculpture than

any that had ever been created before. If the ideas about sculpture in architecture are based on Michelangelo, and the architectural forms derive from ancient sources on which Bramante also drew, the *School of Athens* is nonetheless quintessential Raphael. It was characteristic of him to synthesize from the varied forms around him a more coherent vision than either of his two great colleagues in Rome had achieved.

NOTES

1. For an illustration, see Jones and Penny, 1983, pl. 56.
2. See Jones and Penny, 1983, pl. 25.
3. See Hartt, 1987, fig. 287.
4. See Hartt, 1987, pl. 67.
5. Ambrogio Lorenzetti's *Allegory of Good Government in the City,* in the Palazzo Pubblico in Siena, is unambiguously a picture of that town; the cathedral is represented accurately enough for there to be no mistaking it. See George Rowley, *Ambrogio Lorenzetti* (Princeton: Princeton University Press, 1958), vol. 1, p. 112, and vol. 2, figs. 157 and 200.
6. See Hartt, 1987, pl. 18.
7. See Hartt, 1987: for Fra Angelico, pl. 27; for Carpaccio, fig. 428; for Mantegna, fig. 398.
8. For the Laurana panels, see Millon and Lampugnani, 1994, 234–5, 238–9, 242–3.
9. See Hartt, 1987, fig. 358.
10. Among the well-known examples of the pictorial anticipation of architectural designs are the palace facades with applied pilaster orders in Masaccio's fresco *The Raising of Theophilus* in the Brancacci Chapel in Santa Maria del Carmine, Florence. Painted in the mid-1420s, they were not equaled in built architecture for thirty years or more. See Millon and Lampugnani, 1994, 247.
11. For many years, two panels, one in Baltimore and one in Urbino (variously attributed to Luciano Laurana, to Piero della Francesca, and to anonymous painters) were thought to represent *piazze* in ideal cities. In 1948 Richard Krautheimer suggested that they were in fact sets for comedy and tragedy, arguing that the elements in the architecture correspond to the descriptions in Vitruvius's *Ten Books on Architecture* of the buildings appropriate for comic and tragic scenes. "The Tragic and Comic Scenes of the Renaissance: The Baltimore and Urbino Panels," *Gazette des Beaux-Arts,* ser. 6, 33, 327–46. The idea never met with much acceptance in the literature of the Renaissance theater, and later its author largely abandoned it. Richard

Krautheimer, "The Panels in Urbino, Baltimore and Berlin Reconsidered," in Millon and Lampugnani, 1994, 233–57.

12. Vasari, 1568, 2:187. This passage is not quite so clear as it seems at first, for Vasari concludes the passage quoted by saying that the buildings that Bramante helped Raphael paint in the Stanza della Segnatura are in the scene representing Mount Parnassus, in which Raphael showed Bramante measuring with a sextant. That is wrong; there is no architecture in *Parnassus* at all, nor is there any in the other scenes in this room, except in the *School of Athens,* and so that is what Vasari must have meant, especially as it contains a figure drawing with a compass. If, however, Vasari was so obviously mistaken about the scene in which the architecture appeared, might he not also have been wrong about the whole idea that Bramante helped Raphael? From Vasari's claim that Raphael taught Fra Bartolommeo perspective (1568, Life of Fra Bartolommeo, 2:194) before he left Florence, it is clear that Bramante's help with the *School of Athens* would have been limited to the design of the architecture and would not have been required for rendering it in convincing perspective.

13. In the Life of Bramante we read that it was he who "brought Raphael to Rome" (Vasari, 1568, 2:189). In the Life of Raphael (2:226), Vasari says just that Bramante told Raphael he had got the pope to agree to have some rooms in the Vatican painted and that Raphael "might have a chance of showing his powers there."

14. For Bramante's interior designs for Saint Peter's, see Bruschi, 1977, 156, fig. 160.

15. Creighton Gilbert, *History of Renaissance Art throughout Europe* (New York: Abrams, 1973), 163. Other authors have made the same point: Hartt, 1987, 510.

16. Vasari says, for instance, that Brunelleschi taught perspective to Masaccio, who utilized the lessons to great advantage in his paintings (by which Vasari must mean, first and foremost, the *Trinity*). Vasari, 1568, Life of Brunelleschi, 1:272.

17. See Paul Barolsky, *Giotto's Father and the Family of Vasari's "Lives"* (University Park: Pennsylvania State University Press, 1992), for an extended discussion of Vasari's frequent invention of such relationships.

18. See Axel Boëthius and J. B. Ward-Perkins, *Etruscan and Roman Architecture* (Baltimore: Penguin, 1970), 506, fig. 192 and pl. 256.

19. Apollo and Minerva are sunlit, as are the first two niches on the left wall of the nearer barrel vault, whereas the last two niches on that wall and all of those on the right wall are in shadow. This indicates that the light is coming from a point high above and behind the viewer's right shoulder, but many of the shadows cast by the figures extend toward the viewer, suggesting a different solar angle.

20. Jones and Penny, 1983, 210.

21. See Bruschi, 1977, 145–62.

22. This sort of analysis must be done with caution, for the figures in the fresco are not all in the same scale, and their placement in the scene is not entirely consistent; Plato and Aristotle seem smaller than the figures under the Minerva niche, although the latter seem to be in a slightly more distant plane. Nonetheless, a rough idea of the relative size of the building can be established, and it is not on the huge scale of the Vatican basilica.

23. See Boëthius and Ward-Perkins, 1970 (as in n. 18 of this chapter), pls. 105 and 122.

24. There have been a number of attempts in the twentieth century to make a believable graphic reconstruction of the building on the basis of what we can see of it. The most recent and extended are to be found in Emma Mandelli, "La realtà della architettura 'picta' negli affreschi delle Stanze Vaticane," in Gianfranco Spagnesi, Mario Fondelli, and Emma Mandelli, eds., *Raffaello, l'architettura "picta." Percezione e realtà* (Rome: Monografica Editrice, 1984), 155–79.

25. See Boëthius and Ward-Perkins, 1970 (as in n. 18 of this chapter), 272, fig. 104.

26. Although this remark is often cited in reference to Bramante's aspirations at Saint Peter's, nobody seems to know who said he made it. See Jones and Penny, 1983, 210, n. 17.

27. Ferdinando Castagnoli, "Raphael and Ancient Rome," in Mario Salmi, ed., *The Complete Work of Raphael* (New York: Reynal, 1969), 569 (from Italian original).

28. Castagnoli, "Raphael and Ancient Rome," 570–4. The project is somewhat ambiguously described in a famous letter written to Pope Leo X, apparently around 1519–20. The letter is now attributed jointly to Raphael and his friend the humanist Baldassare Castiglione, who appears to have written the introduction. See Christof Thoenes, "La 'Lettera' a Leone X," *Raffaello a Roma* (Rome: Edizioni dell'Elefante, 1986), 373–81.

29. Except for a few unimportant examples, painted sculpture appears in Raphael's work only after he got to Rome in 1509, and always in a context that suggests antiquity. The sculpture is never related to narrative but "ornamental, and perfectly comparable to other architectonic embellishments" such as capitals and cornices. Kathleen Weil-Garris Brandt, "Raffaello e la scultura del Cinquecento," in *Raffaello in Vaticano* (Milan: Electa, 1984), 221–33.

30. De Tolnay, 1954.

31. Kathleen Weil-Garris, *The Santa Casa di Loreto: Problems in Cinquecento Sculpture*, 2 vols., Ph.D. diss., Harvard University, 1965 (New York: Garland, 1977).

32. Hartt, 1987, 511: "The head, torso and legs of the Apollo . . . are so obviously based on the *Dying Slave* that Raphael must have been able to draw at least from Michelangelo's model." It is known that Michelangelo resented Raphael and accused the younger artist of stealing ideas from him. Howard Hibbard, *Michelangelo* (New York: Harper & Row, 1975), 144. It should be pointed out that there are Roman gems and seals that show Apollo holding his lyre in a pose that bears some similarity to the one Raphael used. See Giovanni Becatti, "Raphael and Antiquity," in Mario Salmi, ed., *Complete Work*, 517, fig. 45. It seems improbable, however, that a painter would have made the leap from a tiny gem to a complex niche sculpture. It is more likely that Raphael drew on the work of a sculptor, who would almost certainly have been Michelangelo.

33. De Tolnay, 1954, pls. 96 and 97.

34. The only marble sculptures connected with Raphael, those of Jonah and Elijah in the Chigi Chapel in the Church of Santa Maria del Popolo in Rome, were carved by Lorenzetto. They do not tell us as much as we would like to know. As is frequently pointed out, Lorenzetto is a shadowy figure whose style is too insufficiently known for us to say to what extent he may have been expressing his own ideas rather than Raphael's. Nonetheless, in the frontal view of the Jonah (see *Complete Work*, 422, fig. 31, and 423, fig. 32) we find something fairly close to the conception of Apollo in the fresco.

COLOR AND CHIAROSCURO

Color and chiaroscuro play a major role in creating the qualities of the *School of Athens* that Heinrich Wölfflin characterized in *Classic Art* (*Die klassische Kunst,* 1899).* Color enhances the illusion of space and is paramount in fixing figures comfortably within that space. Desaturated colors contribute to qualities of repose and unity, whereas varied color arrangements work together with varied poses to separate figures or to link them together, creating complexity and lucidity. Yet Wölfflin himself does not discuss coloring and chiaroscuro, both of which play a minor role in his concept of "classic" art.

Coloring has traditionally been a peripheral topic in much of modern art history of the Renaissance. During the Renaissance itself, color had a low status in art theory and criticism, because it was associated with the mechanical, craft aspects of painting, rather than the intellectual component, and was considered a feminine aspect which appealed to transient, sensuous, and even frivolous aspects of painting.[1] In more recent times color has been considered a fugitive quality, because colors change with age, and subjective, because each of us "sees" colors differently; hence, the analysis of coloring was judged beyond the reach of "scientific" methods in art history.[2] Today we recognize that the notion of scientific accu-

* This essay was written during a stay in Rome funded by an NEH grant for a Summer Seminar (1992) directed by Marcia Hall. I have benefited from her mentorship and from the many comments of her students at Temple University which she graciously shared with me. I also thank Kathleen Weil-Garris Brandt, Claire Farago, and Martin Kemp for their helpful comments.

racy and perfect objectivity in historical discourse is an unrealizable ideal and that history is a construction of the modern historian who selects and focuses upon bits of data and impressions to construct an image of the past. This revisionist view allows us to challenge the second-class status of the concept of coloring by countering that it is no more imprecise or subjective than other concepts used in analyzing painting or in art history. Rather, our difficulty in speaking about it results from its "visualness" and from the meager literary vocabulary for color as compared to the wealth of words and phrases for expression and invention.

It is best at the outset to define terms and use them carefully. "Coloring" is a broad term for the practice of using color and thus includes the handling of paint and finish and the modulation of colors with light and dark, which we call "chiaroscuro." "Hue" refers to the colors of the spectrum (red, blue, green, etc.); "value" refers to the lightness or darkness of colors; "saturation" refers to their vividness or intensity. "Tone" is used as a general designation for colors tempered by mixture with white, black, or gray, whereas "tint" describes colors lightened by mixing with white, and "shade" describes darkened colors.

Throughout the sixteenth century and in the early seventeenth century, Raphael's coloring was not judged negatively but was regarded as an important model of naturalism and of decorum. Even critics who considered him to have been superseded by more recent artists regarded his coloring as innovative and historically important. These aspects of Raphael's painting were largely ignored in the late seventeenth, eighteenth, and nineteenth centuries, with their enthusiasm for Raphael's invention and portrayal of ideal beauty, and they were also overlooked by early formalist critics such as Wölfflin. Modern scholars have begun to reverse these patterns by building upon color science and psychology, as well as the theory developed by modern painters.[3] We can also enlarge our understanding of color and chiaroscuro by studying the critical discourse of that past, so that our analyses will be grounded in the fabric of cultural history.

This chapter consists of two parts. In the first part, I look at the critical reception of Raphael's coloring in the sixteenth and seventeenth centuries and show how the concepts of these early sources relate to modern discourse. In the second part, I undertake an analysis of the coloring of the *School of Athens,* focusing

upon six aspects of coloring that critics at different times in the past have considered essential ingredients of perfect coloring. These aspects are (1) variety in color arrangement, (2) *unione* of the whole, (3) *unione* and *dolcezza,* (4) relief, (5) the massing of light and shadow, and (6) chiaroscuro in perspective. Raphael's *School of Athens* is shown to occupy an important historical position, both as the culmination of Quattrocento traditions and as a model for new traditions. I trace the outlines of this development up to the early seventeenth century, when Raphael was held up as a model of naturalistic coloring. He was seen as an alternative to the dramatic and expressive coloring of the Venetian painters who had inspired both Caravaggesque tenebrism and Rubens. Such dichotomies ultimately led to a denigration of Raphael's achievement as a colorist in the influential writings of Roger De Piles (1708), Joshua Reynolds (1769–90), and Anton Raphael Mengs (1780).[4]

RAPHAEL'S COLORING AS SEEN BY HIS CRITICS

The earliest biography of Raphael, by the humanist Paolo Giovio (1483–1552), gave great importance to Raphael's coloring. Giovio praised its unity and softness, stating that Raphael had united coloring with drawing, sweetened the harshness of excessively vivid colors, and mastered the medium of oil painting. He wrote,

> In the drawing of lines which border those established by the boundaries of color, and in the mixing and softening of harsh, vivid colors, this most pleasing artisan [Raphael], worked outstandingly above all other things. And this was the one thing that had been lacking in Buonarroti: namely, that well-drawn pictures should also have the lucid and inviolable enrichment of mixed colors in oil.[5]

Giovio's cogent statement must be understood in the context of his age. Michelangelo's painting on the vault of the Sistine Chapel was regarded as a serious challenge to Raphael's hegemony in painting, in which coloring played as significant a part as other aspects of style. Michelangelo's approach was to juxtapose pure, vivid hues, frequently in the same piece of drapery. Giovio's characterization of Raphael's coloring was also framed in response to ancient art

criticism, especially to Pliny's praise of Apelles for limiting his palette and using a dark varnish to tone down the harshness of pure color.[6]

But Giovio is not merely reframing an ancient *topos,* for his assessment is securely founded on Raphael's own practice of avoiding pure, unmixed colors. The practice Giovio describes is what Marcia Hall has recently characterized as the central feature of "*unione* mode," which involves the toning down of color saturation and the limiting of color values to create a greater sense of unity in the distribution of colors across the surface of the picture.[7] Because in our perception some vivid colors advance more than others, they disrupt pictorial unity by interfering with the subtle illusion of relief and pictorial space.[8] Sixteenth-century texts frequently criticized bright colors as appealing to philistine taste and creating a tapestrylike effect or resembling playing cards. The painter's ability to use color to create convincing illusions of form and texture was upheld as a desirable alternative from the earliest writings about the aesthetics of color in the Italian Renaissance.[9]

Unione and *dolcezza* (softness or sweetness) were also emphasized by Ludovico Dolce (1508–68) in his advocacy of Raphael's superiority to Michelangelo. Like Giovio, Dolce argued that colors should not call attention to themselves for their intrinsic beauty as pigment, and he tied Raphael's historical importance to his skill in using them with the bold statement that anyone who does not recognize Raphael's superiority is "either envious or one of those unsophisticates who values the beauty of pure color more than art."[10] Dolce recognized that as individual colors lose the beauty of their purity, the coloring as a whole gains beauty through the artfulness of the effects created by the juxtaposition of colors. Developing this theme, he established another leitmotif in Raphael criticism based upon the *topos* of Aristotelian moderation, a middle way between two extremes. Excessive blackness offends the eye, and extreme whiteness is not pleasing either. Raphael's ideal is in between, consisting of subtle gradations between white and dark.

Unione and *dolcezza* describe a second critical concept which involves the handling of color to create soft edges and unobtrusive boundaries. Giovio and Dolce praised Raphael for these qualities, as did Giorgio Vasari (1568), Raphael's most important biographer. In his Life Vasari cited Raphael as an exemplar of graceful use of color,

an artist who knew how to relate the colors of drapery to the flesh tones so that seminude figures did not seem cut in two. He also praised the artist for excelling in creating the effect of drapery folds disappearing into shadows and coming forward into light. *Unione,* then, describes not only the harmony of tempered color saturation but also the soft execution of individual pictorial forms so that all the parts of a picture fit together seamlessly into the whole. Dolce noted that Raphael avoided distinct contour lines as well as abrupt junctures within forms, which allows light to meld into shadow and the edges of one color field to blend softly into adjacent areas. Modern writers discuss this under the concept of *sfumato* and acknowledge that Raphael learned to soften the edges of his forms by observing Leonardo's *sfumato,* as well as the paintings and drawings of Fra Bartolommeo (1472–1517), who was himself responding to Leonardo and contemporary Venetian painting.[11]

Relief was the quintessential aesthetic of Renaissance coloring, and reception of Raphael naturally turned to his contribution in this field. Dolce had admired the fact that Raphael was able to achieve tonal unity and relief in fresco, superseding what many other good masters could not achieve in the more flexible and responsive medium of oil. Vasari analyzed Raphael's achievement as a matter of moderating the excessive darkness of shadows; earlier, in his biography of Leonardo, Vasari had suggested that contrast was a key to obtaining strong relief and that Leonardo's dark manner had been the first flawed realization of this. The Lombard painter Giovanni Paolo Lomazzo reinforced what was now a *topos* of Raphael's moderation in the use of light and shadow, establishing him as a model of naturalistic coloring. Lomazzo argued that Raphael's naturalism arose because he avoided the pitfalls of too much blending and dilution, which make a work seem weak, and avoided the seduction of too much boldness and sketchiness; thus he created a convincing distribution of light according to nature.[12] A seventeenth-century painter, Matteo Zaccolini, reiterated this idea in his treatise "Color Perspective" (1622). He presented Raphael as a model of sweetness and *unione* for creating relief without either excessive darkness or an abundant use of white.[13] He explained that relief could be maximized by choosing neutral tones lighter than the shadows and darker than the highlights, thus allowing the full range of modeling to be perceived without the distortions of brightness contrasts.

Zaccolini also cited Raphael as a model for coordinating light and shadow with the illusion of pictorial space. He wrote that Raphael "makes the near appear near and the far appear far, clarifies the division of the intervals, and creates *dolcezza* [sweetness] and *unione*." I have called this practice "chiaroscuro perspective," because it involves a systematic reduction in the contrast between light and dark.[14] Gradations of chiaroscuro (e.g., of light and dark) create the impression of distance and atmosphere. Such practices became a part of what French seventeenth-century writers termed "aerial perspective" (*la perspective aérienne*), which we also refer to as "atmospheric perspective." Zaccolini and other seventeenth-century writers regarded chiaroscuro perspective as representative of naturalism, because (in their view) its principles were derived from nature and because it also conformed to the appearance of nature. Seventeenth-century naturalism emphasized this intersection between theory (in this case, scientific principles) and optical appearance.

Like Zaccolini, André Félibien, in his *Entretiens sur les vies et les ouvrages des plus excellens peintres anciens et modernes* (1666–88), saw Raphael as a model of naturalistic color and chiaroscuro, emphasizing his role as a guide to Poussin in the painting of color and chiaroscuro.[15] In his analysis of Poussin's *Rebecca and Eliezer at the Well* (Paris, Louvre, 1648), Félibien (1619–95) observed that Poussin used light and shadow to define the roundings of individual figures and to describe the placement of figures and objects in space.[16] Félibien's statement that Poussin took Raphael as his guide should be understood in the context of a larger discourse in which Raphael's approach was seen as an alternative to Caravaggesque tenebrism as well as to the coloring of Rubens and the Venetian painters. Both were judged "unnatural" or "artificial" in their treatment of light and shadow. The last sentence in his discussion makes this clear: "This style and course of action made his [Raphael's] paintings seem to conform to what one sees in nature: for without the artifice of great shadows and great lights, objects are seen just as they normally appear outside and in open spaces, where one never sees these large masses of light and darkness."[17]

Félibien was reacting against the opinion of Roger De Piles (1635–1709), who had advocated the massing of light and shadow as the most important principle of chiaroscuro. De Piles used this

theory to champion Rubens and to challenge the hegemony of Poussin, who was Félibien's hero. Not surprisingly, De Piles's criticism also turned to Raphael, whom he praised in all respects except coloring. His main criticism was that Raphael had not understood the essential principle of massing until after he had finished the *School of Athens* and begun to work in the Stanza d'Eliodoro, but De Piles also lamented that Raphael's color was not eye-catching. In the French critic's last and most influential treatise, *Cours de peinture par principes* (1708), De Piles quantified the evaluation of painting in four categories, including color, much like a college professor grading student essays. Although Raphael received the highest total of all, his low mark in coloring was inferior to those of some twenty-two Venetian and northern artists and even to that of Michelangelo. Thus De Piles established a trend in which Raphael's coloring would be negatively judged by future generations until is was finally overlooked entirely. By contrast, De Piles credited Titian with the principle of massing, and consequently the development of coloring came to be regarded as a filial line proceeding from Titian to Rubens to Watteau and to Delacroix.

We have come full circle in our examination of Raphael's critical reception, and it is now time to examine his coloring in the *School of Athens,* from the viewpoint of Renaissance art criticism.

A COLOR ANALYSIS OF THE *SCHOOL OF ATHENS*

COLOR ARRANGEMENT

One of the first things we notice upon viewing the *School of Athens* (Fig. 5) is the great variety of colors that Raphael employs and harmonizes together. The palette of the fresco painter included white; several shades of brown; several yellows, greens, and blues; reds, ranging from orangish red to purplish red; and black. Raphael employed all of the hues available. This aesthetic of variety and copiousness had also characterized the palette of early Italian panel painting. Indeed, it was seen as a broad principle of pictorial composition and invention, valid for figure types, poses, and gestures as well as color. The principle of variety was explicitly stated by Leon Battista Alberti in his treatise *De Pictura* (*On painting,* 1435), as a precept for beautiful coloring. Alberti wrote,

Grace will be present when colours are placed next to others with particular care; for, if you are painting Diana leading her band, it is appropriate for this nymph to be given green clothes, the one next to her white, and the next red, and another yellow, and the rest should be dressed successively in a variety of colours, in such a way that light colours are always next to dark ones of a different kind. This combining of colours will enhance the attractiveness of the painting by its variety, and its beauty by its comparisons.[18]

Alberti's aesthetic includes a variety of colors as well as an arrangement that conjoins colors of contrasting lightness and darkness. Color contrasts were recommended which would enhance the beauty of colors, a principle systematized as "simultaneous contrast" by the modern color theorists Michel Eugène Chevreul and Josef Albers.

The ideal of multicolored paintings was one that had been typical of Italian painting at least since the time of Duccio and Giotto and was still current in the late fifteenth century. Typically, all colors of the palette were used in each scene. Two examples are Ghirlandaio's *Last Supper* (Florence, Ognissanti, 1480) and Perugino's *Delivery of the Keys* (Vatican, Sistine Chapel, 1481–3), both of which would have been known to Raphael. The principles underlying their disposition ranged from simple color chains to color inversions, which Shearman has described as "isochromatism."[19] More complex patterns of repetition emerged in the late Quattrocento, but little effort has been made to discover their underlying principles.

Although Raphael used all of the colors in the palette and clearly subscribed to the traditional aesthetic of copiousness and variety, his arrangement in the *School of Athens* no longer reminds us of a typical Quattrocento fresco. Regular patterns of isochromatic composition are no longer evident. Indeed, Raphael avoids exact repetition, so that when hues are replayed, they always recur in another context, creating the effect of greater variety than the six or seven hues the fresco palette would normally allow. Colors are toned down or brightened, or juxtaposed with a lighter or a darker hue that affects our perception of its color value.

How Raphael achieved this tremendous variety is still not known, although we hope that the current restoration of the fresco will shed some light on this issue. Raphael probably took advantage

of natural pigment variations, reversing the Quattrocento artist's concern with uniform quality of hue in each scene or wall; this is indicated by the greater variation of red, yellow, and violet tones – which were earth colors – compared to the more limited blues, which were painted after the plaster was dry (*a secco*), with azurite.[20] Raphael may have added varying amounts of white and black to tone down the vividness of hues and adjust their lightness and darkness; fresco painters traditionally added white, as Cennino Cennini described in the early fifteenth century; Armenini also mentions the admixture of black and dark earth colors in summing up sixteenth-century practice.[21] Pigment preparation may also have accounted for some variation.[22]

This sophisticated refinement of the principle of copiousness and variety first emerged in the Stanza della Segnatura. In his Florentine altarpieces, such as the *Coronation of the Virgin* (Vatican, Pinacoteca, 1504), we find exact repetitions, carefully placed to lead our eye around the crowd of dazzled Apostles. There is still repetition in the slightly later, more complex *Entombment* (Rome, Borghese Gallery, 1507), where the introduction of desaturated colors in the group of women on the right introduces a new degree of variation. However disjunctive, the shift is designed to keep our focus on the vividly colored foreground figures surrounding Christ. Then, in the *Disputa*, saturated and desaturated colors are better integrated, so that we barely notice the toning down of colors in the second row and to the sides. Some color repetitions still take place, with significant impact: I am thinking particularly of the two standing figures in the foreground on either side, who direct us to look toward the center, both of whom wear yellow vestments and blue robes.

A precedent for Raphael's aesthetic is found in Florentine Quattrocento panel painting. For example, in his early *Adoration of the Magi* (London, National Gallery), Botticelli obtained some twenty tones of red and pink from only three or four pigments, which were varied by using different underpaint and glazes, while two or three blues and yellows were made to produce about fourteen different blues and a dozen different yellows.[23]

But fresco technique did not lend itself to underpainting and glazing. Hence, Raphael relied extensively upon juxtaposition to further differentiate his hues. If we follow through the repetitions of

one hue, such as blue,[24] in the group surrounding Euclid (Fig. 9), we find that it looks light juxtaposed with green in the kneeling pupil, looks darker juxtaposed with deep yellow in the Ptolemy (Fig. 16), and seems a medium value as the shadow for a pale violet *cangiante* in another pupil. None of these juxtapositions is repeated in the other seven occurrences of blue throughout the composition. In the *School of Athens,* Raphael raised copiousness and variety to a new level of complexity, transforming it from a decorative and symbolic arrangement of colors into a rich natural world of infinitely subtle, deceptively natural variations.

Michelangelo also transformed Quattrocento isochromatism on the vault of the Sistine ceiling but in a totally different way. In place of the simple axial and diagonal inversions and repetitions, he introduced a level of complexity which the viewer perceives intuitively but cannot comprehend in rational terms. With capes, sashes, trim, and *cangiantismo,* the seers are each draped in an average of five different colors, in contrast to the average of two, or at most three, in a typical Quattrocento painting such as Ghirlandaio's *Last Supper* (Florence, Ognissanti).[25] Although exact repetitions of individual colors do occur, we never see the same combination of colors together;[26] hence, the effect is, as in Raphael, one of infinite variety. Yet Michelangelo's ceiling vibrates with an air of artifice. He presents a dazzling vision of jewel-like colors, more resplendent through their juxtapositions. Raphael's color arrangement, on the other hand, seems so natural that we barely notice the artifice used to create its variety and harmony.

UNIONE OF TONE

Part of the key to Raphael's success is his restriction of color saturation to narrow the range of tones and thereby create tonal unity. As we saw in the first section of this chapter, Giovio and Dolce praised Raphael's ability to create pictorial unity by mitigating the vividness of pure hue. Hall suggested in her discussion of *unione* mode that Raphael restricts saturation to 25 to 50 percent of what is possible; if this is true, such a limited range would avoid the unevenness of pure hue, in which some pigments are naturally high in saturation and others quite low.[27] Leonardo was Raphael's inspiration, having shown how the painter could imitate with chiaroscuro the infinitesi-

mal gradations of color in light and shadow. Leonardo had embraced high saturation as the beauty of color revealed in the lights; in order to create the illusion of unified light, he totally avoided white, restricted the value range of colors to medium and darker shades, and limited the number of hues used.[28] Raphael, however, used nearly a full range of color values in the *School of Athens*. He had explored the effect of desaturated color in several panels painted during his years in Florence, perhaps already seeking expression for the aesthetic of toned-down color, perhaps as another solution to the problem of pictorial unity.

Raphael generally avoids pure black – there are a few patches describing black-colored objects – but he does use white and very dark browns. He thus employs a wider range of color values than appears at first glance. Significantly, he gives the impression of greater unity by avoiding the juxtaposition of extremes. The over-all effect is one of gentle modulation within a reduced range.

A black-and-white reproduction of the painting is useful to study value relationships because it converts color to grays. Here we can see just how close in value are the two drapery tones of each figure in the *School of Athens*. The exceptions are especially prominent figures: Plato and Aristotle (Fig. 24) under the arch, and the standing figure in the twisted *serpentinata* pose just left of center (no. 30), whose energetic pose and lively color made more compositional sense before the introduction of the seated Heraclitus–Michelangelo. Compared with the greater contrast of drapery tones in the *Disputa* (Fig. 4), where Raphael juxtaposed light against dark, it appears that Raphael has here developed a new principle of color organization: paired drapery colors contrast in hue but not in value or saturation. Exceptions serve as accents to focus the eye.

Although white is at the top of the value scale, it can, by following these principles, be integrated into the fabric of the whole without losing unity. Alberti had recommended that painters use it sparingly: extensive use was considered to be tiring to the eye and, moreover, to limit the effectiveness of white strokes as indicators of luster and sheen.[29] In the *School of Athens,* the three figures draped in white robes wear vestments treated as *cangianti* in which white or yellow is used as the highlight color. The shadow color in each case remains above middle gray, thus creating a unity of value by limiting the

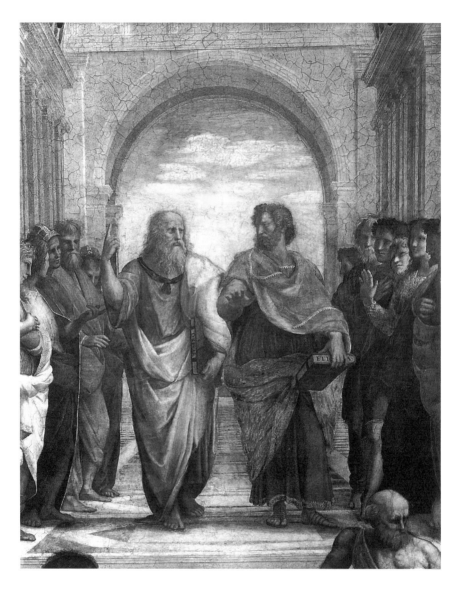

Figure 24. Plato and Aristotle. Detail from *The School of Athens*. Stanza della Segnatura, Vatican Museum. (Photo: Vatican Museums.)

value range within each individual figure. But when we move from the parts to the whole, the full value range becomes apparent; indeed, each of the four main groups has a full value range from white to dark brown or black. By contrast, in the *Disputa,* white robes and vestments are juxtaposed to darker, deep colors, such as dark green, and golden yellow ocher, recalling Alberti's advice to put light next to dark, as well as Leonardo's admonitions.

DOLCEZZA AND UNIONE

Unione is a quality of the parts as well as the whole. We saw earlier that Dolce and Zaccolini used the term to describe the soft transitions between highlight and shadow which create the impression that shadow is a diminished light continuous with the illumination, not a distinct entity. Early in the Quattrocento, Cennino Cennini had emphasized the soft, smoky quality of color modeling tones used to create the illusion of illumination and relief.[30] By the time Raphael arrived in Florence, Leonardo had transformed the practice of modeling with light and color.

Leonardo had used viscous paints to create indistinct contours and interior edges; he veiled the edges of forms in *sfumato,* a translucent shadow so named because, like smoke (*fumo*), it has no distinct boundaries. The best surviving example is his portrait of a woman known as the *Mona Lisa* (Paris, Louvre), although the present state of the picture is certainly different from whatever Raphael saw when he sketched a portrait of a woman in a similar pose.[31] The corners of the eyes and mouth of the woman in Leonardo's painting are veiled in a murky *sfumato* that blurs their definition; her hairline and the contours of her face are similarly veiled in this shadowy haze; and her hair itself is covered with a dark, transparent veil. The effect is one of suggestion, not definition: the beholder completes the image, based upon memory, which, in the case of a face, is more three-dimensional than any painted image.[32]

In the *School of Athens,* Raphael demonstrated that Leonardo's soft style of oil painting could be transformed for the medium of fresco. This was no mean achievement, as Dolce had indicated; oil painting techniques were not easily transferred to fresco painting, which traditionally had depended upon a minimum of mixing and upon a transparent layering or velation. Like Leonardo, Raphael

created the effect of dark edges by gradually modeling down from the projecting illuminated parts. He avoided dark contour lines, which were still used by most of his contemporaries in fresco. The recent ceiling frescoes of his teacher, Pietro Perugino, in the Stanza dell'Incendio, make a suitable comparison, for in the tondo show-ing *Christ Spreading the Holy Spirit,* the forward-gesturing hand of Christ is separated from the similarly toned vestment behind it by a thin black line. Raphael, however, separated the raised hand of Plato from its background by color contrasts, powerfully shading the left edge, which borders on a light beige ground, and lighten-ing the right side, which borders on a darker gray ground (Fig. 24). Aristotle's foreshortened hand is similarly separated from the arm behind it by its strong chiaroscuro.

Raphael also created indeterminacy at the boundary between two different colors by darkening and desaturating the colors in the shadow until they were virtually indistinguishable. An example is the blond man climbing the steps (no. 11): the white of his robe moves from very light gray in the lights into a darker gray in the shadows, the same value as the shadow of the green vestment. And since the green also loses its intensity in the shadow, the boundary between green and white takes on the softness and indeterminacy that Raphael's critics would praise as *dolcezza* and *unione.*[33]

This extensive modeling – from near white to near black, in the white drapery – also differs from the practice of Leonardo, whose drapery tones tend toward the lower half of the value scale, model-ing down from a medium value at full saturation in the lights to a very low value in full shadow. Because Raphael's painting looks lighter, one barely notices that his modeling range encompasses the full value scale, as Alberti had once recommended. He works down to very desaturated (dark grayish) shades in the shadows and works up to high-value tints in the lights, either lightening color with white or using naturally light hues. This again differs from the *Disputa,* where the individual hues seem to be less fully modeled, subordinated to the greater value contrast of their pairings.

RELIEF

Unione and *dolcezza* are aesthetic principles of modeling, but we must remember that the principal aim of modeling in light and dark

colors was to create the illusion of relief. Simply stated, "relief" is the appearance of three-dimensionality. In Renaissance theory it involves two aspects: the illusion of "gibbosity" (rounded forms), and the separation of figures from grounds. Relief was paramount to the Italian theory of painting, and Raphael's ability to create it was appreciated by his contemporaries with an enthusiasm that we cannot share in this age of photography. Cennini and Alberti laid out the basic precepts of creating relief, which had been invented in classical antiquity: lighter tones represent the projecting parts of objects, darker tones the recessions. However, neither theory nor practice remained constant. Alberti proposed that relief would best result from the even distribution of light and shadow on each figure, recommending a lateral light that allowed the painter to divide light from shadow on each rounded figure along a midline.[34] Leonardo refined these ideas in both theory and practice. He argued that relief is best created by infinitesimal gradations, which naturally appear in dim light without much contrast. He also introduced two new issues to the discourse on relief: the indeterminate quality of boundaries, for which he invented the practice of *sfumato*, as we have seen, and the optimum background color. In the early 1490s, Leonardo argued that illuminated figures will seem more three-dimensional if emerging from a dark, receding ground. He later argued for the principle of maximum contrast. Yet, from the time of the *Last Supper* (1495–8), Leonardo began exploring the use of lighter, neutral grounds and the presence of reflected light. It was certainly works with light grounds, such as the *Madonna of the Yarnwinder* and the *Leda,* that Raphael saw as the most recent examples of Leonardo's style.[35]

Raphael experimented with dark backgrounds in several pictures after his arrival in Florence in 1504: the *Orleans Madonna,* the *Bridgewater Madonna,* and several contemporaneous portraits.[36] But Raphael generally preferred the traditional higher-value grounds of the landscape background and lightened up his chiaroscuro modeling accordingly, as Vasari had noted, imitating the softness and subtlety of *sfumato* without blackness. Transferred to an architectural setting in the *School of Athens,* the neutral tones of the landscape became a medium-value beige. The color serves as a light ground for dark hues and shadowed parts and as a dark ground for illuminated flesh and light colors. Raphael works according to a principle that Zaccolini would later articulate: relief is best created

by a middle tone that allows the viewer to perceive the full range of modeling tones and does not distort the balance of light and dark through excessive contrast.

In carrying out these principles, however, Raphael brilliantly rejected the idea of a static, fixed color and regarded the neutral ground as shifting in value from the presence of light. Full relief without great contrast finds its greatest expression in the *School of Athens*. We have seen that Raphael eschewed extreme contrasts in the treatment of individual figures, creating *dolcezza* and *unione* with closely spaced hues and using contrast advantageously to separate figures from their grounds. The same principles underlie Raphael's use of color and chiaroscuro in the relationship of figures to each other and to the architecture. In a naturalistic way, Raphael used cast shadow to minimize the distinction of figure–ground values where shadow served the compositional focus. The feet of Plato and Aristotle are in shadow, as is the pavement flanking them on both sides; this creates a unity of tone that visibly welds their feet to the ground, whereas the upper body detaches itself from the light ground behind and becomes a focus for the eye. Cast shadows on the ground also work to unify the group surrounding Euclid (Fig. 1, no. 23). Color juxtapositions of various hues with similar saturation and value also connect figures into groups. For example, Socrates (no. 49) is flanked by an old bald man in purple (no. 51), and the youthful Alcibiades (no. 45) in bluish green and blue, all colors of medium-low value but different enough in hue to create a separation of each figure within the unity of the whole.

THE MASSING OF LIGHT AND SHADOW

The naturalism of Raphael's *School of Athens* also arises from his distribution of chiaroscuro in broader masses. Although De Piles had criticized Raphael for ignoring this principle in his paintings preceding those in the Stanza d'Eliodoro, Sir Joshua Reynolds, in his *Discourses on Art* (1797), recognized the *School of Athens* as an example of placing "the principal broad mass of light in the middle space of ground . . . to avoid the confusion of a multiplicity of objects of equal magnitude.[37]

In contrast to De Piles's distribution theory, in earlier theories of chiaroscuro by Alberti and Leonardo, each figure is modeled inde-

pendently in light and shadow to bring out its projections and recessions. The chiaroscuro of the whole is coordinated by a light source from the side, so that each figure has one side illuminated and one side shadowed. We can characterize this as a "relief paradigm," for each figure must be modeled in both light and dark, whereas accidental effects, such as cast shadows, are subordinated to the plasticity of the individual figures.

Leonardo operated within a relief paradigm in his paintings and drawings and in the pictorial precepts he formulated, although his notebooks are full of observations of accidental effects of light and shadow, such as penumbra and colored reflections. Indeed, the relief paradigm remained operative through most of the sixteenth century. We find that even in 1587, Giovanni Battista Armenini (*De' veri precetti della pittura*) specifically advised painters to ignore the accidents of directional lighting in order to emphasize the three-dimensional relief of the whole:

When imitating any relief of whatever light, one must always keep in mind that the limb or least part that is more forward and closer to one's sight is to be made lighter; and those parts which recede are to be made to disappear into very soft shadows, according to how one turns, in the same way that one sees the body of a round column recede. Nor must anyone be misled by an abundance of light which, coming from one direction, strikes the relief almost equally, since one must also shade that part wisely, even though it is bright, for the aforesaid reason of being further from the eye of the painter.

But perhaps it is well to give an example. Let us suppose someone wants to portray in relief a head that is under a bright light and seen frontally. One can see that the light will flood, with almost equal illumination, the greater area of the head on the same side from which it shines. One must not copy in one's drawing what one sees, for the head is obviously round; and since the nose projects most, is nearer to one's view, and is more brightly lit, it is necessary to make the nose brighter than the forehead, and similarly the forehead brighter than the cheeks, and these brighter than the ears, continuing thus to the extremes of the head. Therefore, in such a way, one can supply with judgment and with art what the visual perception fails in this most important part.[38]

Raphael himself worked within this relief paradigm. The figure of Christ in the *Transfiguration* (Vatican, Pinacoteca, 1517–20) is illuminated by a bright light and seen frontally, as in Armenini's example; Raphael ignores the specific direction of the light (from behind) to model the figure according to traditional principles. In the same picture, however, Raphael breaks out of this paradigm and renders wonderfully naturalistic effects of accidental light on the Apostles below.

Raphael's first foray into effects of accidental illumination emerges in the Stanza della Segnatura. In the *School of Athens,* whole figures are now thrown into shadow, and a few heads, such as that of the dark-haired man behind Epicurus (Fig. 1, no. 38), show an irregular pattern of accidental illumination. Only minor figures are treated thus – figures in the rear, partially occluded by the principal actors in the allegory, who are incidental to the narrative, but it indicates a new way of thinking about light and shadow. "Accidental" illumination is also used in this way in the *Disputa* (Fig. 4), where whole figures on the periphery appear in shadow. The dark-haired kneeling youth on the left is completely shadowed, because he is blocked from the light by both the blond kneeling youth in front of him and the youth energetically bending over his back.[39]

In both frescoes, these shadows are transparent, revealing sufficient information about form and color to render the figures legible. Raphael has realized that a full range of values is not essential to convey plasticity: it is enough to have a gradation of tones that constitute a portion of the value scale. The shadows of these figures are consistent in value with the full shadows of figures in the light, and relief is conveyed by using the midtones as if they were highlights. The effect is to make the more distant figures recede, both in space and in attention. We will return to this effect in the conclusion.

Looking again at a black-and-white illustration of Raphael's *School of Athens* (Fig. 5), we can more easily observe how Raphael has organized the distribution of chiaroscuro of the whole. A frontal-lateral light coming from the upper right illuminates the scene, but fails to reach the figures on the right side under the barrel vault, who, however, receive some light from the broad opening behind. Raphael takes liberties with the strict application

of this "rule," as he did in the case of linear perspective "rules."[40]
He frequently makes subtle adjustments in the shape and position
of shadows and highlights to clarify the poses and spatial relation-
ships of the figures.

Scholars have noted that the chiaroscuro of the whole was care-
fully worked out in the magnificent monumental cartoon for the
painting, which is conserved in the Biblioteca Ambrosiana in Milan
(Fig. 19).[41] It is the earliest monumental cartoon that survives, al-
though we have reason to believe that Leonardo and Michelangelo
made full-sized cartoons for their battle pictures in the Grand Coun-
cil Hall in Florence, the *Battle of Anghiari* and *Battle of Cascina*. The
survival of this cartoon results from a new technique of working in
fresco, in which partial cartoons were made from the master cartoon
and used as needed for the wall by pouncing or tracing with the
stylus. Eve Borsook has proposed that throughout the execution, the
master cartoon would be displayed on the floor, serving above all as a
guide in the execution of the chiaroscuro of the whole.

Drawings for the *Disputa* reveal even more clearly that Raphael
was thinking in terms of broad masses of light and shadow. In the
compositional study (Windsor, Royal Library, 12732) for the left
side of the fresco (Fig. 25), wash is laid on in broad areas to indicate
patches of shadow. Similarly, in the gray chalk drapery study in
Vienna for the lower left side, we see some figures in half shadow
and others in full shadow instead of the full range of modeling
tones used for each figure in the style of earlier studies. In the
painting, however, these broad distinctions of chiaroscuro are less-
ened. Light and shadow alternations lead the eye back into space,
but there is less sense of a unity of the whole through the presence
of light than in the drawings, perhaps as a consequence of working
without a full-sized "master plan," or perhaps as an artifact of
restorations that have altered its original appearance.

The same transformation seems evident in the *School of Athens*.
Comparing the painting to the cartoon, we can observe how Ra-
phael distributed colors with respect to the chiaroscuro to create an
equilibrium in the composition. The shadowed figures on the right
under the barrel vault are painted in darker, deeper tones of color
but with stronger highlights than those on the illuminated side,
where neutral, desaturated colors dominate. This has the unfortu-
nate effect of neutralizing the massing of chiaroscuro in the compo-

Figure 25. Raphael's drawing for *La Disputa*. Windsor Castle, The Royal Collection. (By permission Her Majesty Queen Elizabeth II.)

sition, reducing its effectiveness as a compositional device.[42] Raphael may not have been entirely pleased with the result, for he did not repeat the experiment in the Stanza d'Eliodoro, where the colors are distributed in accordance with the massing of light and shadow.

CHIAROSCURO IN PERSPECTIVE

In the compositional study for the left half of the *Disputa* in the Royal Library at Windsor (Fig. 25), Raphael varied the depth of shadow to accord with distance. Not only did he apply a lighter wash on the heavenly figures at the top of the compositional arch,

as Ames-Lewis observed;[43] he also used a lighter wash on the Apostles at the left of the group, that is, those intended to be in the conch of the semicircle, farthest from the spectator. In the absence of color, Raphael experimented with tonal differences to create the effect of atmospheric distance, enhancing the diminution of size and the blurring of focus.

In his earlier Florentine paintings, Raphael had modified the handling of color to achieve effects of atmospheric perspective, but he relegated these effects to the remote distances of landscapes. In the *Canigiani Holy Family,* for example, the landscape is divided into three zones of color. In the foreground and middle ground, recession is created by diminishing size and detail. It is only in the third zone, the remote background, with its azure lakes and mountains and a tiny village veiled in the azure haze, that the perspective of chiaroscuro becomes an effective clue to the great distance. Such treatment of remote distances was typical of Quattrocento practice.[44]

The Windsor compositional drawings for the *Disputa* indicate a new attitude in which the perspective of diminishing contrast, which we call chiaroscuro perspective, is carried through the whole composition. It enhances the illusion of spatial recession created by linear perspective, while it simultaneously links and differentiates the figure groups. This was but a moment of experimentation, however, chiaroscuro perspective is not evident in many of the later compositional studies.[45] Indeed, in the fresco it is linear perspective and acuity perspective (the reduction of detail and clarity) that create the effect of recession. Each figure in the fresco of the *Disputa* is modeled in the range of chiaroscuro appropriate to its illumination; thus the Virgin is as strongly modeled as Saint Peter, although she is farther back in depth.

In the *School of Athens,* experimentation with chiaroscuro perspective is taken a step farther. Although drapery hues and modeling tones remain constant in figures, regardless of distance (responding, as always, to differences in illumination), the shadows cast by figures onto the pavement do seem to diminish in intensity from foreground to background. A tonal gradient also characterizes the painted architecture, with the greatest contrast on the marble surfaces of the first great barrel vault, and noticeably dimmer highlights as well as lighter shadows in the spaces of the second and third vaults.[46]

Figure 26. Raphael, *Expulsion of Heliodorus*. Stanza d'Eliodoro, Vatican Museum. (Photo: Vatican Museums.)

Neither of these experiments, however, fully prepares us for the masterful organization of chiaroscuro perspective in the *Expulsion of Heliodorus* (Fig. 26). Raphael placed the strongest lights and the darkest shadows on the foreground figures and diminished the obscurity of the shadows and brightness of the lights in the middle ground and background. The foreground figures thus create a scale to which the diminution of light and shadow tones are compared, enabling the viewer to judge the proximity of the object in conjunction with other distance cues, such as diminishing size. Raphael subtly controls the recession of space with a minimum of linear perspective through gradients of chiaroscuro contrast as well as those of color and clarity.

RAPHAEL, LEONARDO, AND MICHELANGELO

We have thus far considered Raphael's use of massing and chiaroscuro perspective in isolation from that of his two great con-

temporaries, Leonardo and Michelangelo. Jones and Penny put forth the intriguing suggestion that the massing of shadow that unites individual figures in the *Expulsion of Heliodorus* and the *Repulse of Attila* was "a device already found in Leonardo."[47] Although we do not have surviving examples of Leonardo's use of this device, we should not discount the possibility of his influence on the younger artist, for we have already seen that Raphael's use of *dolcezza* and *unione* was inspired by Leonardo's own experimentation with toned-down color and *sfumato*. The drawings for the *Battle of Anghiari* merely hint at the possibility of some broader distribution of chiaroscuro in the lost cartoon; there is not enough evidence to determine whether the lost wall painting included chiaroscuro perspective, yet the written evidence favors Leonardo's interest in it.[48] Around the time that he was exploring how changes in color with distance could be organized mathematically by degrees of blueness, he formulated a basic tenet of chiaroscuro perspective. The text derives from a lost manuscript dated after 1500 that was copied into the "Treatise on Painting": "That shadowed body which is farthest from the eye will show least difference between its lights and shadows."[49] Thus, Raphael could have been inspired by oral discussion with Leonardo as well as by visual examples.

However, I want to emphasize how important it is *not* to minimize Raphael's creativity as a colorist as we set about tracing the sources of his inspiration. Art historians frequently find that earlier precedents can be identified for many significant innovations, but such tracing of sources can degenerate into meaningless semantics if one overlooks the broader cultural context of imitation, function, and reception. None of Leonardo's surviving paintings or drawings demonstrates the massing of light and shadow, the compositional organization of color into masses of value, and the use of chiaroscuro perspective that we see in the *Expulsion of Heliodorus* or even in the *School of Athens*. Leonardo prepared the way by showing how to tone down colors to create unity and by exploring how the focus can be directed away from the secondary figures by using dark shadow to diminish color intensity, clarity, and relief. But it was Raphael who discovered how to put these devices together with natural lighting to organize spatial recession. This discovery freed the painter to explore new approaches to multifigure compositions, leading to arrangements that were more

natural, more complex, and more sophisticated than those devised by any of his predecessors.

Working independently of Raphael, Michelangelo also introduced on the vault of the Sistine Chapel the practice of diminishing both the contrast of light and shadow and the clarity of interior detail. For example, in the lunette of *Ozias, Oatham, and Achaz,* the children in the background are painted in a much-diminished contrast range, lacking the highlights and midtones used to model the flesh of the nearer figures and closer in tonality to the grayish violet (*morellone*) background. As a result, they are less sculptural, flatter, and seem more dimly illuminated. They are also more sketchily painted, lacking the definition of musculature and texture that illumination provides. Michelangelo's system imitates the appearance of relief sculpture.

The style of relief sculpture that had dominated Florentine Quattrocento art involved gradations from high relief in the foreground to very low, flattened (*schiacciato*) relief in the background. Because these distant figures are rendered with greater flatness and not undercutting, they have very weak shadows in normal illumination. Furthermore, sculptors frequently beveled the edges of distant forms to soften the gradations of light, and the flatter forms would have fewer lusters because they lacked the great prominences to reflect the light. Thus, relief sculpture would create its own gradients of diminishing chiaroscuro, from the high contrast of lustrous and deeply undercut high relief in the foreground to the low contrast of the *schiacciato* in the distance. It is likely that Raphael's treatment of chiaroscuro was inspired by his study of relief sculpture.

Raphael's *School of Athens* is a landmark in the history of coloring. We have seen that Raphael expanded the possibilities of the traditional aesthetics of copiousness and variety, *unione* and *dolcezza,* and relief. He also opened new directions of exploration through the massing of light and shadow and the organization of chiaroscuro in perspective space.

NOTES

1. For a general history of color theory, see Gage, 1993. For its status in the Renaissance, see Barasch, 1978. On gendered aspects of color, see Jacqueline Lichtenstein, *The Eloquence of Color* (Berkeley and Los Angeles: Uni-

versity of California Press, 1993), and Patricia Reilly, "Writing out Color in Renaissance Theory," *Genders* 12 (1991), 77–99.

2. By "scientific" I refer to the positivist orientation of art historical methods, starting with Morelli, which emphasized objectivity and external criteria rather than intuition and personal response.

3. Color has occupied a few modern scholars of Raphael, and a few specifically address the *School of Athens,* such as S. J. Freedberg's color analysis of the fresco, 1961, 1:124–6; Theodor Hetzer's color analysis, 1957, 44; and Emil Waldman, 1913–14, 23–4. My work builds upon studies of color in the Renaissance by Weil-Garris Posner, 1974; Hall, 1992; Shearman and Hall, 1990; and Shearman, 1962. Some recent biographers of Raphael also integrate color analyses into a monographic history of the artist's development; especially recommended are Jones and Penny, 1983; and Oberhuber, 1982.

4. For a fuller discussion of these issues, with citations to sixteenth- and seventeenth-century texts, see my earlier articles "The Critical Reception of Raphael in the Sixteenth and Seventeenth Centuries," *Text* 9 (1996), in press, and Bell, 1995, 91–111. In order to minimize the notes, citations have not been repeated here.

5. Paolo Giovio, *Dialogus de viris litteris illustribus.* Reprinted in Golzio, 1936, 191–3. My translation. I thank Peggy Brucias for her assistance.

6. There is an extensive literature on this subject; see the accessible discussion of dark varnishes in Weil-Garris Posner, 18–22, and recent discussion by John Moffitt, "Leonardo's 'Sfumato' and Apelles's 'Atramentum,' " *Paragone* 40 (1989), 88–94.

7. Hall, 1992, 94, and 101–2.

8. For further discussion of this concept, see Ackerman, 1980, 11–44, esp. 16–18, and Janis Bell, "Light and Color in Caravaggio's *Supper in Emmaus* (London)," *Artibus et Historiae* 16 (31) (1995), 139–70.

9. Barasch, 1978, 95–111; Gage, 1993, 117–38.

10. Ludovico Dolce, *Dialogo della pittura, intitolato L'Aretino,* 1557.

11. Some examples of sfumatesque edges in works executed after Raphael moved to Florence are the *Terranuova Madonna* (Berlin-Dahlem, Staatliche Museen), the *Small Cowper Madonna* (Washington, D.C., National Gallery of Art), and the *Madonna del Granduca* (Florence, Pitti), the latter of which, according to the latest technical studies (see Shearman and Hall, 1990, 80), was originally painted with a landscape ground and later overpainted to get the dark ground we see today.

12. Giovanni Paolo Lomazzo, *Trattato dell' arte della pittura, scoltura, et architettura* (Milan, 1584), 2:9–589, and *Idea del tempio della pittura* (Milan, 1590), 1:242–373. Robert Ciardi, ed., *Scritti sulle arti,* 2 vols. (Florence: Centro Di, 1973–6), 1:286.

13. Florence, Laurentian Library, MS Ashb. 1212². This treatise is unpublished. For a general history of the manuscripts, see Janis Bell, "Cassiano dal Pozzo's Copy of the Zaccolini MSS," *Journal of the Warburg and Courtauld Institutes* 51 (1988), 103–25.

14. It is sometimes called "tone perspective" in modern artist's manuals. See the discussion in the last section of this chapter, and, for more information, Janis Bell and Martin Kemp, "Non-linear Perspective," under the heading "Perspective" in the *Dictionary of Art* (London: Macmillan, in press).

15. Elizabeth Cropper, *The Ideal of Painting: Pietro Testa's Düsseldorf Notebook* (Princeton: Princeton University Press, 1984), 135–6. Félibien, 1666–88, vol. 4 (1672), entr. 8, p. 116. See also my earlier essays cited in n. 4 to this chapter.

16. Félibien, 1666–88, entr. 8, 4:103–4.

17. Félibien, 1666–88, entr. 8, 116; see also Cropper, 1984 (as in n. 15 to this chapter), 135–6.

18. Alberti, 1435, bk. 1, par. 48, 1972, 91–3.

19. John Shearman, "Isochromatic Color Compositions in the Italian Renaissance," in Marcia Hall, ed., *Color and Technique in Renaissance Painting: Italy and the North* (Locust Valley, N.Y.: Augustin, 1987), 151–60.

20. Blues were frequently painted with the mineral lapis lazuli, which was more stable but much more expensive than azurite. Preliminary investigations indicate that the blues in the *School of Athens* were mostly painted *a secco* in azurite and have been extensively repainted (oral conversations with Arnold Nesselrath).

21. Cennino Cennini, *Il Libro dell'Arte,* translated as *The Craftsman's Handbook,* by D. V. Thompson (New Haven: Dover, 1933), 49–50 (chap. 71, "The Way to Paint a Drapery in Fresco"); Armenini, 1587, 178–9; Raffaello Borghini, *Il riposo* (Florence: Marescotti, 1584), modern edition edited by Mario Rosci, 2 vols. (Milan: Edizioni Labor, 1967), bk. 2, p. 171, talks about toning down the whiteness of the intonaco with the admixture of some black.

22. Cennini, *Craftsman's Handbook,* 37–8 (chap. 62, "On the character of Ultramarine blue, and how to make it") discusses this in the case of blue made from lapis lazuli, where the first filtration of lapis particles will yield a deep, luminous blue, the second a less intense blue, and later filtrations successively lower grades. It is to be hoped that the restoration of the *School of Athens* will clarify the issue of pigment variations. In the later frescoes in the Stanze, analysis has revealed some velation (e.g., the curtain has azurite over a *morellone* preparation) and a frequent use of *mezzo fresco,* for which see Fabrizio Mancinelli, "Raffaello e l'*Incoronazione de Carlo Magno* (ca. 1516)," in Eve Borsook and Fiorella Superbi Gioffredi, eds., *Tecnica e Stile:*

Esempi di pittura murale del Rinascimento italiano (Milan: Silvana Editoriale d'Arte, 1986), 115.

23. Ronald Lightbown, *Sandro Botticelli: Life and Work* (London: Elek, 1978), 24–5.

24. Even though the blues are mostly overpainted, the effect of color juxtaposition is equivalent and seems all the more remarkable because the overpainted azurite has even less variation than we might expect from Raphael.

25. Hall, 1992, 127.

26. The lunettes are similarly diverse, with color repetitions minimized but not totally avoided. *Azor and Sadoch* has the same yellow–violet *cangiante* juxtaposed to green as does *Ozias, Ioatham and Achaz; Aminabad* wears a green–orange *cangiante* with gray leggings, while *Asa, Josaphat, and Ioram* has the same green–orange *cangiante* but with lighter gray pants. On Michelangelo's coloring, see the forthcoming *Atti,* ed. Kathleen W. G. Brandt, of the 1990 conference at the Vatican, "Michelangelo's Sistine Ceiling."

27. Hall, 1992, 94. Shearman, 1962, was the first to identify tonal unity and discuss its advantages; there is also a useful discussion of the problem of color unity in Ackerman, 1980. A grayish film has been found covering large parts of the Borghese *Entombment* and the *Canigiani Holy Family* identified as a glair to protect the paint from damage (see Hubertus Von Sonnenburg's "Examination of Raphael's Paintings in Munich," 65–78, and especially 68, in Shearman and Hall, 1990.) It may also be related to the dark *atramentum* of Pliny, designed to tone down color intensity. This finding suggests that Raphael would have sought similar effects in fresco.

28. The traditional view of Leonardo's restricted palette has been challenged by Pietro Marani, "Le alterazioni dell'immagine dell'*Ultima Cena* di Leonardo dopo le più recenti analisi," *Kermes* 3 (1990), 3–9; Farago, 1994, 314–28, and "Leonardo's Color and Chiaroscuro Reconsidered: The Visual Force of Painted Images," *Art Bulletin* 73 (1991), 63–88; Martin Kemp, *The Mystery of the Madonna of the Yarnwinder* (Edinburgh: National Gallery of Scotland, 1992), and review of Hall (1992) in *Burlington Magazine* 135 (1993), 353; and see also Janis C. Bell, "Color and Theory in Seicento Art: Zaccolini's 'Prospettiva del colore' " and the Heritage of Leonardo," Ph.D. diss., Brown University, 1983, 634–42. The *Madonna of the Yarnwinder* is the closest evidence of this in a panel painting in reasonable condition. Problematic, however, is that early reflections of Leonardo in Venice, such as Giovanni Agostino da Lodi's *Christ Washing the Feet of the Apostles* (Venice, Accademia, inscribed 1500), have a very dark background and the murky *sfumato* we have come to associate with Leonardo and that early sources refer to Leonardo's paintings as "dark."

29. Alberti, 1435, bk. 1, par. 46, 1971, 87–9.

30. Barasch, 1978, 5, 10.

31. Joannides, 1983, cat. 175, dates the Paris drawing c. 1507–8.

32. For a brilliant analysis of the psychological impact of indeterminacy, see the section on the beholder's share in E. H. Gombrich, *Art and Illusion* (Princeton: Princeton University Press, 1956), 181–241.

33. Armenini, bk. 2, chap. 7, 182–4, describes how this is created by overlapping light over dark tones in the wet plaster to mitigate the abruptness of shadow and to soften the transitions from one tone to another.

34. Alberti, 1435, bk. 1, par. 46, 1972, 89. See also the discussion in Ackerman, 1980, 13–14.

35. Both works have been known through copies, although many scholars now identify the New York and Edinburgh versions of the *Madonna of the Yarnwinder* as Leonardo's originals, for which see Cecil Gould, "Leonardo's *Madonna of the Yarnwinder:* Revelations of Reflectogram Photography," *Apollo* 136 (1992), 12–16; Kemp, 1992, cited in n. 28 to this chapter; and Carlo Pedretti, "The Mysteries of a Leonardo Madonna, Mostly Unsolved," *Achademia Leonardi Vinci* 5 (1992), 169–75. The Vinci *Leda* is the best copy but is not generally accepted as autograph. On Leonardo's theory of contrast, see also Martin Kemp, "The 'Hammer Lecture' (1992): In the Beholder's Eye: Leonardo and the 'Errors of Sight' in Theory and Practice," *Achademia Leonardi Vinci* 5 (1992), 153–62.

36. The black ground of the *Madonna del Granduca* (Florence, Pitti, 1504) was painted over Raphael's original setting in a loggia revealing a landscape view, for which see Marco Chiarini's essay "Paintings by Raphael in the Palazzo Pitti, Florence," in Shearman and Hall, 1990, 79–83, at 80.

37. Sir Joshua Reynolds, *Discourses on Art* (1797), ed. Robert R. Wark (San Marino, Calif.: Huntington Library, 1959), Discourse VIII, lines 391–2, 157.

38. Armenini, 1587, bk. 2, chap. 1, p. 155.

39. The uneven distribution of light and shadow in Leonardo's *Adoration of the Magi* (Florence, Uffizi) represents neither massing nor accidental illumination, and hence seems an unlikely precedent for Raphael's innovation.

40. Many scholars have noted the larger size of Plato and Aristotle; M. H. Pirenne, *Optics, Painting and Photography* (Cambridge: Cambridge University Press, 1970), points out that the spheres held by Ptolemy and Zoroaster are not foreshortened.

41. Oberhuber and Vitali, 1972; Borsook, 1985, 127–36. See also Carmen Bambach, *Cartoons of the Italian Renaissance Artist: Workshop Practice and Design Theory, 1300–1600* (Cambridge: Cambridge University Press, in press).

42. It is hoped that current investigations will reveal whether this is also an artifact of previous restorations.

43. Ames-Lewis, 1986, 76.

44. Janis C. Bell, "Color Perspective c. 1492," *Achademia Leonardi Vinci* 5 (1992), 64–77.

45. Examples are the nude figure study for the left foreground group in Frankfurt (Städel Institut, 379) and the *modello* in London (British Museum, 1900-8-24-108).

46. Because this section is heavily overpainted, it remains to be determined whether this reflects Raphael's intentions or the "invention" of a later restorer.

47. Jones and Penny, 1983, 121.

48. On the basis of literary evidence, Farago, 1994, 318–21, emphasizes Leonardo's concern with gradients of color. Leonardo's concept of *colore* included value and saturation (*bellezza*) as well as hue.

49. Leonardo, "Treatise on Painting," Biblioteca Apostolica Vaticana, Vatican Codex Urbinas Latinas 1240, fol. 162.

PAGANS IN THE CHURCH:
THE *SCHOOL OF ATHENS* IN
RELIGIOUS CONTEXT

The first detailed description of the Stanza della Segnatura is that by Giorgio Vasari, published in 1550 but written some years earlier on the basis of impressions formed during several sojourns in Rome, starting in 1531, when Vasari was part of Cardinal Ippolito de' Medici's entourage. At that time, and later, Giorgio must have had access to the Stanze, and numerous details in his account in fact suggest close on-site scrutiny. He tells readers which books the central figures in the *School of Athens,* Plato and Aristotle, hold (the *Timaeus* and the *Nichomachean Ethics*); calls attention to the beggar's bowl on the steps in front of Diogenes (Fig. 1, no. 28); and identifies several figures as contemporary portraits: the bald, bending man at the viewer's right "is Bramante the architect, they say" (no. 23), and another figure "is the portrait of Federico II, Duke of Mantua" (no. 36), while still another is "Raphael, the master who painted this work" (no. 19). Indeed, the minuteness of his firsthand observation is such that Vasari attempts a literal translation of the Latin phrase "causarum cognitio," inscribed above the *School of Athens* in the allegorical ceiling roundel (Fig. 11). The words mean "the cognition of causes" (a handy definition of speculative philosophy), but Giorgio associates the Latin *causarum* with the Italian word *cose,* "things" and renders the phrase "cognizione delle cose." "V'è una femmina fatta per la cognizione delle cose," he says: "a woman has been painted to represent the 'cognition of things.' " It is a mistake, but the kind one makes from memory, on the basis of firsthand experience. So too his description of another of the allegorical roundels, that above the *Parnassus,* is extremely detailed: a figure "crowned

with laurel, holding an ancient instrument in one hand and a book in the other, her legs crossed and her eyes lifted heavenwards."[1]

Given the precision in his treatment of secondary features of the room's imagery, it comes as a surprise that Vasari badly mixes up major figures in the two main paintings, the *School of Athens,* on the eastern wall, and the *Disputation on the Eucharist* or *Disputa* (Fig. 4) on the opposite, western wall. In practice, he discusses these two compositions as if they were a single scene. Of the *School of Athens* (which depicts an ideal assembly of pagan philosophers), he says that it shows "when theologians reconciled philosophy and astrology with theology" and then transfers a figure we would expect to find in the *Disputa* (which depicts an assembly of theologians) to the opposite side of the chamber: Saint Matthew the Evangelist, whom Giorgio sees in the seated figure in the foreground of the *School of Athens,* at the viewer's left – the figure normally identified as Pythagoras (Fig. 1, no. 33; Fig. 27), a pre-Christian Greek thinker.

Vasari goes so far as to imply direct interaction between the two frescoes: "Certain astrologers" in the *School of Athens* have inscribed figures on small tablets, he says, and "they send them to the Evangelists by means of several very lovely angels, and the Evangelists expound them." The only figures Vasari could reasonably have taken for angels are in the *Disputa,* whereas his "astrologers" stand in the *School of Athens,* so he seems to have imagined two-way traffic from the eastern to the western wall, or – to put it differently – to have thought of the two frescoes as a continuum, an unbroken visual and thematic flow in which (as he says) skillful composition of the whole story ensured Raphael's claim upon his contemporaries' respect.

Most readers of Vasari's essay are disoriented by his "to-and-fro" description. Gaetano Milanesi, the late nineteenth-century editor of Vasari's works, called his description "a hotchpotch," and George Bull, in a modern English translation of selections from the *Lives,* characterizes the whole passage as "very muddled."[2] They are right, of course: here, as in other parts of the *Lives,* Vasari got the facts skewed. Yet his confusion is instructive, arising as it does not from ignorance of the works discussed (as was indeed the case with his glaring inaccuracies in regard to Leonardo's *Mona Lisa* or Michelangelo's *Bruges Madonna*) but from excessive familiarity. We

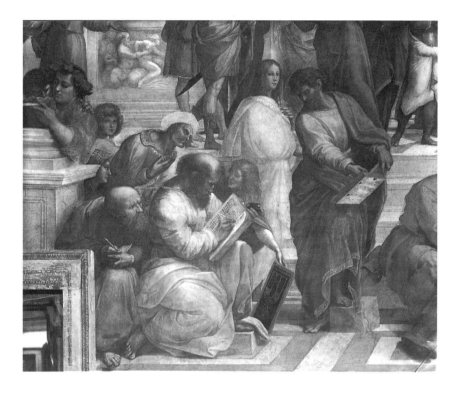

Figure 27. Pythagoras group. Detail from *The School of Athens*. Stanza della Segnatura, Vatican Museum. (Photo: Vatican Museums.)

have to ask why a trained sixteenth-century observer, able to recall and reconstruct small details, would conflate the two principal images in the Stanza into what, at certain points in his description, becomes a single visual and iconographic unit. The question is important, for it invites reflection on how Renaissance visitors to the Stanza della Segnatura "registered" the frescoes with their eyes and "read" them with mind and heart – poetic processes that differed substantially, it appears, from those with which modern art historians read them.

The key to this difference in perception lies in the fact that Vasari and other Cinquecento observers were indeed "visitors" to the Stanza. They physically entered the room, stood in the middle, and turned from one to the other of the principal frescoes, also taking in the *Parnassus* (Fig. 6) and images relative to *Jurisprudence*

(Fig. 7) on the northern and southern walls, along with the ceiling allegories. Unlike nineteenth- and twentieth-century "viewers" (and the distinction in terminology is intentional), their experience depended on immersion, not extrapolation: it was conditioned by familiarity with decorated rooms where the imagery on one wall found echoes and reverberations with those on the others, rather than by graphic or photographic reproductions that isolate each segment of a visual totality. Modern scholars too may "visit" the Stanza, obviously, but habits of perception shaped by academic art history make it hard to avoid fragmenting what Vasari saw as a continuous whole. Typically, twentieth-century viewers fight their way through crowds to get into the room and, amid the babble of guides and tour leaders, shift attention from "masterpiece" to "masterpiece," seeing what art books and slide lectures have taught us to see: separate pictures.

Connected with the distinction between Renaissance "visitors" and modern "viewers" are several more serious differences in perception. Unlike us, medieval and Renaissance Italians entered painted rooms such as the Stanza della Segnatura confident that they would recognize what they saw and be able to make sense of the interlocking themes on the different walls. They "visited" an iconographical program, that is, as one visits acquaintances, expecting to understand the conversation and to take part in it, on the basis of shared experience and interests. An example of how complex such "insider" dialogue could be – one probably known to Raphael and which has parallels with the imagery of the Stanza – is the Chapter Hall of the Dominicans at Santa Maria Novella in Florence, the so-called Spanish Chapel, decorated by Andrea Bonaiuti about 1365. There, as later in Raphael's painted room, one of the two principal walls depicts thinkers (Saint Thomas Aquinas, with Old and New Testament personages), and the other bears a composite illustration of the traditional understanding of the Church and the "economy" of the religious life, related subjects that visitors in former times were expected to understand and be interested in but that modern viewers often find abstruse and visually discontinuous.[3]

Another example, chronologically and stylistically nearer the Stanza, is the refectory at Santa Maria delle Grazie in Milan, where in the mid-1490s Leonardo da Vinci painted his *Last Supper* opposite an

only slightly earlier *Crucifixion* by local Lombard masters at the room's other end. For habitual visitors to the refectory – the friars themselves and educated laymen – the narrative and theological connections between the two scenes must have been compelling: on one wall, Jesus' announcement Holy Thursday evening that one of his disciples would betray him, and on the facing wall the result of that betrayal, the Crucifixion on Good Friday afternoon. In theological terms, visitors saw the "gift" Jesus made of his body and blood sacramentally – the institution of the Eucharist – and, directly opposite, the historical actualization when he gave up his life on the Cross.[4]

The way Vasari saw Raphael's *School of Athens* and *Disputa* in the papal palace must have involved a comparable association of ideas and images on facing walls, since he imagined Saint Matthew among the philosophers, and angels sent by pagan astrologers to Christian Evangelists, who in turn expound the pagans' doctrine. Indeed, his feeling that Raphael's two frescoes were a single composition may have been still more intense than what contemporaries experienced in the refectory at Milan. There, the conspicuous disparity between Leonardo's fluid figure style at one end of the room and the archaic figures at the other interfered with a visitor's sense of unity. In the Stanza della Segnatura, by contrast, the consistent use of perspective on both walls and the uniform figure style create a powerful visual impression of a single scene. What is more, the virtually life-size scale of Raphael's figures, their natural movements, and the great number of contemporary portraits throughout the room must have made sixteenth-century visitors feel that the space at the center of the Stanza was itself part of the composition and that "visitors" were also "players" on a stage that stretched from the *School of Athens* to the *Disputa,* opening to right and left in the *Parnassus* and *Jurisprudence* images.

Again, this is an experience for which Renaissance Italians had cultural equipment lacking in modern viewers. They were familiar with religious theater, where successive and related scenes in mystery plays might be performed on stages at opposite ends of a church nave or around the perimeter of a piazza, with the audience "in between" and thus automatically included in the action. The closest artistic parallels to Raphael's spatial and figural illusion in the Stanza are indeed the frozen dramas at San Vivaldo (Fig. 28), a Franciscan

Figure 28. Anonymous master, facing tabernacles, San Vivaldo, Tuscany. Early sixteenth century.

pilgrimage site in Tuscany, where, starting in the same years Raphael was at work in the Stanza, anonymous architects and sculptors created similar "audience involvement" scenes. In one of these, visitors entered a space between two prosceniumlike edicules; on the "stage" in front were realistic, painted terracotta relief figures of Jesus crowned with thorns and presented to the crowd by his torturers. And behind the visitor, on a facing stage – also in high relief and realistically pigmented – stood "the crowd," looking across real space at Christ in the opposite edicule (Fig. 29). Visitors thus became actors in the event, members of the throng before which Jesus suffering is displayed.[5]

Raphael achieved the same dynamic involvement of the viewer with more sophisticated means. His figures in the *School of Athens* do not look across at the *Disputa* like the crowd at San Vivaldo staring at Christ but seem to move toward the other image, emerging from the depth of a magnificent vaulted structure in which Raphael

Figure 29. Anonymous master, figures looking at Christ, facing the Ecce Homo Chapel, San Vivaldo, Tuscany. Early sixteenth century.

situates them. This impression is especially strong in the two central figures, Plato and Aristotle (Fig. 24), who appear to have paused momentarily in the course of an advancing movement, and in Diogenes (Fig. 1, no. 28) and Heraclitus (no. 29), respectively sprawling on the stairs and projected toward the front plane, at right and left of center. In the *Disputa,* across the room, perspective and figure arrangement are used to get the opposite effect: instead of advancing toward us, the figures at eye level, separated from the viewer by railings at left and right, move into the depth of the scene toward an altar, to which a completely open pavement af-

fords unobstructed visual access. Since the normal traffic flow through the Stanze introduced visitors through a door in the *School of Athens* wall – facing the *Disputa* that is – the impression on entering was (and still is) of advancing, like the figures in the *Disputa* itself, toward the altar and the Eucharist.[6] When the visitor took in the fresco behind him, the *School of Athens,* and saw that Plato and Aristotle too were "advancing," his own movement in the direction of the altar became part of a more significant reality: a stately progress of noble men through a splendid statued hall. Standing in the middle of the Stanza, a Renaissance cleric or layman could believe himself a living component in the movement of history out of pagan antiquity, through the present, and toward the eternity of Christ, an eternity already glimpsed in the sacramental bread displayed on the altar, believed to render really present those higher mysteries that Raphael shows above the altar: the Holy Trinity and the Communion of Saints.

The composition of the two shorter walls reinforces the "processional" movement toward Christ. That on the south – of *Jurisprudence* (which visitors saw first, having only to turn slightly to the left on passing through the door) – shows seated figures, including a portrait of Julius II as Pope Gregory IX, angled toward the *Disputa.* And the northern wall, with the *Parnassus,* creates a transition of levels: from the eastbound assembly in the *School of Athens* (where all the figures are in the lower half of the composition), to this natural hillside over the window (where the higher-placed figures force our eyes to ascend), concluding in the multi-level *Disputa,* with God the Father as the culmination of a rising composition that moves around the room. Intellectually, this movement progresses from philosophy, behind the visitor, through poetry, at the right, to the highest form of "knowledge" and "inspiration," God himself, contemplated in Christ, Mary, and the saints, in the Sacred Scriptures, and in the Eucharist: all shown clearly in the *Disputa.* The Stanza della Segnatura was probably Pope Julius II's library, with book cabinets along the lower walls, containing a fair sampling of the theological, philosophical, poetic, and legal works to which the frescoes allude, and the iconographic program was thus meant to situate the contemporary visitor within a grand procession of human thought, leading to the vision of God himself. This

room where the pope kept his books was to be a *summa* of every-thing Italian Renaissance Christians believed about God's plan for human beings in time and eternity.

The composition of the two main murals, the *School of Athens* and the *Disputa,* suggests that Raphael and those who advised him wanted this "divine plan" to be perceived as unfolding inside a church. The deep-vaulted hall out of which the philosophers ap-pear to move (on one wall), and the railed-off area of the pavement (on the facing wall) with an altar in a semicircular space, would have put Renaissance viewers in mind of the nave and apse of a church, as Luisa Becherucci noted.[7] The architecture of the *School of Athens* in fact evokes Bramante's project for the new Basilica of Saint Peter, begun a few years earlier, and this whole "progress of human knowledge toward God" may have been conceived in relation to the teaching authority of Saint Peter's successors, the popes. In any case, the movement of human intellectual and spiri-tual history that Raphael illustrated for Pope Julius would have been seen as occurring "in the Church": that is, within the histori-cal institution of which the pope is visible head as Vicar of Christ.

This "ecclesiology" – this range of ideas about the Church as institution – did not originate in the early sixteenth century. The same basic themes are in fact implicit in the program of the fourteenth-century Spanish Chapel, mentioned earlier, where one wall shows an assembly of thinkers and the facing wall has a symbolic, multi-level description of religious life on earth and Christ and the saints in heaven. What is new in the Stanza della Segnatura is Ra-phael's depiction of pagan thinkers "in the Church." Few Renais-sance images suggest a comparably syncretistic vision of intellectual history; perhaps the sole significant parallel is Giovanni di Stefano's monumental pavement square inside the main door of Siena Cathe-dral, where the secret learning of the pagans, transmitted by Hermes Trismegistus (identified in an accompanying inscription as "the con-temporary of Moses") introduces believers to the cathedral.[8] But no fifteenth- or sixteenth-century artist ever attempted what Raphael was asked – or at least permitted – to show in the Stanza della Segnatura: the great figures of Greco-Roman and ancient Near Eastern thought, who, as they converse and exchange ideas, them-selves seem to move toward Christ, in whom ultimately "all the

jewels of wisdom and knowledge are hidden," according to the New Testament (Col. 2:3).

The convictions underlying this highly original reading go far back in Christian history. Among the first defenders of the "Christianity" of the pagan philosophers was Saint Augustine, himself schooled in ancient thought and, before his conversion, a sometime adherent of Neoplatonic mysticism. In a beautiful passage in his treatise "On True Religion," Augustine argued that "if Plato were alive today, and willing to answer our questions . . . he would teach that truth is not seen with bodily sight, but by the mind alone, and that every soul which cleaves to truth becomes perfectly happy." Carnal pleasure (to which Augustine had been no stranger in his youth) impedes the soul from attaining this beatific state, he argues, since matter and sense generate a confusing diversity of "opinions" in place of truth, which by contrast is clear and simple. Only when healed by God's grace is the soul able to "intuit the immutable Form of things: that ever equal beauty, always like itself, unextended in space, unchanged in time, the beauty that preserves itself in all things single and identical – that beauty which men do not believe in, yet which really exists, and indeed exists in the highest measure of being."[9]

The way Saint Augustine juxtaposed these standard Platonic categories has structural similarities with Raphael's visual contrasts in the *Disputa* and the *School of Athens:* on the one hand, "ultimate truth," a higher reality invisible to bodily sight, unextended in space, unchanged in time, single and identical, versus the multiplicity of material things. In the *Disputa* we are shown the "beauty which men do not believe in, yet which exists in the highest measure of being," God, who is "unextended in space" (depicted in fact against an archaic, gold-leaf background). By contrast, in the *School of Athens* Plato points heavenward to a "higher truth" that is still invisible: the space defined by the architecture overhead remains unoccupied. Turning, then, from this "profound" but "empty" space of pagan speculation back to the populous spacelessness of the upper portion of the *Disputa,* it is clear that Raphael intended the facing areas of wall to be complementary: the great arches of the *School of Athens* mirror the semicircle of Christ's cherub aureole, giving "material" depth to what in itself is immaterial and "unextended."

Another structural contrast between Raphael's two scenes de-

pends on the second Platonic distinction evoked by Saint Augustine: that between the "multiplicity" and "diversity" of sense experience, on the one hand, and spiritual beauty, which is "single and identical," on the other. The central compositional unit of the *School of Athens* is "multiple" and "diverse": the binary group of Plato and Aristotle, implying the pluralism of ancient classical thought. On the opposite wall, in the *Disputa,* the central unit of composition is "singular" and "identical": the vertical core of forms lifting our eye from the Eucharist to the Spirit, Christ, and the Father – "one God in three Persons." This central "oneness" in the *Disputa* is further emphasized by the gazes and gestures that many of the lower-level figures direct toward the altar, very different from the breakup into self-absorbed, psychologically unconnected groups in the *School of Athens.* Again, it is a calibrated complementarity and seems to allude to the most difficult conundrum of ancient thought: the contradictory claims on consciousness of the One and the Many – the urge toward synthesis and belief in an underlying unity in nature and experience, apparently at odds with the infinite multiplicity that sensory data reveals.

The *School of Athens* and the *Disputa* are not mere negative foils, however. The two frescoes illustrate a positive progression: the philosophers "move toward Christ," the pagans are "in the church." This notion was in fact deeply rooted in the Italian humanism of the fourteenth and fifteenth centuries. Giovanni Boccaccio, for example, applying the question of the One and the Many to the basic religious issue of monotheism versus polytheism, insisted that the ancients had used polytheistic language for literary reasons, not because they really accepted a multiplicity of gods. "Who is witless enough to suppose that a man deeply versed in philosophy hadn't more sense than to accept polytheism?", he asked. Those ancient sages were "most devoted investigators of truth and went as far as the human mind can penetrate. Thus they knew beyond any shadow of doubt that there is but one God . . . The multitude of other 'gods' they looked upon not as gods but as members or functions of Divinity; such was Plato's opinion, and we call him a theologian."[10]

Building on these ideas, another early humanist, Coluccio Salutati, claimed that, although the full mystery of God – the mystery of the Holy Trinity, that is – remained hidden from pagan

writers, "nevertheless, much that they said about their own gods, while they struggled to lift them to the majesty of deity . . . was in conformity with the true God." That is, Salutati saw polytheism as an effort to penetrate "the mystery . . . and profundity of the Trinity" – ultimate source of both "oneness" and "manyness" in all that exists: the Trinity, a single deity (Salutati calls God "the supreme simplicity") in whom, however, are three Persons: Father, Son, and Holy Spirit (699–703).

Perhaps the clearest exposition of these ideas is Giovanni Caldiera's "Concord of the Poets, Philosophers and Theologians," written in the mid–fifteenth century. Insisting that the ancient pagans really (if obscurely) understood God, Caldiera distinguished three levels of apprehension of the mystery: philosophical, poetic, and theological. He also used literary images strikingly similar to the visual ones Raphael later introduced in the Stanza della Segnatura. Caldiera said that "philosophers . . . observing the first causes of things" (as in the *School of Athens,* above which is written "causarum cognitio"), situated the generative force of all life in the elements. Some "thought it fire, still others water or earth . . . wherefore the poets assigned the principle of divinity to the prime elements," he concluded (704–7). Caldiera considered these ancient poetic paraphrases of philosophical intuitions "higher," nearer ultimate truth – much as, in the Stanza della Segnatura, the assembly of poets on Parnassus occupies higher ground than that of the philosophers in the *School of Athens* and is nearer the level of God in the *Disputa.*

Turning to Sacred Scripture, Caldiera argued that "besides this natural kind of knowledge" furnished by philosophy and poetry, "there is another mode in which the divine light is infused into our minds": revelation, the heaven-sent information about supernatural realities – what the inscription above the *Disputa* calls *divinarum rerum notitia.* Caldiera cites Jewish and Christian authors who "transmitted these predictions to us in writing after the Son of God had assumed human flesh and protected a secret divinity beneath the veil of humanity in order to fully complete the mystery of the Passion and redeem lost humankind." And in the *Disputa,* Raphael in fact illustrates these "writings," the four Gospels displayed by putti directly below Christ "veiled" with humanity and showing the wounds of his Passion. Finally, to explain what "redemption"

consists of, Caldiera turned to the Trinity (the centermost subject of Raphael's *Disputa*), averring that "we have received from Christ's teaching the complete explanation of the Father, Son and Holy Spirit" (704–7).

For Caldiera, men and women are saved by understanding and accepting the Trinity, the mystery of love among Persons of the Godhead that is the inner life of God himself. The ancient pagans, he says, intuited this, but dimly: they "saw the splendor entirely through a cloud." The Jews saw the splendor of divinity beyond the cloud but could not distinguish the three Persons. Christians inhabit the cloud and therefore distinguish divinity and Trinity. "But certain men who are closer to divinity dissolve the cloud as though they were living in heaven, and see divinity and the entire mystery of the Trinity clearly, and everything that we hold by faith, they know by certain knowledge" (704–7). These ideas seem to be echoed in the *Disputa,* where "certain men" are closer to divinity, "living in heaven": the saints on the "dissolved cloud" of the upper level, including Mary and John the Baptist, all able to see God in Christ, who "assumed human flesh." Raphael in fact emphasizes the "fleshiness," showing Jesus' upper body nude, with the wounds visible. This intellectually "revelatory" function of the incarnate Christ is stressed by other fifteenth-century thinkers: some years after Caldiera, Marsilio Ficino asks, "What else was Christ but a certain living book of moral and divine philosophy, sent from heaven and manifesting the divine idea of the virtues to human eyes?" (741). Here in the pope's library, Raphael shows us that "living book of moral and divine philosophy," Christ in the center of the *Disputa,* as the "higher truth" about which the discussants in the *School of Athens* obscurely reason, not yet able to penetrate the veil beyond which only faith in the Incarnation and the Passion lead.

There is a still more extraordinary aspect to these interconnections, however. Educated people in the Renaissance believed that if the pagan philosophers could reason about the mystery of God it was not by their own powers, not the result of merely human dialectical skills. As Ficino insisted, if the Greek philosophers "have any outstanding dogmas and mysteries, they usurped them from the Jews . . . Plato imitated the Jews . . . was nothing but Moses speaking in the Attic tongue . . . and the Platonists used the divine light

of the Christians to interpret the divine Plato. This is what Basil the Great and Augustine proved: the Platonists usurped the mysteries of the Evangelist John for themselves" (741–2). That is, the obscure intuitions of a spiritual truth akin to Judeo-Christian belief that we find in ancient philosophy and poetry can be explained by the early influence of Jewish prophecy and the Mosaic Law on Greek thought. Ficino says that the Greeks did not clearly understand what they had "usurped" but nourished the hope of one day attaining to full enlightenment. "Plato predicted in his letters that these mysteries could at length become manifest to men after many centuries," Ficino says, adding that "this indeed happened . . . immediately after the preaching and writing of the Apostles and apostolic disciples. For the Platonists used the divine light of Christians to interpret the divine Plato" (742).

What these humanists were expressing, and what Raphael illustrated in the grand facing frescoes of the Stanza, is a millennial Christian belief that every human quest for wisdom is inspired by God, the universal Father, who – through his Spirit of truth, and often across centuries of slow cultural evolution – brings men and women to Christ, "the power and wisdom of God" personified (1 Cor. 1:25). A first-century Christian text describes the privilege of believers who, after countless centuries of human striving, understand what earlier seekers never grasped: the Letter to the Ephesians states that God "has let us know the mystery of his purpose, the hidden plan he so kindly made in Christ from the beginning, to act upon when the times had run their course to the end" (Eph. 1:8–9)

In their search for wisdom, Raphael's pagan thinkers are part of God's "hidden plan . . . made in Christ from the beginning." They have embarked upon a search that will end only when the void above Plato is filled and men at last lift their eyes from the multiplicity and diversity of speculative reason to that "living book of moral and divine philosophy sent from heaven" who is Christ. And when they do, the lesson this "living book" will impart is precisely that of unity in diversity: the solution to the ancient problem of the One and the Many. The "hidden plan" that God "so kindly made in Christ from the beginning," the Letter to the Ephesians continues, was that "he would bring everything together under Christ, as head: everything in the heavens and everything on earth" (Eph. 1:9–10). In Christian belief, in fact, Christ is the source of all unity

and multiplicity: he is a visible "image of the unseen God" (Col.
1:15) and thus "supreme simplicity" (in Salutati's phrase). At the
same time he is God's "Word" through whom all the world's
diversity was defined: "In him were created all things in heaven
and on earth" (Col. 1:16). Throughout time, moreover, "he holds
all things in unity" (Col. 1:17), reconciling the inherent contradic-
tion between manyness and oneness: resolving the problem when
he reveals that the Divinity itself is simultaneously multiple and
single, three Persons in one God.

The pagan thinkers have a place "in the Church" because God's
hidden plan always included them, even before they realized it. In
their obscure but God-given insight that ultimate wisdom is
higher than material existence and in their yearning to solve the
riddle of the One and the Many, they furnished an intellectual
framework upon which later ages would build: helped move
history toward Christ, "the living book . . . sent from heaven."
They have always been in the Church, and – in the physical and
moral space of the Stanza – they "stand behind" the Renaissance
Christian who, entering, found himself "in front of" them: more
advanced, better able to behold a plenitude to which the pagans
never raised their eyes. The plenitude is Christ, in the *Disputa* on
the opposite wall: a spiritual God revealed in bodily form as true
man, who overcomes the tragic division in human nature and
society, giving his life on the Cross. Standing in this "church" that
spans the ages, with the pagans behind him in the "nave," a
Renaissance humanist might have remembered another passage
from the Letter to the Ephesians:

> There was a time when you who were pagans . . . were im-
> mersed in this world, without hope and without God. But now
> in Christ Jesus, you that used to be so far apart from us have been
> brought very close, by the blood of Christ . . . Through him,
> both of us have in the one Spirit our way to come to the Father.
> So you are no longer aliens or foreign visitors: you are citizens
> like all the saints, and part of God's household. You are part of a
> building that has the Apostles and Prophets for its foundations,
> and Christ Jesus for its main cornerstone. As every structure is
> aligned on him, all grow into one holy temple in the Lord; and

you too, in him, are being built into a house where God lives, in the Spirit. (Eph. 2:11–22)

Only a few hundred feet from where Bramante's new basilica was being built, and even nearer the chapel in which Michelangelo paired pagan Sibyls with the Prophets of Israel, Raphael opened the "house where God lives, in the Spirit" to admit the ancient philosophers, poets, and lawgivers. His is indeed a "catholic" – that is, universal – image of the Church, and the glory that opens up before Plato and Aristotle in the *Disputa* on the facing wall is a glory meant for all.

NOTES

1. Vasari-Milanesi, Vita di Raffaello, in Vasari-Milanesi, 1568, 4:315–86, esp. 330–6.
2. Vasari-Milanesi, 1568, 4:331, n. 1, says, "che guazzabuglio!."
3. Timothy Verdon, "Christianity, the Renaissance and the Study of History: Environments of Experience and Imagination," in Timothy Verdon and John Henderson, eds., *Christianity and Renaissance: Image and Religious Imagination in the Quattrocento* (Syracuse: Syracuse University Press, 1990), 1–37; Verdon and Henderson, "L'uso iconografico della Bibbia," in Rinaldo Fabris, ed., *La Bibbia nell'epoca moderna e contemporanea* (Bologna: Edizioni Dehoniane, 1992), 83–99.
4. Verdon, "L'uso iconografico della Bibbia" (as in n. 3 of this chapter).
5. S. Borsetti, ed., *Gli abitanti immobili di San Vivaldo, il Monte Sacro della Toscana* (Florence: Giunta Regionale Toscana, 1987); Peter Meredith and John E. Tailby, eds., *The Staging of Religious Drama in Europe in the Later Middle Ages: Texts and Documents in English Translation,* Early Drama, Art and Music Monograph Series, no. 4 (Kalamazoo: Medieval Institute, Western Michigan University, 1983); Timothy Verdon, "Effetti speciali nello spettacolo e nell'arte quattrocentesca," *Biblioteca teatrale,* n.s. 19–20 (1990), 7–20.
6. Shearman, 1972, 3–58 (see esp. 13–17, with Shearman's conclusions regarding the "traffic flow" through the rooms as originally used).
7. Becherucci, 1969, 9–198 (esp. 97–9). See also, for the iconography of the *Disputa* but with developed reference to the *School of Athens,* Pfeiffer (Rome: 1975).
8. Friederich Ohly, *La cattedrale come spazio dei tempi: Il Duomo di Siena,* trans. Maria Augusta Coppola, Monografie d'Arte Senese, no. 8 (Siena: Accademia Senese degli Intronati, 1979), 36–7.

9. Saint Augustine, *De vera religione,* 3, 3, quoted in Maria Bettetini, ed. and trans., *Aurelio Augustino: Ordine, Musica, Bellezza* (Milan: Rusconi, 1992), 287–8. My translation.

10. The citations and paraphrases from humanist writings are taken from Charles Trinkaus, *In Our Image and Likeness: Humanity and Divinity in Italian Humanist Thought,* 2 vols. (Chicago: University of Chicago Press, 1970), 2:696. Cited hereafter by page number in the text.

INGRID D. ROWLAND

THE INTELLECTUAL BACKGROUND OF THE *SCHOOL OF ATHENS*: TRACKING DIVINE WISDOM IN THE ROME OF JULIUS II

> The spirit will not settle for images; it yearns to pursue reality. The picture of a fountain does not quench thirst; it only stimulates it, and, if anything, sets it on fire.
>
> Egidio da Viterbo, "Sententiae ad mentem Platonis"

Raphael's *School of Athens* (Fig. 5) decorates one wall of a room in the Vatican Palace now known as the Stanza della Segnatura – the "signing room" – because for much of the sixteenth century it was used as the public audience hall in which the pope signed his bulls.[1] Pope Julius II probably intended the room to serve a somewhat more intimate purpose; Léon Dorez, Deoclecio Redig de Campos, and John Shearman have argued convincingly that it was designed to house the pope's private library of some 218 books.[2] Giovanni Morello has further shown that the room was actually known in Julius's time as the "upper library" (*biblioteca superiore*).[3] As these scholars all observe, there are few paintings more deeply involved with books and reading than the four frescoes of the Stanza della Segnatura.

Thanks in large part to the efforts of his successor Leo X and the great Flemish humanist Erasmus, Julius II has come down to posterity with the reputation for aggressive action rather than deep thought.[4] The size of his personal library, substantial but not immense, has sometimes been adduced as evidence of his scant interest in bookish matters.[5] At the very least, the Stanza della Segnatura, with its painted exaltation of books and learning, should

be sufficient to refute such a conclusion. In fact, however, the private library housed in the papal suite functioned in tandem with another library, the Biblioteca Apostolica Vaticana, the great Vatican Library, founded by Nicholas V in the mid–fifteenth century and substantially reorganized in 1475 by Pope Sixtus IV, together with his cardinal nephew Giuliano della Rovere, the future Julius II.[6] Since the time of Sixtus the Vatican Library's already impressive holdings had been housed in a suite located two floors beneath the Stanze.[7] Thus, from the beginning of Giuliano della Rovere's ascent within the hierarchy of the Church, the Biblioteca Vaticana had played a crucial role in his thinking about religion, about the papacy, and about himself. By the time the cardinal nephew had himself become pope, his new Stanza would serve as the stately housing for a personal collection that drew upon, and accurately represented, the Vatican Library as a whole.

The characterization of Julius as aggressive is perfectly fair; this he was, to an extreme degree.[8] However, the original purpose of the papal library was itself aggressively active: the institution's complete name, the Biblioteca Apostolica Vaticana, shows that it was (and is) conceived as a means of spreading the Christian Gospel through the promotion of knowledge, intended, in the words of Sixtus himself, to function "for the enhancing of the Church militant, for the increase of the Catholic faith, and for the convenience and honor of the learned and studious."[9] To the popes of the fifteenth century, the collected wisdom of their forebears served to demonstrate the universal validity of Church doctrine, and doctrine could be significantly deepened by knowing the foundations on which it had been based. These foundations included the three wisdom traditions by which, in the eyes of the fifteenth-century popes, God had prepared humanity to understand the meaning of Christ when he appeared in Palestine during the first decades of the Roman Empire. The first of these wisdom traditions was that of the Old Testament, the second that of Greco-Roman antiquity. The third was a complex that the scholars of the fifteenth century termed *prisca theologia*. In effect, *prisca theologia* represented the ancient civilizations of which the Greeks and Romans themselves had been aware and to whom they themselves attributed powerful traditional wisdom: Egyptian, Babylonian, Persian, and Etruscan.[10]

The Vatican Library's original collections thus included far more

than Bibles, the writings of the Church Fathers, and those of the
Scholastic theologians. Works by ancient Greek and Roman authors
stood alongside the "Egyptian" prophecies of Hermes Trismegistus
and the biblical commentaries of the Jewish Neoplatonist Philo of
Alexandria (first century A.D.).[11] We may gather something of
Giuliano della Rovere's importance to this collection from the
fresco that adorned the library's entrance wall from the time of his
involvement with it.

In many respects Melozzo da Forlì's fresco for the entrance of
the Vatican Library is a frontispiece, not for a single volume but for
a whole collection of books. *Sixtus IV Organizes the Vatican Library,
1475,* painted in 1477 (Fig. 30), argues for the fundamental role of
the Vatican Library in shaping the Sixtine papacy's presentation of
its own place in the history of Rome.[12] The other custodians of the
pope's future reputation are the papal nephews, whom Melozzo
paints with penetrating eye as they assemble around their uncle.[13]

An elderly Pope Sixtus IV sits enthroned to the far right of the
composition, flanked by one nephew in holy orders. He is the
eighteen-year-old Raffaele Riario, who hovers at his uncle's right
hand; in December 1477 he would be rewarded with a cardinal's hat.
At the pontiff's red-shod feet, facing him, kneels the library's first
custos, or librarian, Bartolommeo Sacchi, a humanist in the papal
court, customarily known by his Latin sobriquet "Platina." The teal-
robed scholar, just a hint of lace at his cuff, points downward toward
a fictive marble plaque, set beneath the dedication scene on which
the pope's achievements are acclaimed in Platina's own Latin ele-
giacs. Behind the librarian, at the center of the fresco, glowers the
pope's powerful cardinal nephew Giuliano della Rovere, at thirty-
four a man in the prime of his maturity.[14] Two other nephews, clad
in fur-lined velvet and wearing ponderous ornamental chains
around their necks, stand off to the left. The stocky lantern-jawed
man in red is Giovanni della Rovere, prefect of Rome and the
brother of Cardinal Giuliano. The willowy blond is Girolamo
Riario, Sixtus's main confidante on military matters. Their relative
insignificance to the scene at hand is made evident by their own
rather vacant stares into indeterminate space, and more explicitly
evident by the way in which Platina and Cardinal Giuliano are
showing them both their capacious backs. The interactions among
Pope Sixtus, Raffaele Riario, and Giuliano della Rovere, on the

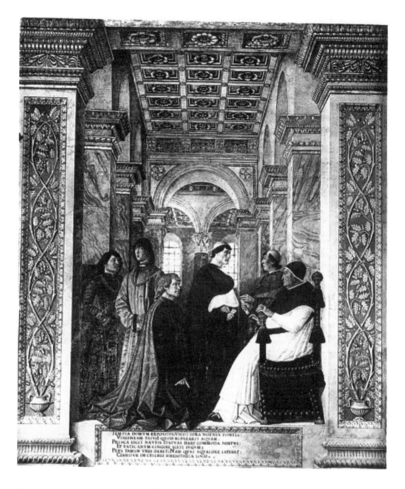

Figure 30. Melozzo da Forlì, *Sixtus IV Organizes the Vatican Library*. Vatican, Pinacoteca. (Photo: Vatican Museums.)

other hand, are anything but vacant. Inveterate rivals for their uncle's favor, Giuliano della Rovere and Raffaele Riario would become two of the most influential men of the Italian Renaissance – patrons, builders, and holders of the Vatican's purse strings. In Melozzo's fresco, still young men, they avoid each other's glances with studied nonchalance. The diminutive Riario plants himself close to the impassive pope, at his auspicious right hand; the uncle's physical bulk and the parallel profile make the clear implication that

this blue-clad, pallid nephew himself expects one day to be eminently *papabile*.[15] Raffaele Riario may stand at the pope's right hand, but the fresco's center has been occupied by the strapping frame of Cardinal della Rovere, resplendent in crimson and ermine. Through half-closed eyelids he scowls quite beyond his cousin in the direction of the pope; Riario looks back, blinkingly attentive. Cardinal Giuliano's stance itself is vaguely menacing; he seems to have stepped forward just a moment before, crowding his younger cousin back behind the papal throne. And yet the aggressiveness of his stance can hardly match the expression in Cardinal Giuliano's eyes, a gaze whose withering arrogance very nearly pins Raffaele Riario to the wall behind him. By moving just off-center, Cardinal Giuliano has revealed the capital and part of the shaft of a single Corinthian column, standing in odd isolation from the otherwise neatly bilateral symmetry of the fresco's architectural setting. The juxtaposition of human figure and column had become by 1477 an iconographic commonplace in art, just as "pillar of the Church" had long ago entered Vatican rhetoric: there is no doubt here who acts as the true support for the Vatican Library. As if to drive home the point, Melozzo has paired the cardinal with the kneeling figure of Platina, a graying, tall man who directs our attention to the fictive commemorative plaque below him with stately insistence. Melozzo's image has made it abundantly clear that the Apostolic Library of 1475 was no institution for the meek and bookish; conceived as an active agent in promoting the Gospel, it was placed in the hands of an energetic, if not downright pugnacious, crew.[16] Within Rome itself, as Platina informs us in his elegiac caption to the fresco, the Biblioteca Apostolica comprised the crowning episode in Sixtus's grand scheme of urban planning, a scheme entirely conceived, in the ancient Roman tradition, to include "temples" (the humanists' Ciceronian term for churches), bridges, aqueducts, ports, and city walls, but none of these enterprises was more weighty than the library itself.[17] These are Platina's own words on the subject:

> With churches and palace restored, and the streets, fora, city
> walls, bridges,
> Now that the Aqua Virgo at Trevi is back in repair,
> Now you may open our age-old port for the shippers'
> convenience,

And girdle the Vatican grounds, Sixtus, with a new wall.
Still, Rome owes you more than this: where a library
 languished in squalor,
Now it is visible in a setting befitting its fame.[18]

Platina's elegy reminds the fresco's viewers that the elderly pope,
sitting in evident discomfort on his curule chair, has been a vigor-
ous planner and builder in Rome itself. Paradoxically, however, in
this image it is the world of ideas contained in the Vatican Library,
just a suggestion of its brightly lit interior visible behind its "pillar,"
Cardinal Giuliano, that represents the pope's most active interven-
tion in the restoration of Rome.

The running of the Vatican Library may have been charged to
Platina, but Cardinal Giuliano seems to have had some conspicuous
role in promoting the institution itself, a role that is clear mostly from
Melozzo's fresco and a smaller fresco in the Ospedale di Santo
Spirito, where again the Cardinal and the librarian stand in tandem
to present the library to the pope.[19] Some thirty years later, the
Stanza della Segnatura takes up this same task of promotion, aiming
at the restricted circle of dignitaries who might visit the pontiff in his
private apartments. Privacy, for Julius, was never much of a solitary
state; the diaries of his masters of ceremonies detail the comings and
goings of an endless parade of retainers, friends, and visitors.[20] For
these people the frescoes of the Stanza della Segnatura provided a
visual key to the way in which their pontiff interpreted his role as
head of the Church. It was an epic role. He threw himself into it
with all the ferocious impatience of his advanced age and his frail
body, aware, as his contemporaries remarked, that he had limited
time left in which to change the world as he saw fit.[21] Those who
were slow to understand what Julius II had in mind were likely to be
enlightened by blows of his cane.

On a basic level, the frescoes of the Stanza della Segnatura repre-
sent the four divisions into which several contemporary humanistic
libraries organized their holdings: Theology, Philosophy, Letters (or
Poetry), and Jurisprudence.[22] In the Stanza della Segnatura, these
divisions are labeled as such by Latin inscriptions on the ceiling
above each wall. Within the four-part scheme, the *School of Athens*
stands for Philosophy, a subject that in both the ancient and the
Renaissance world included the wide variety of technical and scien-

tific learning known as "natural philosophy." Hence the ceiling inscription specifies Philosophy as *causarum cognitio:* the "knowledge of things," rendered in a Latin phrase whose lofty pedigree goes back to Cicero and Virgil.[23] The personified Philosophy (Fig. 11) holds two volumes representing the two great divisions of her subject: "Moral" and "Natural."

Raphael's painting presents certain immediately recognizable figures from classical antiquity: statues of Apollo, god of music (Fig. 13), and Minerva, goddess of wisdom (Fig. 14), as well as the portraits of famous philosophers such as Plato, Aristotle (Fig. 24), and Socrates (Fig. 18). In the Rome of Julius II, however, these familiar figures often appear in art and literature with added meanings that are highly specific to the papacy and its aspirations; they are marshaled, in other words, in particular combinations in connection with particular ideas. They retain their conventional meanings: Minerva still denotes wisdom, Socrates is still the restless questioner, but the precise significance of wisdom or restless inquiry reflects the pope's own careful attention to the imagery of his reign.

Julius has left a relatively scant personal record. He hated public speaking and never sat still long enough to write a journal.[24] However, Rome was full of people willing to speak for him and about him. A particularly useful source for a deeper understanding of the specifically Julian ideas animating the *School of Athens* is provided by the orators of the papal court, whose task of presenting the pope's programs in words meshed with the work of artists like Raphael and the papal architect Donato Bramante, who performed the same service through the visual imagery.[25] The orators themselves were a diverse group, linked by a few shared characteristics: a reputation in their own day as outstanding speakers, the conviction that papal Rome promised the Christian fulfillment of all that had been good about classical antiquity, and a strong dose of personal ambition, which took fire in the presence of this furiously active pope.[26] Aside from these generic similarities, however, the three orators with whom we shall be concerned could hardly have been more different: Battista Casali, Egidio Antonini da Viterbo, and Tommaso ("Fedra") Inghirami.[27]

Battista Casali (1473–1525) was a professor from the age of twenty-three at the Studium Urbis, the university of Rome, a rumpled, long-haired academic with an academic's tendency to

rebel against such restrictions on his self-expression as appropriate clothing or protocol. Despite his eccentricities, he made fairly regular public appearances under Popes Julius II and Leo X.[28]

Little more physically prepossessing was the powerful Egidio Antonini da Viterbo (1469–1532), prior general of the Augustinian Order, at eight thousand members (including the young Martin Luther) the largest monastic order of its day. Dressed in his black Augustinian robes, with his long black beard and tousled black hair, Egidio looked slightly sinister until he began to speak.[29] Then, eyes flashing and hands waving, he sent his listeners on strange journeys of the imagination, to the center of the sun, off to the New World or Madagascar, or into the structure of the human soul. When he followed his stylish Latin with an Italian translation, he could sway crowds of hearers from every walk of life.[30] In the Rome of Julius II, he had no equal as an orator, and Julius knew it as well as anyone. The pope, notorious for dozing through any speech longer than a quarter of an hour, could listen to Egidio da Viterbo for two hours at a stretch, never missing a word.[31]

As fastidiously neat as Battista Casali and Egidio da Viterbo were unkempt, Tommaso Inghirami (1470–1516) was the impeccably mannered, impeccably dressed librarian of the Vatican from 1508 to 1516. His contemporaries called him "Fedra" or "Fedro," after his bravura performance at the age of sixteen in a production of Seneca's *Hippolytus,* staged at the palace of Cardinal Raffaele Riario: as Queen Phaedra, the young man had extemporized in Latin, brilliantly and imperturbably, while a stage set collapsed behind him. In later life, the pretty youth had grown enormously fat. The obesity accentuated his wall eyes and effeminate manners, but even so, in scripted dramas as in life, Fedra remained Rome's greatest actor, and an orator equaled only by Egidio da Viterbo for dramatic eloquence.[32]

The image of a School of Athens first appears in an oration delivered by Battista Casali on 1 January 1508, shortly before Raphael was charged with frescoing the Stanza della Segnatura. Within the context set by Casali's oration, a complex of ideas developed by Egidio da Viterbo during the Julian papacy suggests what specific meanings might be attached to various figures in Raphael's *School of Athens.* Busy Egidio, however, could never have spared the time to consult with Raphael about developing a

coherent artistic celebration of literature with which Raphael himself had no direct contact. The most likely person to have performed such an intermediary function, for a variety of reasons to be discussed subsequently, is none other than Fedra, librarian of the great Vatican collection from which the Stanza della Segnatura drew its inspiration.[33]

Battista Casali's oration of 1 January 1508 was delivered in the Sistine Chapel *coram papa,* that is, in the presence of Julius himself, to celebrate the Feast of the Circumcision. Christian males in early sixteenth-century Rome did not undergo circumcision; hence, most of Casali's homily sought to raise the practice from a specific initiation rite for Jewish males to a metaphor for the sense of self-limitation and self-sacrifice that marked the Christian concept of humility. At the very end of his oration, however, Casali says the following:

> Once . . . the beauty [of Athens] inspired a contest between the gods, there, where humanity, learning, religion, first-fruits, jurisprudence and laws are thought to have arisen and been distributed to every land, where the Athenaeum and so many other gymnasia were to be found, where so many princes of learning trained her youth and schooled them in virtue, fortitude, temperance, and justice – all of this collapsed in the whirlwind of the Mohammedan war machine.

> But . . . just as [your uncle, Sixtus IV], as it were, laid the foundations of learning, you set the cornice upon it. There is the pontifical library which he erected, in which he has, as it were, brought over Athens herself; gathering what books he could from the shipwreck he established a very image of the Academy. You, now, Julius II, Supreme Pontiff, have founded a new Athens when you summon up that prostrated world of letters as if raising it from the dead, and you command that, amid threats of suspended work, that Athens, her stadia, her theaters, her Athenaeum, be restored.

> To be sure, your other projects are magnificent indeed and splendid, yet I do not see how, without [letters] to celebrate them, they would not remain voiceless and mute. Yet this Athenaeum you have restored shall never grow silent. Every day it will sing your praises in a hundred tongues, and when those other projects

are ruins, so long as these texts are read, they shall rise again day after day, and forever the memory of them shall be renewed. This is why, Blessed Father, you achieve what your soldiers shall never conquer by arms, shackling your adversaries with bonds of learning, learning with which, as with a sponge, you will erase all the errors of the world and circumcise the ancient roots of evil at their base with a sickle of adamant.[34]

To Casali, then, the Vatican Library and the learning contained within it are the single most effective Crusade that Julius might mount. As in Melozzo's fresco, the library is a powerfully aggressive institution, an active stimulus, conceivably *the* active stimulus, to the cultural ferment of Julian Rome.

Not too long after Casali's peroration, Ignatius of Loyola would put precisely this idea of learned Crusade into action, with his legions of globe-trotting, brilliant Jesuits. Under Julius, the crusade of enlightenment occurred through other channels, art and architecture conspicuous among them. John O'Malley, who first published the text of Casali's sermon in 1977, pointed out as well its clear bearing on the decorative program for the Stanza della Segnatura.[35]

Casali's sermon gives vivid voice to the Vatican Library's ideological importance in the Rome of Julius II. To learn the exact reasons for which Julius valued its ancient texts, however, we must turn to another of his preachers, probably the most important preacher of them all. Egidio Antonini da Viterbo (Giles of Viterbo), was elected prior general of the Augustinian Hermits in 1507 with the enthusiastic support of the pope.[36] He had already held the post of vicar general for about a year, appointed by Julius II at the death of the previous prior general, Mariano da Genazzano. The pope's hand-picked choice to lead the largest monastic order in the Christian world might have been expected to wield an unusual degree of influence, but the association between Julius II and Egidio da Viterbo went especially deep. A committed proponent of Church reform, Egidio seems at the same time to have supported Julius in his domineering designs for the papacy. Pope and prelate colluded on such disparate projects as Julius's military campaigns of 1510–11 and the convening of the Fifth Lateran Council. Whenever resistance mounted to his belligerent plans, Julius exploited Egidio's famous eloquence to garner popular

support. Without regard for Egidio's health, spiritual or physical, or the prelate's myriad other commitments, the pope dispatched his busy Augustinian spokesman to preach wherever trouble seemed to be brewing: in elliptical public sermons, Egidio warned the French to leave Italy in 1509, urged the Romans to support the Ferrara Salt War in 1510, consoled Sienese businessmen in 1511, spurred on the assembled churchmen of the Fifth Lateran Council in 1512.[37]

The Stanza della Segnatura and its imagery were clearly forged in the same crucible as Egidio da Viterbo's public preaching during these years.[38] The apparent thematic interdependence of frescoed apartment and sacred oratory stems from their shared inspiration by Julius in person. Egidio's sermons were ostentatiously complex, yet they moved large groups of people to action in support of the pope. Raphael's iconography is similarly complex, and yet similarly moving on the most basic level. These shared qualities stem on the one hand from the ardent complexity of the pope's own intelligence, on the other, from the simple, relentless push of his conviction. Whereas Raphael must have worked out the details of his fresco's iconography with the collaboration of a literary scholar (here to be identified as Fedra Inghirami), there is no doubt that the emphases, the layers of meaning, and the straightforward enthusiasm animating the *School of Athens* derive ultimately from the pope. Paolo Giovio, the only contemporary to remark directly on the program of the Stanze, said, indeed, that the first two rooms were executed "to the specifications of Julius II."[39]

Shortly after his appointment as vicar general to the Augustinians in 1506, Egidio da Viterbo began an endeavor to modernize the standard theological guide to the doctrine of the Church, a dull but exhaustive four-part handbook called the *Sentences* (*Sententiae*), composed by Peter Lombard, later bishop of Paris, in the mid – twelfth century (1148–52).[40] The format of Lombard's text, a series of questions and answers, at least reflects the fervid intellectual atmosphere of twelfth-century Paris in its passion to organize. Its concerns range from the mysteries of the Trinity to the practicalities of remarriage. The closely marshaled arguments, organized as a series of points and objections, are fortified by references not only to the Church Fathers but also to the sage of the hour, Aristotle, newly recovered from long oblivion. If Lombard himself was a workhorse, not a genius, and the

Sententiae no more than a convenient encyclopedia, still it eventually engendered a host of commentaries by more insightful souls. In fact, commenting on Lombard's four books quickly became a standard exercise by which aspiring theologians, in Paris and elsewhere, established their claims to university degrees. (Thomas Aquinas, John Duns Scotus, and Aegidius Romanus are just three among the multitude.)[41] Commentaries on the *Sentences* continued well into the humanist era; the most immediate predecessor to Egidio da Viterbo in this arena had been the curialist Paolo Cortesi in 1504.[42]

In his own recasting of Lombard's work, which he called "Sententiae ad mentem Platonis" (The *Sentences* according to the mind of Plato), Egidio da Viterbo took an entirely new approach to this age-old game. His self-appointed task was a daunting one: to reconcile Lombard's quintessentially Scholastic text with the Neoplatonism of Marsilio Ficino, under whose spell Egidio himself had fallen at the turn of the century. Thus his chosen sage is Plato, not Aristotle (hence the title "ad mentem Platonis"), and along with the Church Fathers Egidio intends to cite the wise heads of classical antiquity. Most characteristic of the age, perhaps, is Egidio's conviction that God is beautiful and that an adequate theology must be beautiful as well, in language, in image, and in effect.[43] On an artistic plane, the *School of Athens* performs a nearly identical function, underlining the ways in which Christian theology may have been anticipated in ancient philosophy and making this point with the utmost grace in the world. Its parallels to the "Sententiae ad mentem Platonis" are, as we shall see, remarkable, and they were noted already by Nelson Minnich and Heinrich Pfeiffer some twenty years ago.[44]

This is not to say that Raphael painted the *School of Athens* with a copy of Egidio's "Sententiae" in hand. The text was never completed and therefore circulated only in manuscript. Significantly, however, most of the passages that bear on Raphael's painting appear in the initial sections of the book (the first fifty or so of the Vatican copy's 279 folios), which seem to be among the earliest in order of composition.

A more obvious disparity between text and fresco is posed by the fact that the "Sententiae" were composed in Latin, a language with which Raphael had no great familiarity. On the other hand, the artist had almost certainly heard Egidio preach, and even when

he preached in Latin, that earnest prelate would frequently translate his sermon into Italian *volgare* in order to be understood by every member of his audience.[45] It is clear that the Augustinian prelate's true impact on Julian Rome depended to a great, and now irrecoverable, extent on his verbal encounters with her citizens. He was an avid correspondent, an impassioned conversationalist, a zealous enforcer of reform, and, as all these characteristics imply, an inveterate talker. The "Sententiae ad mentem Platonis" record ideas that must have found forceful spoken expression more often than we know; only a few can be traced now from surviving documents. Raphael, therefore, would have been familiar with the general direction of Egidio's thought. The scholar with whom Raphael must have collaborated in working out the details of the *School of Athens* would have been conversant in a much closer sense with many of the ideas expounded in the "Sententiae" and probably with the text himself; this is particularly true of the collaborator proposed here, Fedra Inghirami.

Despite the fact that it has been filtered through a patron, Julius II, an artist, Raphael, and an unidentified but learned third party (possibly Fedra), the influence of Egidio da Viterbo emerges in two particularly important ways in the *School of Athens*. He, of all his contemporaries, best explains precisely why the ancient philosophers are so important to the early sixteenth-century papacy, and he does so in a rhetorical style that makes striking use of visual imagery. These also happen to be the qualities of Egidio da Viterbo's thought to suffer the most immediate eclipse. His ecumenical visions fell victim to the turmoil unleashed by the Lutheran reform; Luther began as an Augustinian, and the two may well have met in Rome in the winter of 1510. Egidio's remarkable visual sense was largely bound up in mnemonic techniques that went out of general use in the eighteenth century. Ironically, therefore, the great universalist of Julian Rome turned out to be uniquely the creature of a single generation. It was Raphael, who knew Egidio's ideas only at second hand, who was able to create of them a universal statement. And it is to Raphael that we now turn our attention.

Within the Stanza della Segnatura, the *School of Athens* acts in nearly every capacity as a pendant to the *Disputa* directly opposite; in effect the two frescoes portray a Triumph of Philosophy and a

Triumph of Theology. The cause for triumph is the same: each
tradition has discovered, in its own terms, the Trinity of God. For
Christian theology, the Trinity is fundamental. For ancient philoso-
phy, the case must be argued retroactively, and its most eloquent
advocate in Raphael's day was Egidio da Viterbo, whose fascination
with the Trinity was obsessive.

Inspired by Egidio's arguments, the essential message of both
paintings is this: the Trinity, revealed in the Incarnation of Christ,
has offered humanity the gift of participation in God through the
sacraments of the Church. Philosophy had pointed the way for the
ancient Greeks and Romans, as the Hebrew prophets had done for
the Jews. To prove this contention, the "Sententiae ad mentem
Platonis" begins with a demonstration that theology and philosophy
have set themselves the identical task: to know God:

> The highest human good is to be found in that other life which
> is joined to God and sees the divine essence; but here we pursue
> the greatest good that can be granted humanity on earth: that we
> be joined to God as completely as possible, and this is most
> completely possible if we are joined in mind, in will, in contem-
> plation, and in love.[46]

On a wall of a private suite in the pope's Apostolic Palace, there
is no question about the means by which we mortals are intended
to achieve that union "in mind, in will, and . . . in love;" the pope
is as securely implicit as Christ's vicar on earth in Raphael's paint-
ings as he is in Egidio da Viterbo's theology. The terrifying Cardi-
nal Giuliano of Melozzo da Forlì's fresco was now pontiff in his
own right, invested with all the power he had once only craved
and eager to make that power clear to the members of his flock.
From all accounts he was likely to stick an impatient nose into
every corner of his great impending business as pope, especially
artistic works in progress.

Remarkably, however, in the Stanza della Segnatura Julius
evokes his own authority only by allusion. He is more concerned,
particularly in his artistic commissions, to glorify the amplitude of
the divine plan than he is to narrow his attention to his own role
within the institutional Church. This faith in the attractive power
of his universal vision was shrewd as well as visionary, for the
pope's ability to inspire Church reform or, more simply, Christian

faith, greatly exceeded his resources for enforcing them. Julius induced his flock to accept Christian doctrine by unabashed appeal to their aesthetic sense. Thus, Egidio da Viterbo calls his "Sententiae" a "dinner for the spirit," while Raphael presents the details of ancient philosophy and modern theology in artful equilibrium.[47] The initial steps into this complicated world are surprisingly easy.

Saint Paul may have inveighed against the philosophers when he preached in Athens (Acts 17:16–34) and when he wrote his first letter to the Christians at Corinth, but this is not the view that guided Renaissance popes to gather the works of the ancient philosophers into the Vatican Library.[48] To the humanist world, ancient philosophy, by inquiring into matters higher than immediate human needs, had first sent the human mind in search of God. Philosophy prepared the Gentile world to understand the significance of the Messiah's arrival and resurrection, just as the Hebrew prophets had prepared the Jews. The Roman church was explicitly composed of both traditions, whose inseparable harmony has seldom been expressed more effectively than in an early Christian mosaic on the rear wall of the Church of Santa Sabina in Rome. Two stately women, representing "The Church of the Gentiles" and "The Church of the Jews," frame the fourth-century dedication plaque that stands between them, inseparable sisters. The Santa Sabina mosaic has been on view since the time of Saint Jerome; thus, Raphael and Egidio da Viterbo must have known it well when each of them gave new life to the idea it represents.

The Stanza della Segnatura suggests in particular that the resources of every ancient tradition must be brought to bear in order to clarify the knotty doctrine of the Trinity, whose full nature, incomprehensible to human minds, is perceptible only through imperfect representations, like philosophy, or theology – or Raphael's frescoes. In the compositional schemes of the *Disputa* and the *School of Athens,* Raphael has pointedly situated his clearest likeness of this transcendent Christian truth just beyond the actual picture plane: rays, packed with evanescent cherubim, stream down through the *Disputa* from a hidden light source above the painting to bathe the three hypostases: God the Father, the Resurrected Christ, and the Holy Spirit. Raphael's figural images of the Persons of the Trinity in this painting are not, in other words, his most godlike likenesses of God – the light from beyond the fresco transcends them, and its

source remains invisible. The painted Trinity, which we see in its hieratic glory, is only a simulacrum, as remote from trinitarian reality as the triple window that pierces the cupola of the invisible dome of the hall in the *School of Athens* to signify that same Trinity through the abstraction of number.

With marvelous economy, Raphael has embodied the all-important distinction between ancient philosophy's prefiguration of the Trinity and theology's realization of the Trinity of Christ. He does so by manipulating perspective: the *Disputa*'s vanishing point occurs at the elevated Host (Fig. 4). The Eucharist, as a sacrament in which the faithful are believed to partake of Christ's body and blood, makes explicit contact between the divine and the human spheres. In Raphael's hands, this mediating symbol serves at the same time as a visual fulcrum for the painting's compositional system: Trinity and saints are ranged in orderly cloud banks above; humanity mills about in relative chaos below. The vanishing point of the *School of Athens,* by contrast, has been deliberately obscured among the robes and books of Plato and Aristotle, "the two great princes of Philosophy," as Egidio da Viterbo is wont to call them. Just as there is no secure visual anchor for the perspective system, so, too, the texts of Plato and Aristotle offer a glimpse into the mystery of the Trinity without secure physical participation in it.

The perspective structure of the *School of Athens* focuses, as we have seen, on the pairing of Plato and Aristotle, Plato a venerable graybeard, his former pupil Aristotle also well into his own authoritative maturity. Framed by a dome of which we catch only a hint of the pendentives, each of the two philosophers gestures with the right hand while holding a book in the left. Their stance and their gestures can be paralleled in Quintilian's *Institutiones oratoriae* as well as in ancient sculpture; these focal figures are pointedly orator-philosophers. Plato clutches a copy of his *Timaeus,* Aristotle his *Ethics*.[49] The books are clearly labeled in Italian: every literate person who entered the Stanza della Segnatura, even if literate only in *volgare,* was meant to recognize who these philosophers are: "God does not manifest himself only to sages; indeed, He wants there to be no one who does not know him; at least, certainly, there are people who know him who are not sages."[50] The representative texts for the "two great princes of philosophy" have been carefully chosen. Both speak about human attempts to know divin-

ity. Furthermore, both philosophers agree, in defiance of the populous pagan pantheon, that divinity's ultimate expression is One. At the same time, the message is conveyed by gesture in Plato's upraised finger:

> Philosophy, which tracks down all things and examines them, judges that all number and multiplicity are absent from God, as Plato says, and his student Aristotle.
> Humankind has as its purpose the understanding of divine things, as even Aristotle must confess in his *Ethics*. Therefore, if it is necessary to pursue that end, then it is necessary to come to understand God.[51]

This pairing of Plato and Aristotle is both unusual and timely. It, too, surely had drawn its inspiration in significant measure from Egidio da Viterbo. By nature a conciliator, Egidio strove his entire life to knit people, nations, and creeds together. He took special pains in his "Sententiae" to emphasize Aristotle's origins as a student in Plato's Academy, so that, with their "great princes" reconciled, Scholastic might agree with Neoplatonist and empiricist with idealist, Old World with New, that the search for God was a universal impulse and salvation accessible to all people of faith:

> Now these princes of Philosophy can be reconciled, and however broadly there may be disagreement between them about creation, the Ideas, or the purpose of the Good, these points [of agreement] can be sought out and demonstrated . . . [then] they can be seen hardly to disagree between themselves at all . . .
> These great Princes can be reconciled, if we postulate that things have a dual nature, one which is free from matter and one which is embedded in matter . . . Plato follows the former and Aristotle the latter, and because of this [in fact] these great leaders of Philosophy hardly dissent from one another. If we seem to be making this up, listen to the Philosophers themselves. For if we are speaking about humanity, which is, after all, the subject under discussion, Plato says the same thing; he says that humankind is Soul in the *Alcibiades,* and in the *Timaeus,* that humankind has two natures, and we know one of these [natures] by means of the senses, the other by means of reason. Also, in the same book he teaches that each part of us does not occur in

isolation; rather, each nature cares for the other nature. Aristotle, in the tenth book of his *Ethics*, calls humanity Understanding. Thus you may know that each Philosopher feels the same way, however much it seems to you that they are not saying the same thing.[52]

In Egidio's scrupulous lexicon, human happiness begins with intellectual knowledge (*cognitio*) about the world that God has created. He cites a line from Virgil (*Georgics* 2.490) to emphasize the timelessness of this fact: "Felix qui potuit rerum cognoscere causas" (Who knows the causes of things is happy). This same line has given rise to the painted motto *causarum cognitio* of the allegorical figure enthroned in a roundel on the ceiling above the *School of Athens. Cognitio,* intellectual knowledge, gives rise in turn to understanding, *intelligentia,* the transcendent form of intellectual knowledge, stemming from mastery of the kind of knowledge expressed by *causarum cognitio.* "No one doubts that nature is distant indeed from the Divine, just as a human knowledge [*scientia*] is a knowledge of causes produced by demonstration. Divine knowledge is the understanding [*intelligentia*] of causes."[53]

Both knowledge and *intelligentia* follow upon apprehension of God's traces (*vestigia*) in the phenomenal world: these traces are divine qualities, such as order, measure, and beauty, by which Creation reflects the nature of its Creator. Knowledge results from the collection, however haphazard, of information about order, measure, and beauty: most aspects of *vestigia* can indeed be expressed in terms of number. *Intelligentia* is the knowledgeable synthesis of the divine qualities gleaned by tracking *vestigia*.[54] It is something more rational, yet less complete, than wisdom, *sapientia,* which represents the next, higher, stage of enlightenment. Even Aristotle, the arch-empiricist, must acknowledge that his investigations of the phenomenal world point toward the Absolute. His *Ethics* acknowledge the need to investigate both the physical and the spiritual world, and to the exploration of the latter he devoted his *Metaphysics*. But unlike *intelligentia,* which is obtained by human industry and reason, the next step beyond, *sapientia,* can only be attained through an infusion of divine grace. The *School of Athens* is *intelligentia* embodied, the state where beauty and measure and intellectual knowledge declare the glory of their Creator and are

able to discern that part of this glory is divinity's triune nature. This insight is the triumphant achievement of philosophy. The next degree of penetration into the nature of the universe is one of personal relationship, expressed in Egidio's vocabulary as *sapientia,* but also as love, often with striking erotic overtones. Personal relationship with God, to Egidio's mind, required the divine grace of the Incarnation, the clear proof of the Trinity in the person of the resurrected Christ. It could also be approached through personal participation of the faithful in Church and sacraments. Love and *sapientia* are therefore the Triumph of Theology. In the Stanza della Segnatura, they can be found embodied in the resurrected Christ and elevated Host of the *Disputa.*

The theme of triumph is also embodied in Raphael's fictive architecture. Plato and Aristotle are framed by a series of three nesting, barrel-vaulted spaces, two of them corridors in a lofty building, the hindmost a freestanding triumphal arch. Ancient Roman generals who had been awarded a triumph would lead their procession through a series of such arches until they reached the Temple of Capitoline Jupiter, overlooking the Forum. There they offered their spoils of war to the city and its tutelary deity.

Raphael's philosophical triumph is behaving somewhat differently. The members of the victory train are engaged in fervent discussion or rapt in contemplation, and rather than parading about the city, they have already arrived at their temple. The great hall owes its scale to such standing ruins as the Baths of Diocletian, from which, indeed, it seems to derive its spatial sense, and with good reason: baths were a frequent setting for learned gatherings in the Roman world, particularly the great imperial bath complexes, several of which survive to a spectacular extent in modern Rome. The pattern of coffering in the nearer pair of barrel vaults has been borrowed from another imposing ancient structure, the Basilica of Maxentius (or Constantine) in the Roman Forum. Thus the hall itself, although it shelters a preponderance of Greeks, makes rather specific visual reference to the strictly localized antiquity of Rome.

Was Raphael aware that he had put Greek philosophers inside a Roman building? Ten years later he was to be the first Renaissance artist to identify differences of style in archaeological material.[55] In 1509, however, he had barely arrived in Rome and had never seen, nor did he ever see, Greece. He would have had no firsthand idea

of an ancient building except those suggested by Roman ruins. But perhaps the question itself is not quite appropriate. Battista Casali's discourse of 1508 had stated quite explicitly that Rome was the new Athens of the Christian world; in the language of images, Raphael's great building makes the same point.

As for the structure's identity, it is not an ancient temple, for it lacks a cult statue. It cannot, therefore, be a temple to Philosophy, as many scholars have proposed. The deity honored by these massed philosophers is, rather, quite clearly the same God who animates the *Disputa* in so many different likenesses, from radiant light to elevated Host.

When Saint Paul preached to the Athenians (Acts 17:16–34), he called his listeners' attention to a shrine on the Areopagus dedicated "to the unknown god," the *agnôstos theos*. This, declared Paul, was the very God whom he preached. Like the *agnôstos theos,* the deity who infuses the *School of Athens* with grace is hidden from view, but Plato's gesture makes clear that this is not a God unknown.

Yet, lacking an altar, neither can the great building be an image of the future Saint Peter's. Rather, Raphael's painted structure and Bramante's architectural project are both attempts to recapture the scale, the spatial feel, of ancient Rome. The identification "Liceo d'Atene," from which derives the English "School of Athens," serves perfectly well to characterize Raphael's building.[56] Its domed halls shelter knowledge, *causarum cognitio,* while promoting the continued search for a more complete grasp of divine reality. It is a place of seeking rather than of worship.

Still, like the Temple of Capitoline Jupiter, the School of Athens does hold the spoils of a campaign, at least in the terms set by Egidio da Viterbo:

> We must track the parts of the divine trace [*vestigium*] by which human hunting brings back the Trinity as its prize.
> With good cause he [Plato] calls the intellect Knowledge [*scientia*], and after this he puts knowledge by means of the first and supreme Cause, wherein resides the ultimate goal of all inquirers, and true philosophers, for in the *Timaeus* he had said, "knowing what it is, is the sweet prize of victory." Now this "it" is the nature of any individual matter, and the cause whereby all qualities inhere in individual matters.[57]

Under the spacious vaults of the School of Athens, Plato has recorded the "sweet prize of victory" in the book he holds close. At the same time, however, he points beyond the painting to remind his pupils that what he has recorded cannot ever really be expressed by human faculties.

Like triumphal arches and bath buildings, the School of Athens is filled with statues, only two of which can be easily identified. These two images, Apollo to the left and Minerva to the right, represent the two ancient deities who, to the mind of Egidio Antonini, embodied the principle of the Trinity before its ultimate revelation in Christ. Apollo is an image of Christ conceived as light, as beloved Son, while Minerva's unusual birth from the head of her father signals the eventual circumstances of the Incarnation.

In the sixth book of the *Republic* Plato puts the begetter, and father, and finally he puts the son, whom at one point he calls the Sun shining outward, and at another Minerva, broadly, inwardly wise; the third Person [of the Trinity, i.e., the Holy Spirit] he praises amply in his *Symposium,* calling it now Venus, now Love.

He [Plato] was in the habit of calling the twin gifts of the divine Child now Minerva, wisdom, now the Sun, light. The one child shines brilliant in herself; the other makes plain the way to the Highest Good by means of reason.

Minerva, the true child of God, whom intelligence alone had begotten, would be the one to transmit to mortals wisdom about things human and divine.

Minerva . . . who signifies intelligence [*intelligentia*], as Plato bears witness.

Minerva is the true child of God among all the immortals, whom God will have begotten as most like himself, as is said in the sixth book of the *Republic.*

In the sixth book of the *Republic,* Plato says that the Sun, the son of God, is not being, but above being . . . Thus the way of knowing ought to be above reason . . . because if reason is not equal to what is above reason, one should hurry toward the light of that alone which, when it leaves the Sun, manifests the Sun: the son, and the Good itself: the Sun's father. That light is the inpouring of faith, and by this faith those divine matters want to

be known. In the sixth book of the *Republic* Plato devotes the most extensive discussion to this fact, about the Sun being the origin of all goodness, [which we obtain] of the Sun thanks to its begetting by the Father, which they call the Good.[58]

In between these descriptions of divine foreshadowing in the classical pantheon, Egidio makes a point of showing (21r) how the search for God resembles making statues. In essence, he delivers a discourse on images and likenesses, which, because it is transmitted by means of a written text, seems on the surface to be a purely verbal exposition. Raphael's fresco proves otherwise; through the painted image of two statues sculpted in the round, the artist says the same thing as Egidio's six folio pages. Below the statues are three plaques carved in bas-relief. In a sense, these simulacra are less "real" than the full-round images above them. The two panels beneath Apollo show respectively, a man striking another man, and a Triton fondling a Nereid with lusty abandon as she perches on his fishy tail. Beneath Minerva sits Reason enthroned within the Zodiac. These scenes, too, find ready exegesis in the "Sententiae ad mentem Platonis": For . . . all things which exist under Heaven are, as it were, sunk beneath the waves of matter, and only the human soul emerges like a crag, or an island, and lifts its head out of the sea: and as the fourth book of the *Republic* tells us, it has three parts: lust, anger, and reason.[59]

Egidio later elaborates: lust is the forerunner of the love of God; anger, of fortitude in the service of God; reason, of wisdom, *sapientia*. The three plaques beneath the statues in the School of Athens thus represent images of the human soul and its capacities at the stage before they have been transformed by the infusion of divine grace; the contrast between the bas-relief plaques and the full-round sculptures parallels the contrast between the incompleteness of the human soul and the relative completeness of divinity (or, better, perfection, for Latin *perfectio* means "completion"). Apollo and Minerva are far closer to God than any human soul, for they foreshadow the peculiar conjunction, in Christ, of the divine and human natures. Neither statues nor plaques are colored, whereas the living edifice of the *Disputa*, its saints fully aware of the Christian mysteries, is living, breathing (albeit painted) flesh. Yet just as theological truth can only be stated in the approximations of language, Raphael's simulacra,

too, are always, explicitly, imitations of something infinitely more sublime.

Ranged beneath Apollo and Minerva on either side of the paintings are two knots of conversing philosophers: geometers and astronomers to the right (Fig. 16), Pythagoras and his disciples to the left (Fig. 27) identified by a slate with a musical diagram. Their arrangement underneath Apollo and Minerva shows that the statues serve still another symbolic function: Apollo, as god of music, governs hearing. Because wisdom in antiquity was expressed as insight, so Minerva, as goddess of wisdom, governs vision (as her Homeric epithet "gray-eyed Athena" might suggest). Now these two senses, sight and hearing, are those that Plato says first caused humanity to think about God: sight because it raised our eyes to the heavens, hearing because it supplied us with the first hints of the celestial harmonies generated by the music of the spheres. Again, Egidio da Viterbo may serve as a trusty guide to understanding the painting more fully.

> As is written in [Plato's] *Phaedrus,* the senses teach us, and especially sight, which excels the other senses by far: looking inward, we tend to inspect something closely first by looking at it before we bring in the other senses; looking outward, we behold the heavens in our field of vision, which are older than we, and prior to us. This is why vision is called the divine sense, both in the *Phaedrus,* and in the sixth book of the *Republic.* Then, the next place in the order is held by hearing. In the same place it is written that there are two divine senses: vision and hearing, because each has its own kind of knowledge, one speculative knowledge, the other music, as we may read in the second book of the *Laws.*[60]

In many different senses, the left side of the *School of Athens* is devoted to music, from the geometric diagram on a tablet in the foreground to the explicitly labeled copy of Plato's *Timaeus,* work in which the music of the spheres is described in detail. The geometric diagram is an ingenious composite illustration of Pythagorean numerical and musical theory, creating a visual analogy between perfect musical harmonies and perfect numbers.[61] Scholars have unraveled the meaning of the diagram's components without being able to point to Raphael's immediate source for the image;

this is because in all likelihood its inventor is the artist himself.[62] A golden-haired youth (Fig. 1, no. 32) holds this diagram up for a mature man who writes intently in a book (no. 33); the youth, by so doing, effectively holds a label up to the figure of Pythagoras.

Curiously, however, Giorgio Vasari, in his Life of Raphael, identifies the writing Pythagoras in the *School of Athens* as Saint Matthew. Though clearly incorrect, this observation by a fellow artist and well-schooled contemporary is revealing. The philosopher's pose is in fact standard for an Evangelist, and the Pythagorean pupil who holds out the slate closely resembles Saint Matthew's characteristic symbol, a dictating angel. Is Pythagoras, then, a sort of Saint Matthew to Greek philosophy? Certainly he may have borne witness to the Trinity; to Egidio da Viterbo's mind, he might have been the first philosopher to have done so.

> The following aspects, which he has discovered in material things, have been identified by Plato, as a beginning, middle, and end [of inquiry]: the authority, form, and goodness which he has perceived in God. Pythagoras, having followed the same reasoning, put the beginning, middle, and end, like Plato, in us; whether he agreed with Plato in placing three kinds of causes in God I can hardly assert, as he has passed nothing on the matter down to posterity. Also in the Book of *Wisdom* the same causes are enumerated, though by different names, when it is said that all things are created in terms of number, weight, and measure. Even our father Saint Augustine, in Book 6 of *De trinitate,* records [them as] unity, appearance, and order.[63]

Around Pythagoras clusters an anachronistic group that includes, among the many Greeks, a turbaned, moustachioed figure clad in purple and bending forward with a courtly hand placed on his heart (no. 35). The robes are contemporary, based on those of Ottoman Turks, several of whom were to be found at the Apostolic Court. In any case, Ottomans were the only Muslims Raphael and his circle were ever likely to see. Islamic scholarship, therefore, figures in the *School of Athens* alongside classical learning as a valid source of knowledge. Like ancient wisdom, it cannot attain to complete Christian understanding of the Trinity, so this Islamic scholar is fitted in among the ancients. His presence is particularly striking in the face of the papacy's continuing rhetoric of Crusade in the early

sixteenth century and shows the radical extent to which the Rome of Julius II was willing to push its universal vision to include one and all.

This exotic foreigner is normally identified as Averroës, the Arabian commentator on Aristotle. The identification is apt, for Averroës had played a significant role in the development of humanist music theory.[64] Again, therefore, the two "great princes" of Philosophy must be reconciled, with Christian Rome's debt to each gratefully acknowledged.

Egidio da Viterbo has a fair amount to say about Averroës; Egidio's university days at Padua had plunged him into the middle of an academic controversy about the Arabian scholar. Temperamentally, the mystic Egidio was repelled by the empirical bent of Averroist philosophy, yet he strives with all his might to incorporate Averroë's himself into the universal harmony of his "Sententiae ad mentem Platonis." He attributes the Arabian scholar's doctrinal error, significantly, to the fact that he had worked from faulty texts of Aristotle.[65] The Vatican Library, by establishing and preserving good texts of the ancients, might therefore be seen as a buffer against the Turk for purely philological reasons.

The identity of the other philosophers in this group has been much disputed, beginning with Giovan Pietro Bellori in 1695. Had Raphael's paramount concern been accurate identification of individuals, all of them at least vaguely Pythagorean, they would have been labeled – by their books, like Plato and Aristotle, or by their physiognomy, like Socrates, or by their actions, like Heraclitus and Diogenes, of whom more subsequently. Whether the marvelous old man who copies the words of Pythagoras (no. 34) is Empedocles, or Zeno, or Archytas of Tarentum, he communicates the urgency of the true scholar at work with utter clarity. Squinting, with drawn mouth, bald head, and gnarled hands, he could not be physically more unlike the handsome young students gathered in the fresco's right foreground, yet their excitement at learning is the same excitement as his, ageless and timeless. In a sense the philosopher requires no more specific identification than his enthusiasm: he could be, and should be, Archytas, Empedocles, Zeno, but also Iamblichus, Plotinus, and Boethius. Raphael could be generic or encyclopedic in creating his population of Pythagoreans; for compositional reasons, his specificity seems to stop with a dozen philoso-

phers or so, in order to keep the possible multitude under some control.

The group clustered under Minerva focuses, like the Pythagoras group, on another slate with a diagram (Fig. 9). The faculty of sight is embodied in a geometric proof offered by Euclid, whose balding head actually belonged in life to Raphael's mentor Donato Bramante (Fig. 1, no. 23). As architect of Saint Peter's, Bramante was busily engaged in exploring geometric principles through the design of buildings and in learned conversations. In addition to identifying Bramante as Euclid, both Vasari and Bellori report that a portrait of Zoroaster is to be found among the group of the geometer's companions. Bellori specifies that the figure with his back turned, wearing the radiate crown of a late Roman emperor, is "Zoroastre Re de' Battriani" (no. 21) and that the figure holding a starry globe is a representative of the Chaldeans, "authors of Astronomy" (no. 22). Zoroaster and the Chaldeans represent, of course, the insights of *prisca theologia,* the compendious wisdom tradition anterior to that of Greece and Rome.[66]

Euclid, Zoroaster, Ptolemy, all tracked divinity in the regular patterns of geometry and the stars. Cleverly, Raphael has placed himself (no. 19) among the champions of sight, his own endeavors thereby elevated to the same plane; he, too, has measured the traces of divinity and sought God in the beautiful. Next to Raphael, again on the testimony of Vasari and Bellori, stands Giovanni Bazzi (no. 20), a painter from the Sienese hinterland who was universally known by his nickname "Il Sodoma," given him for his habit of living among young boys – "and he willingly answered to it," Vasari declares.[67] Sodoma's colorful, eccentric character is indelibly recorded by his self-portrait in the cloister of Monteoliveto Maggiore, where he is long-haired, white-gloved, strangely dressed, surrounded by some of his exotic animals, a fey smile playing about his mouth – the most interesting subject by far in the entire painted cloister. By the time he was guiding Raphael through the intricacies of papal Rome, the wild man had settled into comfortable married life with his wife and a growing brigade of children. There is more of the sobersided family man in Raphael's portrait than there is of the outrageous youth – but the two artists do stand, after all, within the eternal halls of Athens on a wall of the pope's apartments.

As a geometer, Pythagoras himself could easily have figured in this group of philosophers. For that matter, he had also been an enlightened mystic, to whom Egidio attributed glimmerings of trinitarian thought; in some respects, therefore, he is a more likely candidate than Aristotle for placement at Plato's side. He serves especially well, of course, where he is, pinpointing the dichotomy between sight and hearing, but, like Averroës, he saved Raphael's composition from any pretense at Scholastic rigidity in the placement of its figures.

Three, perhaps four other philosophers are conspicuous among the throng. Off to the left, on the landing occupied as well by Plato and Aristotle, snub-nosed Socrates (no. 49), dressed in an olive drab gown, holds forth for a crowd of listeners. A languid blond with pastel armor listens while he effects a careful contrapposto, his vanity as palpable as his attractiveness. This may be the lovely Alcibiades (no. 45), characterized simultaneously as the rake of Plato's *Symposium* and the brilliant general of Thucydides' *History*. The stout little man behind him (no. 46) is usually taken to be another general who sat at Socrates' feet, Xenophon, the plucky hero of the *Anabasis* and author of *Memorabilia* about Socrates. As with the musicians and geometers, the roster of personages who should appear around Socrates outnumbers the places reasonably available: we might want to find, to name a few, Aristophanes, Glaucon, Adeimantus, Cephalus, Speusippus, Critias, Protagoras.

Sprawled across the steps in an attitude as spontaneous as that of Alcibiades is studied, only a swatch of blue to cover his aging modesty, Diogenes (no. 28) buries his nose in a book, ostentatiously oblivious to his fellows. His importance to Raphael's scheme rests on his colorful character, but also on his uncompromising devotion to the pursuit of philosophy, in which he found, a monastic before his time, all wealth and happiness.

Equally antisocial is glum Heraclitus (no. 29), leaning his elbow on a marble block and staring at his suede boots. An afterthought, he was added in 1511 or so and presents a simultaneous portrait of Michelangelo's face and Michelangelo's artistic style. The painter of the Sistine Chapel ceiling appears in part because he keeps company with so many others of his profession: Leonardo, Sodoma, Bramante, and Raphael – in effect all the creators of the visual lexicon for Julian Rome. By temperament, the melancholy

Florentine was well suited to play the part of Heraclitus, both of them congenitally despondent at human folly.

To the left a chubby Epicurus crowned in the ivy that signified participation in a drinking party but engrossed in a book (no. 37), may also be identified with a fair degree of probability, his back turned to the Pythagoreans and Socratics, and indeed to the rest of the school. Like Diogenes and Heraclitus, he, too, is lost in his own world of contemplation; unlike them, he sees no conflict between philosophy and indulging his senses. His physical features bear a striking resemblance to those of Tommaso ("Fedra") Inghirami.

The ancient (and Islamic) world, under Raphael's brush, presents as multifarious a group of intellectuals as any university faculty then or now. It is testimony to his gifts as an artist that his chattering multitude pursues its headlong investigations with so stately an air. Julius's vision has employed a studied elegance as an essential aspect of its power. This ordered elegance was designed to reflect the supernal order which God has imparted to Creation. It was also designed according to a set of quite earthly contemporary rules of artistic composition, common to text and image alike. Because the elegance of the *School of Athens* is so explicitly literary as well as artistic, we must scan Julian Rome to find a person whose familiarity with ancient literature has a sensitivity to visual imagery as great as that of Egidio da Viterbo, a person sufficiently familiar with the pope's ideological intentions (and Egidio's theology) to represent these accurately in discussions with the pope's artist, a person whose awareness of the rules for classical composition in both the literary and artistic sense was both acute and elegant, and, finally, a person who could have spent the time necessary to help create (and repeatedly revise) the intricate iconographies of the Stanza della Segnatura. In fact, as I have already anticipated, there are few members of the Apostolic Court who better fit this description than the librarian of the Biblioteca Apostolica Vaticana, Fedra Inghirami.[68]

It was Fedra, indeed, who would be charged with delivering the funeral oration for Julius II, at the dying pope's request. Together with Egidio da Viterbo, he had been busy for years with the public promotion of Julius's image in oratory. However, Fedra had also continued to maintain his interest in theater, managing his own

dramatic company and taking on the roles, on various occasions, of writer, actor, director, and producer.[69] In other words, Inghirami could block living actors on a stage or in a piazza much as Raphael could assemble human figures within a two-dimensional composition, and he was as familiar as the artist with manipulating the classical repertory of images, personifications, and historical characters in order to tell a story while achieving a visual effect. Two of his extant works of scholarship have to do with the development of style: a treatise on rhetoric, and a commentary on the *Ars poetica* of Horace; in both, Inghirami resorts to powerful visual images in order to make his points.[70] A chief spokesman of the pope, with a well-trained eye, Fedra was confirmed in 1510 as prefect of the Vatican Library, that institution with which the *School of Athens* seems to be so intimately connected on every level.[71] Like Egidio da Viterbo, he was one of the few scholars in Rome who actually knew Greek – for whom, in other words, the School of Athens was an idea with which he could empathize completely.[72] Furthermore, Fedra's love for books (and their contents) was effervescent. When Raphael painted the humanist's portrait (Florence, Pitti) (Fig. 31) sometime during the time when he was working on the Stanza della Segnatura, he posed him with one hand caressing a manuscript and an upturned gaze that in other Raphael paintings signifies heavenly rapture. The restrained elegance of Raphael's painted Fedra is striking, for what survives of Inghirami's writing and oratory is certainly elegant, but it is anything but restrained.

Like Egidio da Viterbo and Battista Casali, Fedra saw the revival of ancient learning as part of a more general religious renewal. His little unpublished commentary on the *Ars poetica* of Horace declares that "every reserve, every supply of things to say comes from philosophy, which is the mother of all things well done and well said, without which we can define and evaluate nothing, nor speak with feeling and breadth about a variety of lofty subjects, like religion, death, piety, charity and especially the virtues and vices, and the soul's perturbations."[73] Fedra's own version of "things to say," *copia dicendi,* emerges in full dramatic force in his funeral oration for the pope: "Good God! What a mind the man had, what sense, what skill in ruling and administering the empire! What supreme, unbreakable strength!"[74]

In the end, every aspect of the *School of Athens* points back to

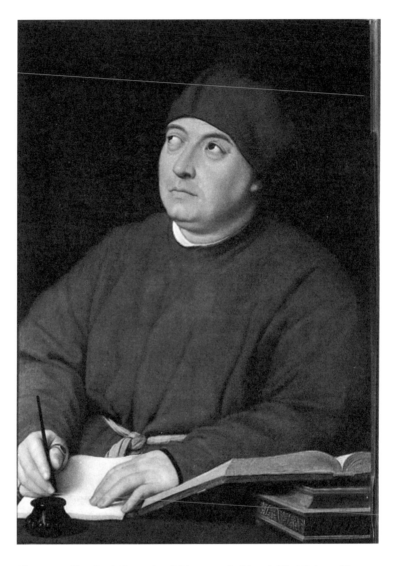

Figure 31. Raphael, Portrait of *Tommaso Inghirami*. Pitti Palace, Florence. (Photo: Alinari/Art Resource.)

Julius himself, whose intellectual powers show in the profundity of
the art and architecture he commissioned, works whose progress
he dogged as he dogged every other aspect of his papacy. The
grand scale of Julius's aspirations ensured many incomplete proj-
ects, but we still have the Sistine ceiling, Michelangelo's *Moses*, the
crossing of Saint Peter's – and the two finest of the Stanze Vati-
cane. In every aspect of his patronage, the pope's brand of muscular
Christianity involved the intellect as well. And the focal point of
that intellectuality, for over thirty years, had been the Biblioteca
Apostolica Vaticana. Symbolic of the preservation of classical cul-
ture, it lies implicit in all the bookish frescoes of the Stanza della
Segnatura, but most pointedly in the *School of Athens*. It is the
collective memory of the ancient wisdom, enshrined in painted
plaster as an offering to God: "Every day this Athenaeum will wing
your praises in a hundred tongues, and when all those other works
have perished, so long as they can be read about, they shall rise
again day after day, and their memory shall be renewed."

NOTES

1. The Stanza was already so designated in 1513 by the papal master of
 ceremonies Paris de Grassis, who first served under Julius II; see Dorez,
 1896, 97–124.
2. Redig de Campos, 1950, 5; Shearman, 1972, esp. 13–17. For the holdings
 of Julius's private library, see Dorez, 1896, 99–109. For a comparison
 between the traditional faculties of a university and the Stanza della
 Segnatura's decorative program, see Pfeiffer, 1975, 154–9.
3. Morello, "La biblioteca di Giulio II," in Morello, 1986, 51–3.
4. The custom of contemporary popes to pay respectful homage to their
 predecessors (especially marked in the selection of their names by Popes
 John Paul I and II) has few precedents in the Renaissance, where the rivalry
 among cardinals was expressed with less reserve. Julius II had been an
 outspoken adversary of his predecessor Alexander VI Borgia, and the unsa-
 vory reputation of the Borgia family was encouraged to grow, without
 limits, during the papacy of Julius. Leo X and his two secretaries, Pietro
 Bembo and Jacopo Sadoleto, belonged to a generation for which the
 political concerns of Julius and his generational contemporaries posed an
 unnecessary distraction from their own overriding (and strikingly selfish)
 interest in personal cultural development. It is Bembo and Sadoleto who
 created the myth of a Golden Age of arts and letters under Leo X and who

had to do so specifically at the expense of Julius II. Erasmus's vicious
posthumous caricature of him, *Julius Excluded from Heaven*, did the rest.

5. So, for example, Eugène Müntz, *La Bibliothèque du Vatican au XVIe siècle*
(Amsterdam: Van Heusden, 1970; reprint of Paris: E. Leroux, 1886), 5;
Ludwig Freiherr von Pastor, *The History of the Popes from the Close of the
Middle Ages* (London: K. Paul, French, & Trübner, 1950), 457n. The
contention is elegantly refuted by Dorez, 1896, 98–9. See also Jones and
Penny, 1983, 49–50.

6. The foundation of the library has been definitively traced to Nicholas by
the present prefect, P. Leonard Boyle, "The Vatican Library," in Grafton,
1993, xi–xv; cf. Boyle, "Sixtus IV and the Vatican Library," in *Rome:
Tradition, Innovation and Revival* (Victoria, Canada: University of Victoria,
1991), 65–73. See also Jeanne Bignami Odier and José Ruysschaert, *La
Bibliothèque vaticane de Sixte IV à Pie XI* (Vatican City: Biblioteca Apos-
tolica Vaticana, 1973). The library of Nicholas V already numbered 1,143
books; Boyle, "Sixtus IV," 69.

7. Toby Yuen, "The Bibliotheca Graeca: Castagno, Alberti, and Ancient
Sources," *Burlington Magazine* 112 (1970), 725–36.

8. See Christine Shaw, *Julius II: the Warrior Pope* (Oxford: Blackwell Pub-
lisher, 1993). The historian's documentary approach is less successful in
dealing with Julius's patronage of the arts (194–207), than with his politi-
cal activity.

9. The translation of the bull *Ad decorem* of 1475 is by Boyle, "The Vatican
Library," xiii ("Ad decorem militantis ecclesiae, fidei catholice aug-
mentum, eruditorum quoque ac litterarum studiis insistentium virorum
commodum et honorem"), as in n. 6.

10. For *prisca theologia* in general, see Frances A. Yates, *Giordano Bruno and the
Hermetic Tradition* (Chicago: University of Chicago Press, 1964); Anthony
Grafton, "The Ancient City Restored: Archaeology, Ecclesiastical His-
tory, and Egyptology," in Grafton, 1993, 87–124. For Etruscan studies in
particular, see John O'Malley, *Giles of Viterbo on Church and Reform* (Lei-
den: Brill, 1967), 31; Walter E. Stephens, "The Etruscans and the Ancient
Theology in Annius of Viterbo," in Paolo Brezzi, ed., *Umanesimo a Roma
nel Quattrocento* (New York and Rome: Barnard College [Columbia Uni-
versity] and Istituto di Studi Romani, 1984), 309–22.

11. Maria Bertòla, *I due primi registri di Prestito della Biblioteca Apostolica Vati-
cana, Codices Vaticani Latini 3964, 3966* (Vatican City: Biblioteca Apos-
tolica Vaticana, 1942), shows Philo and Hermes in circulation from the
time of Platina. Inventories to the library can be found in Eugène Müntz
and Paul Fabre, *La Bibliothèque du Vatican au XVe siècle* (Amsterdam: Van
Heusden, 1970; reprint of Paris: Ernest Thorin, 1887).

12. Melozzo's fresco "frontispiece" is now detached and displayed in the

Pinacoteca Vaticana. Payments are recorded for the artist beginning on 15 January 1477; Boyle, "Sixtus IV," 67 (as in n. 6).

13. Lee, 1978, 114–16.

14. Another cardinal nephew, Pietro Riario, by all accounts the favorite of Sixtus, had died shortly before the inauguration of the Vatican Library.

15. Indeed, Riario nearly won the conclave of 1513. For years he held the important office of chancellor of the Apostolic Chamber, from which he disbursed ecclesiastical salaries and awarded contracts and leases with the Reverenda Camera Apostolica.

16. Egmont Lee's description of Platina is colorful, mentioning "his rashness and irascibility, combined with a lack of judgment which seems to border on the insane." 1978, 111–12.

17. For Sixtus IV as an urban planner, see Lee, 1978, 123–50. Lee's description, 1978, 117, is particularly apt: "The bull of June 15, 1475 by which Dixtus ordered the foundation of the library stated simply that it was intended to serve 'ad decorem militantis ecclesiae' as well as the world of scholarship and the dissemination of knowledge. But in a larger context, the evidence which can reasonably be assumed to reflect the pope's intentions leaves no doubt that the Vaticana must be viewed as part of the series of public works in Rome which were means to proclaim – *Urbe et Orbe* – the wealth, the power, and the universal concern of the papacy. The library ranks high on a list of accomplishments by which Sixtus wished to be remembered."

18. Templa, domum expositis, vicos, fora, moenia, pontes
 Virginem trivii quod repararis aqua
 Prisca licet nautis statuas dare commoda portus
 Et vaticanum cingere, Sixte, iugum.
 Plus tamen urbs debet; nam quae squalore latebat
 Cenitur in celebri Bibliotheca loco.

 Translation provided by author. Text from the fictive inscription at the bottom of Melozzo's painting.

19. The significance of these frescoes to Giuliano della Rovere's relationship with the Vatican Library is taken up by Lee, 1978, 114–16.

20. See the bibliography in Morello, 1986, 70.

21. O'Malley, 1979, 11–12.

22. Frequently this division is associated with the division of university faculties in the early sixteenth century. Dorez, 1896, 101–2, points out that university faculties maintained chairs in medicine rather than poetry and identifies the organization of the Stanza della Segnatura with the literary interests of humanism, beginning, significantly, with the system installed by Tommaso di Sarzana, the future Nicholas V (and therefore founder of

the Vatican Library), for the Dominican Library of San Marco endowed by Cosimo de' Medici.

23. The phrase *causarum cognitio* and its various Virgilian and Ciceronian permutations probably originate in a Latin paraphrase of a Greek philosophical commonplace, the distinction between wisdom and knowledge. The various sources are assembled by Künzle, 1964, 534. "Causarum . . . cognitione" appears in Cicero, *Tusculan Disputations* 5.7, and Cicero, the first translator of much Greek philosophical literature into Latin, may well have been the first to coin the phrase. However, in certain contexts, early sixteenth-century humanists clearly stress the connection with blessedness associated with Virgil's phrase "Felix qui potuit rerum cognoscere causas" (*Georgics* 2.490).

24. His speeches in Vatican Library, Ott. Lat. 2413, 25r, are extraordinarily short (half a page) and self-conscious.

25. O'Malley, 1979, 63–5, makes the analogy between artistic and verbal epideictic rhetoric.

26. In addition to O'Malley, 1979, see John W. O'Malley, *Preaching for the Popes* (Leiden: Brill, 1974).

27. This same trio is treated with great sensitivity by d'Ascia, 1991, 173–201.

28. O'Malley, 1979, 114–15.

29. An invective by the Neapolitan poet Girolamo Borgia, entitled "Egidio Cardinali Canino," provides a riveting physical and moral description of a black-clad, unkempt Egidio in action. Vatican Library, Barb. Lat. 3231, 342r; cf. Barb. Lat. 1903, 68r.

30. See the remarks of Jacopo Sadoleto to Pietro Bembo, *Acta Concilii Lateranensis V* (Rome: Mazzocchi, 1521), Aii verso (the introduction to the transcript of Egidio's opening address to the Fifth Lateran Council): "Nec vero quicquid interfuit illo dicente inter doctos homines: et idiotas: non senex ab adolescente, vir a muliere: princeps ab infimo homine potuit dignosci: sed omnes pariter vidimus praecipites ferri impetu animos audientium: quocumque eos oratori impellere libuisset: tanta vis orationis: tantum flumen lectissimorum verborum: pondus optimarum sententiarum ex eo ferebatur" (In his sacred orations, his eloquence invariably has turned the minds of men toward divine and wonderful things just as he decides; it restrains those who are overexcited and lights up the languid, or, better, inflames them toward the desire for Virtue, Justice, and Temperance, toward the love of Almighty God and devotion to holy religion).

31. O'Malley, 1979, 27.

32. This was the assessment of his friend Paolo Cortesi, *De Cardinalatu* (in Castro Cortesio: Symeon Nicolaus Nardus, 1510), 221r. For Fedra, see d'Ascia, 1991, 188–96; Redig de Campos, 1956–7, 171–9. Symeon Nicolaus Nardus was the printer of Cortesi's *De Cardinalatu,* which came out

posthumously. Nardi and his press were brought from Siena to the Cortesi villa near San Gimignano (Castel Cortesi) by Cortesi's brother to print up what Paolo had completed of the work.

33. Morello, 1986, 76, no. 83, also suggests that Fedra Inghirami and Egidio da Viterbo were the direct sources of the intellectual inspiration for the Stanza della Segnatura.

34. The Latin text of the oration, "Oratio Habita ad Iulium Secondum Pontificem Maximum in Circumcisione," Milan, MS Ambrosianus, G 33, inf. Part II, fols. 12r–17v, is published by John O'Malley, 1977, 271–87, at 279–87. The passages quoted are from 286–7. In paragraph two, the "shipwreck" refers to the conquest of Constantinople by the Ottoman Turks in 1453. In the third paragraph, third sentence "a hundred tongues" is my translation of the phrase "centum linguis," which can mean either "in a hundred tongues" or "with a hundred tongues." In the same sentence, the debt of the final sentiment to the Horatian "exegi monumentum, aere perennius," *Carmina* 3.30.1, would have been clear to all of Casali's listeners.

35. O'Malley, 1977, 275, esp. 279: O'Malley . . . points out that Casali's oration, whatever its relationship to Raphael's painting, eloquently conveys the sense of hope and purpose embodied in the Vatican Library's collection of Greek books.

36. An excellent précis of Egidio Antonini's career and significance can be found in John O'Malley, "Giles of Viterbo: A Reformer's Thought on Renaissance Rome," *Renaissance Quarterly* 20 (1967), 1–11. See also O'Malley's *Giles of Viterbo on Church and Reform*.

37. See the collected articles in John O'Malley, *Rome and the Renaissance* (London: Variorum Reprints, 1981); Ingrid D. Rowland, "Egidio da Viterbo's Defense of Pope Julius II, 1509 and 1511," in Thomas L. Amos, Eugene A. Green, Beverly Mayne Kienzle, eds., *De ore domini: Preacher and Word in the Middle Ages* (Kalamazoo: Medieval Institute, Western Michigan University, 1989), 235–60; Amos, Green, and Kienzle, "A Summer Outing in 1510: Religion and Economics in the Papal War with Ferrara," *Viator* 18 (1987), 347–59.

38. The similarity between Egidio da Viterbo's preaching and the artistic projects of Julius II is also noted by Morello, 1986, 76, no. 84.

39. "Ad praescriptum Iulii pontificis," quoted in Redig de Campos, 1965, 5.

40. George Sarton gives an acid view of Peter Lombard's achievement in his *Introduction to the History of Science* (Washington, D.C.: Carnegie Institution, 1927), 1:383: "The mediocrity of the latter; it clearly reveals Abelard's and Gratian's influence. Although Abelard enjoyed exposing contradictions and difficulties, Peter was essentially conservative and conciliatory and utterly devoid of originality; hence his success."

41. Friedrich Stegmüller, *Repertorium commentariorum in Sententias Petri Lombardi* (Würzburg: Schöningh, 1947), provides a list, with accompanying biographies and listings of manuscripts, for every known commentator on the *Sententiae*. He also includes a biography of Lombard himself (1:1–3.).

42. Paolo Cortesi, *In Quatuor Libros Sententiarum argutae Romanoque eloquio disputationes* (Rome: Eucharius Silber, 1504).

43. Paolo Cortesi had pioneered the aesthetic approach in his commentary on Lombard's *Sentences* of 1504 (see n. 42), as is evident from the title "argutae Romanoque eloquio" as well as the contents of the four prefaces addressed to Julius II, one for each book of the *Sentences*.

44. Pfeiffer, 1975; Pfeiffer, "Die Predigt des Egidio da Viterbo über das goldene Zeitalter und die Stanza della Segnatura," *Festschrift Luitpold Dussler. 28 Studien zur Archäologie und Kunstgeschichte* (Munich: Deutscher Kunstverlag, 1972), 237–54, where he acknowledges Nelson Minnich's role in formulating the idea (248, n. 1).

45. The papal master of ceremonies, Paris de Grassis, found this habit unseemly; besides, Egidio was notoriously long-winded. See John O'Malley, "Fulfillment of the Christian Golden Age under Julius II: Text of a Discourse of Giles of Viterbo, 1507," *Traditio* 25 (1969), 269.

46. Vatican Library, Vat. Lat. 6325, 1r (the opening sentence of the "Sententiae"): "Quoniam summum hominis bonum in alia vita est, ubi Deo iungimur, et divinam cernit essentiam: Hic autem summum bonum assequimur, quod in terris dari homini potest, Deo iungimur quam maxime fieri potest, potest autem quam maxime si mente ac voluntate contemplatione atque amore iungimur."

47. Vat. Lat. 6325, 1r: "Paranda est mensa animo" (A table must be set for the soul).

48. See James Hankins, "The Popes and Humanism," in Grafton, 1993, 47–86.

49. Julius II kept a copy of the *Ethics,* in the Latin translation of Ioannes Argyropoulos, as part of his private library; this book is identifiable as Vat. Lat. 2098.

50. Vat. Lat. 6325, 29r: "non solis sesapientibus aprit Deus, im[m]o neminem esse vult, qui eum esse non norit, aut certe illi etiam norunt qui sapientes non sunt." Chief among these "non sapientes" are "aniculi" – "little old ladies."

51. Vat. Lat. 6325, 18r: "Adde quod Philosophia, quae omnia vestigat, atque examinat, omnem a Deo numerum, multitudinemque abesse diiudicavit, ut Plato, ut discipulus Arist[oteles]"; 24v: "humanum autem genus finem habet intelligentiam divinorum, ut etiam Arist[oteles] in Ethicis fatetur, quare si necesse finem aliquo pacto assequi, itaque Deum aliquo pacto intelligere est necesse."

52. Vat. Lat. 6325, 40r: "Possent tamen principes Philosophiae conciliari, et

quamquam latius ubi de creatione, de ideis, de finibus bonorum dispu-
tabitur, quaerenda ac demonstranda haec sit . . . neque omnino inter se
pugnari existimandi sunt, qui ut non omnino idem dicere, ita non
omnino diversa sentire putari volunt."

See also 55r–v: "Conciliari magni hi Principes possunt, duplices si
ponamus essentias rerum; materia, ac corpore liberas et in materia
iacentes; participatas, ac participantes; illas Plato, has Aristoteles sequitur;
atque ideo inter se magnos hos Philosophiae duces minime dissentire, ac
ne confingere haec ipsi videamur, ipsi audiendi Philosophi sunt. Nam ut
de homine, de quo nunc agitur, loquamur, idem Plato, qui animam in
Alcibiade facit hominem, in Timeo postea, duplicem vocat hominem,
alterum quem sensu, alterum quem ratione cognoscimus: eodem quoque
libro praecepit ut homo totus non parti alteri vacet, sed utramque curet.
Quin et Aristoteles decimo Ethicorum libro intellectum verum vocat
hominem: Ut scias uturmque Philsophum eadem sentire, quamvis alter
non eadem dicere voluisse videas."

53. Vat. Lat. 6325, 113r: "Iam procul a divina esse natura nemo dubitat, ut
scientia humana est cognitio causarum quem demonstraio peperit; divina
est quidem causarum intelligentia." See also Pfeiffer, 1975, 154.

54. The word means "footprint" in Latin; *vestigatio* originates as a verb used
to describe a hunter's tracking.

55. In his letter to Pope Leo X of circa 1519; see Ingrid D. Rowland,
"Raphael, Angelo Colocci, and the Genesis of the Architectural Orders,"
Art Bulletin 76 (1994), 86–112.

56. Gaspare Celio, not, as we used to think, Bellori, was the first to identify
the subject as "Liceo d'Atene" in 1638. Oberhuber, 1983, 54. My thanks
to Marcia Hall for this reference.

57. Vat. Lat. 6325, 39r: "vestigii nobis vestigandae sunt partes, per quae divinae
Trinitatis praedam venatio reportet humana"; 32r: "cum causa scientiam
vocat intellectum postea ponit cognitionem per causam supremam, et
primam, ubi quies ultima quaerentium, ac vere philosophantium est; nam
in Timeo [138] dixerat; quid id sit nosse, dulce victoriae praemium est; id
enim est qui est res, et causa cur omnia insit rebus."

58. Vat. Lat 6325, 20v–22v. See esp. 22v: "Hinc 6. de republica Plato et
genitorem, et patrem, et denique ponit filum quem nunc Solem extra
fulgentem, nunc Minervam intus latissime sapientem vocat: Tertiam vero
personam symposium amplissime commendat, ac nunc Venerem illam,
nunc amorem vocat."

See also 186r: "Quare ob gemina divinae prolis munera. Nunc Mi-
nerva ac sapientia, nunc Sol, et lux vocari consuevit, ut altero quidem in
se ipsa fulgeat, altero viam, ac summum bonum ratione utentibus mani-
festet." At 189v–190r Egidio explains Apollo and Minerva's opposition in

the *Iliad* by the fact that she represents ascetic religious observance, while Apollo, as light, sides with love. This comment alone should be sufficient to show the remarkable degree of Egidio's syncretism.

See also 104v: "Minerva, quae intelligentiam Platone teste significat." Egidio then goes on to find trinitarian significance in her epithet "Tritogeneia" (105r).

Ibid., 20v: "Minerva, id est vera Dei proles, quam intelligentia sola genuisset, esset mortalibus sapientiam, et humanarum divinarum rerum traditura . . . Minervam et veram Dei prolem esse in divinis, quam Deus genuerit sibi simillimam, ut 6. de rep. dicitur."

Ibid., 20v–21r: At sexto de rep[ublica] Dei filium Solem non esse essentiam dicit Pla[to], sed supra essentiam . . . ita et cognoscendi modus esse debet supra rationem . . . quod si rationem superanti rei non par est, ad lumen solius illius confugiendum est, quod cum a Sole egrediatur Solem filium, et patrem Solis bonum ipsum ostendit: lumen utem id infusa est fides, fide itqaue haec divina cognosci volunt, qui quidem sententiam de Sole, solisque cognitione ex generatione filii a Patre, quod bonum vocat, ut totius boni originem in libro eodem de rep[ublica] sexto Plato quam latissime disseruit."

59. Vat. Lat. 6325, 75v: "Nam cum omnia, quae sub coelo, sicut in materiae fluctibus mersa sit, anima sola humana quasi vel scopulus, vel insula prominet, et caput effert è pelago: ac . . . treis habet partes ex 4. de rep[ublica] cupiditatem, iram, rationem."

60. Vat. Lat. 6325, 76v: "sicut in Phaedro [27] scribitur, sensus nos docet, ac praecipue visus, qui sensus alios longe antecellit, tum in hoc ordine, cum omnia inspicere prius, quam aliis apprehendere sensibus consuevimus, tum etiam in ordine externo, cum coelestia obtutu videamus, quae aliis omnibus antiquiora, prioraque sunt. Qua propter visus, divinus sensus dicitur, et in Phaedro, et in 6. de rep[ublica]. Deinde secundum in eo ordine locum auditus obtinet: eodem namque loco scribitur divinos sensus duos esse, obtutum, atque auditum, tum quod uterque scientiam habet propriam, alter spectatricem, alter musicen, ut 2. legum legere est [2.legum.6]."

61. Briefly, the lower section of the diagram makes an analogy between two sets of Pythagorean perfect numbers: the number 10 and the *tetraktys,* that is, the four integers (or monads) 1, 2, 3, 4, whose sum is 10. The upper diagram, labeled in Greek, employs the graphic form traditional for earlier manuscript treatises on music, whether antique or medieval. It shows the musical *tetraktys* formed by the numerical series 6, 8, 9, 12. These intervals describe the harmonic relationships among the elements of the disjunct scale reputedly invented by Pythagoras; 9:8, *epogdoôn* (so labeled in Greek at the top of the diagram) is the interval between the two fourths

(*diatesseron,* respectively 6:8 and 9:12, again labeled in Greek) of this scale's central, and disjunct, tetrachords. See Emil Naumann, "Erklärung der Musiktafel in Raffaels 'Schule von Athen,' " *Zeitschrift für bildende Kunst* 14 (1879), 1–14; Hermann Hettner, *Italienische Studien. Zur Geschichte der Renaissance* (Braunschweig: Vieweg, 1879), 190–212; Rudolf Wittkower, *Architectural Principles in the Age of Humanism* (London: Warburg Institute, University of London, 1949), esp. 109–10; Rudolf Haase, *Geschichte des Harmonikalen Pythagoreismus* (Vienna: Lafite, 1969), 73–4 (with exhaustive bibliography); Ann E. Moyer, *Musica scientia: Musical Scholarship in the Italian Renaissance* (Ithaca, N.Y.: Cornell University Press, 1992), 14–18. More generally, see also Palisca, 1975.

62. Raphael has clearly invented his diagram with the help of a humanist learned in musical theory, although not necessarily a humanist with a deep grounding in Greek; the terms used in the diagrams can be found, for example, in the commentary composed by Macrobius on Cicero's *Somnium Scipionis* (2.1.8), a source readily available in a plethora of manuscripts at the Apostolic Court, many of them illustrated with diagrams based on the pseudo-Boethian *De musica.* The idea of a composite diagram seems to be entirely new, yet another reflection of the fundamental unity that thinkers of Julian Rome sought to identify in every aspect of thought, art, and the cosmos. A close analogy to Raphael's image may be found in a drawing made within Raphael's ambit by the humanist Angelo Colocci, showing a Pythagorean cube, a die, a knucklebone, and the plan of a forum, all serving to illustrate a passage of Vitruvius (6. praef.) in which Pythagorean numerology is applied to literary composition; see Ingrid D. Rowland, "Raphael, Angelo Colocci, and the Genesis of the Architectural Orders" (cited in n. 55), fig. 12.

63. Vat. Lat. 6325, 40r: "Hae partes a Platone distinctae sunt, ex principio, medio, fine, quae in rebus invenit, ex auctoritate idea bonitate, quae suspexit in Deo. Pythagoras eandem sectatus rationem, principium, medium, finemque ut Plato posuit in nobis, itaque convenit cum Plato[one] in Deo an tria Platonis genera causarum collocarit, cum nihil posteritati mandarit, haud equidem affirmaverim. In Sapientiae quoque libro eadem nominibus diversis numerantur: cum facta dicantur omnia, in numero, in pondere, in mensura. Divus etiam Pater Augustinus lib[ro] de Trinitate 6 unitatem, speciem, ordinemque commemorat." This preponderance of threes provides further proof to Egidio of the Trinity's presence everywhere in the human soul. Immediately after the passage just quoted, he attempts by means of convoluted arguments to bring Aristotle into the trinitarian fold as well (40r–v).

64. Palisca, 1975, 397.

65. Vat. Lat. 6325, 81v: "quamquam doctissimus vir extitit, et plane erudi-

tissimus, graeca tamen non vidit, nisi quae in barbaram transierant lin-
guam, quo cum ex multis, tum ex eo convincitur, in primis quod
Aristotelis scripta, in quibus unice studium collocaret, manca, mutilata,
mendosissima habuit" (However learned a man, and clearly highly eru-
dite, he nonetheless had never seen the Greek [text of Aristotle], except
what had been translated into the barbarian tongue, and one can be
convinced of this for the following reason among many, namely that he
had the writings of Aristotle, upon which he concentrated all his atten-
tion, in fragmentary, mutilated and error-ridden versions).

66. Egidio da Viterbo refers to Plato's mention of Zoroaster in the "First
 Alcibiades," Vat. Lat. 6325, 51v, 186r.

67. In his Life of Sodoma, in Vasari-Milanesi, 1568, 6:380. The sobriquet also
 appears on Sienese legal documents: see Archivio di Stato di Siena,
 Estimo del Contado 150.

68. A detailed argument for Fedra's participation in formulating the program
 for the Stanze is made by Künzle, 1964, 511, 532–49. The likeness that
 gives rise to the article's title, however, is almost certainly that of Pope
 Leo X.

69. Redig de Campos, 1956–7, 174, n. 5.

70. O'Malley, 1979, 64; d'Ascia, 1991, 196.

71. Redig de Campos, 1956–7, 175, n. 14, suggests that Fedra may first have
 served as librarian for Julius's private collection, in which case the associa-
 tion with the Stanza della Segnatura would be all the more convincing.

72. Inghirami maintained close contact with a leading Hellenist, Scipione
 Forteguerri (Scipio Carteromachus). Künzle, 1964, 544.

73. Vatican Library, Vat. Lat. 2742, 84v–85r: "sententiarum omnis ubertas et
 quasi silva dicendi a phylosophia proficiscitur, quae mater est omnium
 benfactorum benedictorumque, sine qua nec quicquam possumus iudi-
 care, nec copiose lateque de variis magnisque rebus dicere, quomodo enim
 de religione de morte de pietate de charitate praecipue de virtutibus ac
 vitiis de animi perturbationibus." Fedra's language is highly allusive, with
 notable parallels to the usage of Egidio da Viterbo. The meaning of *silva* in
 this passage is more or less that of "raw material."

74. Funeral oration for Julius II, from Pierluigi Galletti, ed., *Thomae Phaedri
 Inghirami Volaterrani Orationes duae* (Rome: Generoso Salomone, 1777),
 96: "Bone Deus! quod illius ingenium fuit, quae prudentia, quae regendi,
 administrandique imperii peritia? quod excelsi, infractique animi robur?"

SUGGESTED READING

This Bibliography, arranged in chronological order, in-
cludes important works bearing on *The School of Athens* and cited in
the notes. All other works are cited in full in the notes only.

MANUSCRIPT

Egidio Antonini da Viterbo. "Sententiae ad mentem Platonis." Biblioteca
Apostolica Vaticana, Vat. Lat. 6325.

PRINTED BOOKS

1435. Alberti, Leon Battista. *On Painting and On Sculpture: The Latin Texts of
"De Pictura" and "De Statua."* Ed. and trans. Cecil Grayson. London:
Phaidon, 1972.
1568. Vasari, Giorgio. *Lives of the Painters, Sculptors and Architects.* 4 vols. Trans.
A. B. Hinds. New York: Dutton, 1963.
1568. Vasari-Milanesi. *Le vite dei più eccellenti, pittori, scultori, e architetti.* Vol. 4
of *Opere,* ed. Gaetano Milanesi, 9 vols. Florence: Sansoni, 1906.
1587. Armenini, Giovanni Battista. *On the True Precepts of the Art of Painting.*
Ed. and trans. Edward Olscewski. New York: Burt Franklin, 1977.
1666–89. Félibien, André. *Entretiens sur les vies et les ouvrages des plus excellens
peintres anciens et modernes.* [Facsimile of 1725 Trévoux ed.] Farnsborough:
Gregg Reprint, 1967.
1695. Bellori, Giovan Pietro. *Descrizzione delle quattro imagini dipinte da Rafaelle
d'Urbino nelle camere del Palazzo Apostolico Vaticano.* Rome: Giacomo
Komarek.
1794. Luigi Lanzi. *History of Painting in Italy.* Trans. Thomas Roscoe. London,
1847.

1839. Passavant, Johann David. *Raphael of Urbino and His Father Giovanni Santi.* Abridged Eng. version of German. 4 vols. London: Macmillan, 1872.

1882. J. A. Crowe and G. B. Cavacaselle. *Raphael: His Life and Works.* London: Murray.

1883. Springer, Anton. "Raffaels 'Schule von Athen.' " *Die graphischen Künste* 5:53–106.

1896. Dorez, Léon. "La bibliothèque privée du Pape Jules II." *Révue des Bibliothèques* 6:97–124.

1899. Wölfflin, Heinrich. *Classic Art.* Trans. Linda Murray and Peter Murray. London: Phaidon, 1948.

1913–14. Waldman, Emil. "Die Farbenkomposition in Raffaels Stanzenfresken." *Zeitschrift für bildende Kunst* 25:23–4.

1936. Golzio, Vincenzo. *Raffaello nei documenti nelli testimonianze dei contemporanei e nella letteratura del suo secolo,* Vatican City: Pontificia Insigne Accademia Artistica dei Virtuosi al Pantheon.

1938–9. Wind, Edgar. "The Four Elements in Raphael's Stanza della Segnatura." *Journal of the Warburg Institute* 2:75–9.

1948. Fischel, Oscar. *Raphael.* 2 vols. Trans. Bernard Rackham. London: Kegan Paul.

1950. Redig de Campos, Deoclecio. *Le Stanze di Raffaello.* Florence: Del Turco.

1954. De Tolnay, Charles. *Michelangelo.* 5 vols. Vol. 4: *The Tomb of Julius II.* Princeton: Princeton University Press, 1945–60.

1956–7. Redig de Campos, Deoclecio. "L'ex voto del Inghirami al Laterano." *Rendiconti della Pontificia Accademia Romana di Archeologia* 29:171–9.

1957. Hetzer, Theodor. *Gedanken um Raffaels Form.* Frankfurt: Vittorio Klostermann. Originally published 1932.

1959. Chastel, André. *Art et humanisme à Florence au temps de Laurent le Magnifique,* 476–80. Paris: Presses Universitaires de France.

1960. Stridbeck, Carl Gustaf. *Raphael Studies.* Vol. 1: *A Puzzling Passage in Vasari's "Vite."* Stockholm Studies in the History of Art, no. 4. Stockholm: Almquist & Witsell.

1961. Freedberg, Sydney J. *Painting of the High Renaissance in Rome and Florence.* 2 vols. Cambridge, Mass.: Harvard University Press.

1962. Shearman, John. "Leonardo's Colour and Chiaroscuro." *Zeitschrift für Kunstgeschichte* 25:13–47.

1964. Künzle, Paul. "Raffaels Denkmal für Fedro Inghirami auf dem letzten Arazzo." In *Mélanges Eugène Tisserant,* vol. 6, Studi e Testi, no. 236, 499–548. Vatican City: Biblioteca Apostolica Vaticana.

1965. Redig de Campos, Deoclecio. *Raffaello nelle Stanze.* Milan: Martelli. (Trans. John Guthrie, Milan: Martello, 1973, in reduced format.)

1966. Dussler, Luitpold. *Raphael: A Critical Catalogue of His Pictures, Wall-Paintings, and Tapestries.* Trans. Sebastian Cruft. London: Phaidon, 1971, from German original.

1969. Becherucci, Luisa. "Raphael and Painting." In Mario Salmi, ed., *The Complete Work of Raphael,* 9–198. New York: Reynal, from Italian original.

1970. Pope-Hennessy, John. *Raphael.* London: Phaidon.

1972. Gombrich, Ernst. "Raphael's Stanza della Segnatura and the Nature of its Symbolism." In *Symbolic Images: Studies in the Art of the Renaissance,* 85–101. London: Phaidon.

1972. Oberhuber, Konrad, and Lamberto Vitali. *Il cartone per la "Scuola d'Athene."* Fontes Ambrosiani, no. 47. Milan: Silvana Editoriale d'Arte.

1972. Shearman, John. "The Vatican Stanze: Functions and Decoration." *Proceedings of the British Academy,* no. 57. Oxford: Oxford University Press.

1974. Weil-Garris Posner, Kathleen. *Leonardo and Central Italian Art, 1515–1550.* College Art Association Monograph Series, no. 28. New York: Institute of Fine Arts.

1975. Palisca, Claude. *Humanism in Italian Renaissance Musical Thought.* New Haven: Yale University Press.

1975. Pfeiffer, Heinrich. *Zur Ikonographie von Raffaels "Disputa."* Rome: Tipografia Universitaria Gregoriana.

1977. Bruschi, Arnaldo. *Bramante.* London: Thames & Hudson.

1977. O'Malley, John W. "The Vatican Library and the Schools of Athens: A Text of Battista Casali, 1508." *Journal of Medieval and Renaissance Studies* 7:271–87.

1978. Barasch, Moshe. *Light and Color in the Italian Renaissance Theory of Art.* New York: New York University Press.

1978. Lee, Egmont. *Sixtus IV and Men of Letters.* Rome: Edizioni di Storia e Letteratura.

1979. O'Malley, John W. *Praise and Blame in Renaissance Rome: Rhetoric, Doctrine and Reform in the Sacred Orators of the Papal Court, c. 1450–1521.* Durham, N.C.; Duke University Press.

1979. Rash-Fabbri, Nancy. "A Note on the Stanza della Segnatura." *Gazette des Beaux-Arts,* ser. 6, 94:97–104.

1980. Ackerman, James. "On Early Renaissance Color Theory and Practice." In Henry A. Millon, ed., *Studies in Italian Art and Architecture 15th through 18th Centuries,* 11–44. Cambridge, Mass.: MIT Press.

1981. Hope, Charles. "Artists, Patrons and Advisers in the Italian Renaissance." In Guy Fitch Lytle and Stephen Orgel, eds., *Patronage in the Renaissance,* 293–343. Princeton: Princeton University Press.

1982. Oberhuber, Konrad. *Raffaello.* Milan: Mondadori.

1983. Joannides, Paul. *The Drawings of Raphael.* Oxford: Phaidon.

1983. Jones, Roger, and Nicholas Penny. *Raphael.* New Haven: Yale University Press.

1983. Oberhuber, Konrad. *Polarität und Synthese in Raffaels "Schule von Athen"* Stuttgart: Urachhaus.

1984. Brilliant, Richard. "Intellectual Giants: A Classical Topos and the *School of Athens.*" *Source* 3:1–12.

1984. Onians, John. "On How to Listen to High Renaissance Art." *Art History* 7:411–37.

1984. Winner, Matthias. "Il giudizio di Vasari sulle prime tre Stanze di Raffaello in Vaticano." In *Raffaello in Vaticano.* Milan: Electa.

1985. Borsook, Eve. "Technical Innovation and the Development of Raphael's Style in Rome." *Canadian Art Review* 12(2):127–36.

1985. Massari, Stefania. *Raphael Invenit. Stampe da Raffaello nelle collezioni dell'Istituto Nazionale per la Grafica.* Rome: Edizioni Quasar.

1986. Ames-Lewis, Francis. *The Draftsman Raphael.* New Haven: Yale University Press.

1986. Morello, Giovanni. *Raffaello e la Roma dei Papi.* Rome: Palombi.

1987. Hartt, Frederick. *A History of Italian Renaissance Art.* 3rd ed. Englewood Cliffs, N.J., and New York: Prentice-Hall/Abrams.

1989. Garin, Eugenio. "Raffaello e la 'pace filosofica.' " In *Umanisti, artisti, scienziati,* 171–81. Rome: Riuniti.

1990. Shearman, John, and Marcia B. Hall, eds. *The Princeton Raphael Symposium: Science in the Service of Art History.* Princeton: Princeton University Press.

1991. D'Ascia, Luca. *Erasmo e l'umanesimo romano.* Florence: Olschki.

1991. Gould, Cecil. "The Chronology of Raphael's Stanze: A Revision." *Gazette des Beaux-Arts,* ser. 6, 117:171–82.

1992. Bambach Cappel, Carmen. "A Substitute Cartoon for Raphael's *Disputa.*" *Master Drawings* 30:9–30.

1992. Hall, Marcia B. *Color and Meaning: Practice and Theory in Renaissance Painting.* Cambridge: Cambridge University Press.

1992. Shearman, John. *"Only Connect . . .": Art and the Spectator in the Italian Renaissance.* Princeton: Princeton University Press.

1993. Gage, John. *Color and Culture: Practice and Meaning from Antiquity to Abstraction.* London: Thames & Hudson.

1993. Grafton, Anthony E., ed. *Rome Reborn: The Vatican Library and Renaissance Culture.* Washington, D.C.: Library of Congress.

1994. Farago, Claire. "Leonardo's *Battle of Anghiari:* A Study in the Exchange between Theory and Practice." *Art Bulletin* 76:301–30.

1994. Millon, Henry A., and Vittorio Magnago Lampugnani, eds. *The Renaissance from Brunelleschi to Michelangelo: The Representation of Architecture.* Milan: Bompiani.

1995. Bell, Daniel Orth. "New Identification in Raphael's *School of Athens.*" *Art Bulletin* 77:640–6.

1995. Bell, Janis. "Raphael as a 'Scientific Painter.' " In Claire Farago, ed., *Reframing the Renaissance: Visual Culture in Europe and Latin America,* 91–111. New Haven: Yale University Press.

INDEX